Secrets of East A

Nigel Pennick is recognized a[s]
enous European spiritual tradiuons, wnicn ne has
studied and practised since the early 1960s. Cur-
rently, he is teaching the arts of geomantic location
under the aegis of the Honourable Guild of Locators.
He has written many books including *The Ancient
Science of Geomancy, Sacred Geometry, Das Runen
Orakel, Runic Astrology, The Pagan Book of Days, Anima
Loci,* and *Mazes and Labyrinths* (published by Robert
Hale). With Paul Devereux he is the author of *Lines
on the Landscape: Leylines and Other Linear Enigmas*
(also published by Robert Hale) and with Prudence
Jones, *A History of Pagan Europe.*

Secrets of East Anglian Magic

NIGEL PENNICK

ROBERT HALE · LONDON

Robert Hale Limited
Clerkenwell House
Clerkenwell Green
London EC1R 0HT

2 4 6 8 10 9 7 5 3 1

Photoset in North Wales by
Derek Doyle & Associates, Mold, Clwyd.
Printed in Great Britain by
St Edmundsbury Press Ltd, Bury St Edmunds, Suffolk.
Bound by WBC Book Manufacturers Limited,
Bridgend, Mid-Glamorgan.

Contents

Acknowledgements

I would like to thank the following for various assistance and information over the years: Freya Aswynn, Barry Barker, Michael Behrend, John Blackthorn, Ivan Bunn, Michael W. Burgess, Jess Cormack, Jacky Craig, K. Frank Jensen, Prudence Jones, Rosemarie Kirschmann, Patrick McFadzean, Bob Rickard, Jeff Saward, Paul Screeton and John Yeowell. Also the staffs of the Cambridge University Library; the Cambridgeshire Collection at the Central Library, Cambridge; Huntingdon Library; Ipswich Library; Norwich Library; the Fitzwilliam Museum, Cambridge; Cambridge University Museum of Archaeology and Anthropology; the Cambridge and County Folk Museum; Chelmsford and Essex Museum; Saffron Walden Museum; Moyse's Hall Museum, Bury St Edmunds; the Norris Museum, St Ives; the Wisbech and Fenland Museum; the Lynn Museum, King's Lynn; Ancient House Museum, Thetford; the Castle Museum, Norwich; Tolhouse Museum and No. 4 South Quay, Great Yarmouth; the Museum of London; Pitt-Rivers Museum, Oxford; St Edmundsbury Cathedral; various vicars and guardians of countless churches and sacred places too numerous to list; and last, but by no means least, practitioners of the Nameless Art, living and dead, who must remain anonymous.

Introduction
The Character of the Nameless Art

As long as people have lived in this region of England, East Anglian magic has been practised. Of course, the core of East Anglian magic is in Norfolk, Suffolk and Cambridgeshire, but identical traditions also exist on the edges of these counties – in the southern Lincolnshire Fens, Huntingdonshire and Essex. Magic exists at a fundamental level, and its character has always been multi-faceted, reflecting the needs, feelings, passions and fashions of the places and periods through which it has passed. Like all folk traditions, it has no definitive name for itself, being referred to by outsiders by more or less generic terms like 'magic', 'wizardry', 'sorcery' or 'witchcraft'. When I came into its circle in the 1960s, it was referred to by my master as the Nameless Art, or Sigaldry.

Essentially, whatever we call it, East Anglian magic is an oral tradition that continues today, in an age of almost complete literacy. The essential pluralism of oral traditions is often ignored, for it is a tenet of popular culture that all things have a single 'origin'. Those who hold this idea believe that a definitive reality – a 'text' – can be discovered underlying the outward appearance of any practice. But the East Anglian magical arts do not represent a text that existed once or exists now in some abstract realm as a fundamental 'original'. The Nameless Art is nothing if not a dynamic, living, organic, system, existing in the present. There is no orthodox original from which all else is derived, and so to go looking for it is a futile exercise.

The idea that there must be a 'proper original' somewhere is a fallacy that originated in the literary tradition, where there is usually a definitive, original, text of anything framed in

language. But in the Nameless Art, this cannot be so. When any magical act is performed, each practitioner essentially recreates it anew each time she or he does it. This magical performance is not the re-enactment of a previously determined text or script, but a fresh event, newly brought into being by the magician, here and now. It is a new rendering, a new creation which is not a mere repetition of the past, but a re-statement of the essential archetype.

Of course, the essentials of each magical act remain unchanged, being based upon immutable principles, but the form that they take is newly created each time it is brought into being. Such spontaneity can never exist when people are working from authorized texts, for then there is a rigid priesthood, bound to the holy writ of books. Inevitably, this creates attempts to preserve, regulate and enforce the orthodoxy onto those who think differently. Also, because much of the teachings must be presented in a symbolic and metaphorical form, those who take things literally are missing the point.

Like all human systems, historically the Nameless Art has altered and accommodated itself in accordance with changing conditions. Through the work and discoveries of its practitioners, the Nameless Art developed and evolved beyond its ancient roots, absorbing new concepts as they became available. Naturally, the magic of any age reflects the preoccupations of the time. So, the form of the Nameless Art at the present day reflects the time in which we live. But, like everything else, it contains within it the traces of its history. Some magical elements are clearly archaic, coming from its ancient Germanic and Danish roots, whilst others are part of classical occultism. The names of deities and technical terms come from the terminal phase of the East Anglian dialect, which seems to have stabilized in the eighteenth century.

The sources of individual magical elements may be of academic interest, but they are not so important as the understanding that the Nameless Art of East Anglia remains in existence as a dynamic system of value that can adapt to changing conditions and continue to serve as a useful spiritual pathway. The Nameless Art is not handed down as a spectacle for others to see that it continues to exist. Neither is it handed down in order to perpetuate it for its own sake. It is handed down so that its recipients can do magical work, bringing results.

If the recipient of the tradition does not use it creatively, then she or he is just part of an elaborate role-playing game. Any tradition that is really an attempt to return to the past is no more than an empty husk, whose external form may resemble the ancient patterns, but whose inner kernel is lifeless. The Nameless Art is something else.

Although the Nameless Art is essentially oral, that does not mean that there are no texts. At various times, some East Anglian practitioners of the Nameless Art have collected together spells and other material in written form in books that are sometimes known generically as *The Secret Granary*. But, just as each granary contains unique grains, different from those in other granaries, so the various books called *The Secret Granary* also contain different texts, for there is no definitive test. Even *definitive* texts can be interpreted in a number of ways, all of which are authentic. When we try to collect together unwritten materials, we are making a text out of something that in its essence is not textual in character. This book is a published example of material that might be found in a *Secret Granary*. The text is a version of the Nameless Art that has a specific origin in the author's own experience. But East Anglian spiritual magic, being vernacular and oral in character, had and has no central authority that defines, authorizes and enforces any form of authoritarian orthodoxy. Any alternative that properly reflects the inner essence of the Nameless Art is equally valid.

This book presents the magical system of the 'school' of *The Way of the Eight Winds* in the most comprehensive and coherent version yet published. *The Way of the Eight Winds* is a contemporary manifestation of the tradition, a humanistic way that does not subvert the free will of others, or attempt to dominate, command and control. It is not a game of ego-fulfilment for people to play so that they can live out their private fantasies of adventure and power in their own world. The Nameless Art offers the means to be creative within the given conditions of our landscape, lives and histories, to undertake healing and undergo transformation, to worship the divine powers of earth and heaven, and to gain an inner understanding of the nature of reality.

1 Early East Anglian Religion and Magic

The Foundation of East Anglia

Before the province of East Anglia came into existence in the sixth century through the settlement of Anglians from what is now Denmark, it was part of Celtic Britain. The dominant tribe of this region was the Iceni, of whom the tragic heroine-queen Boudicca is the most famous representative. In Celtic times, magic was an integral part of everyday life, and, under Roman occupation, various forms of magical influence arrived from many parts of the Roman Empire. But when, in the early fifth century, the imperial legions were withdrawn to fight on the Continent against internal rebels and external barbarians, Germanic people from what is now Holland, Denmark and Germany began to come to eastern Britain in increasing numbers to raid in the manner of the later Vikings. Attacked from the north by the Picts, from the west by the Irish and from the east by Germanic peoples, mainly Anglians, Saxons and Jutes, the Romanized government of Britain appealed for military assistance from Rome. But, as Rome itself was about to fall to the superior force of the Goths, the British were informed that they could expect no further military support. The military problem of the north especially was so pressing that certain Germanic mercenaries were brought in to fight the Picts.

The prowess of their Gothic cousins in sacking the formerly invincible city of Rome, effectively overthrowing the western Roman Empire, seems not to have been lost on the Germanic warriors who fought for the British government. Soon they began to settle in Britain, bringing over their families, and taking

over land. The superior weaponry and fighting abilities of these Germanic warriors made them more than a match for the Britons, who were forced progressively westwards. It was only the leadership of the man later known as King Arthur that slowed the expansion westward of what was by now called England. After the final defeat of the Romanized Britons in eastern England, the Anglians established the nation of East Anglia, ruled by a regal dynasty, the Uffingas. The name Uffingas (or Wolfingas) appears to mean 'people of the wolf'. They are mentioned in the Old English poem *Widsith* as living in or near Denmark. The date for the arrival of Uffa, the founder, appears to have been the year 526, though the king-list proper begins with (presumably) another Uffa, who was reigning in 571.

The earlier kings of East Anglia are shadowy figures, about whom relatively little is known. Reigning between 599 and 624 was Raedwald, son of Tytil. He was the third king of East Anglia, and was also the *Bretwalda*, supreme king of Southumbria, England south of the River Humber. *Bretwalda* is a title that was perhaps a reinstatement of the office of the former Celtic High King of Britain. It is most likely that Raedwald was buried at Sutton Hoo, the royal cemetery of the East Anglian kings, perhaps in the magnificent ship burial mound excavated in the 1930s. The rich and elegant grave-goods found there, full of magical intent, attest to the high culture of seventh century East Anglian Paganism. But it was also a violent age of constant conflict, in which six of the Wuffingas died in battle over a period of less than eighty years.

Raedwald was reigning in the time when the Roman Catholic Church began to send missionaries into England. When the Church sent priests into East Anglia to compel the people to give up their ancestral religion, many people were baptized forcibly, and then counted by the Church as Christians. However, compelling people by law to be baptized or even to attend church on a Sunday did not make anyone believe in the Christian religion, or care in any way about what the priests were preaching. Consequently, where they were not suppressed, Pagan traditions continued. This was partly because the action that the Church took was in contradiction to the doctrinal principles taught by the priests. According to its monopolistic doctrine, the Church was antagonistic towards Pagan

observances, but in practice it tolerated many of them, and allowed them to continue within the framework of Church festivals. In most places, the Pagans were not expelled ruthlessly from their places of worship, as later monkish scribes sometimes claimed. A few Christian priests, foreigners among a suspicious and conservative peasantry, did not have the power to conduct a cultural revolution, and had to proceed cautiously. Neither were the Pagans so tame or naive as to allow the Christians to wreck the shrines and sanctuaries of their ancestral faith. So, in many places, where the Pagans behaved themselves, the Christian priests conducted their rituals in places where Pagan deities were honoured, and where Pagan worship continued.

Dual Faith Saints and Shrines

The supremely tolerant Pagan polytheism of the Anglians could easily absorb a few Mediterranean divinities without a second thought, so in many cases, and over a long period, Christian images were added to Pagan shrines, or Pagan images were given another interpretation as saints or prophets. The East Anglian king Raedwald, who had been initiated into Christianity in Kent, had a personal shrine in which he worshipped both Pagan and Christian deities. In Raedwald's temple were Pagan and Christian altars. In the pluralistic tradition of Paganism, this is in no way strange. Pagan pantheons are always able to absorb further divinities, as happened in Germanic religion, where the newer deities of order and mastery, the Aesir, were added to the older nature deities, the Vanir. In the Pagan understanding of religion, all deities have their place within the wider pantheon of the gods, and it is possible for a single individual to be initiated into a number of different *mysteries*. So when a Pagan was baptized, he or she did not see this as a renunciation of the gods, but initiation into another cultus. Someone might belong to the association of devotees of Woden of the Crossroads, the Honourable Guild of Carpenters, the society of guardians of the local holy well and the cult of Jesus, without conflict. Only when one or other claims to have exclusive rights do problems arise. Surviving medieval churches attest to this pluralistic approach, containing as they do a wealth of Pagan images. As the Church grew in power and wealth, so the sacred places had churches

erected upon them. When this happened the local deity was usually renamed as a Christian saint, just as the Romans had renamed native divinities after their nearest Roman ones.

A good example of this is St Olaf, who had a major shrine at St Olave's near Fritton, south-west of Great Yarmouth. St Olaf was the king of Norway who was killed by a battleaxe at the Battle of Stiklastad in 1030. Sainted by the church, Olaf's image was set up in churches in Norway and other Norse-influenced lands. The images of Olaf continued the iconic tradition of images of Thor, an axe replacing the thunder god's hammer. In the churches, Pagan devotees of Thor paid respect to the statues as images of their god, whilst Christians venerated him as their royal martyr-saint. Thus, both beliefs were catered for. In both church ritual and secular ceremony too, Pagan prayers and invocations were retained, and just altered slightly by the addition or substitution of the names of Christian divinities. For example, a tenth-century charter of King Edgar invoked 'The High Thunderer', which could be conveniently interpreted by Pagans as Thor and by Christians as their Father God. In a magical charm against sickness, called the *Canterbury Charm*, dating from 1073, are the words 'Thor hallow you'. There are numerous other examples of what the contemporary Odinists call 'dual faith' observances.

Part of this syncretic religion was the cult of St Edmund, the East Anglian sacred king, who at one time was patron saint of England, and whose shrine was at St Edmundsbury (Bury St Edmunds). Edmund was born in Germany, perhaps at Naumburg, in 841, and acceded to the throne of East Anglia, which was then a vassal-kingship, in 855, at the age of fourteen. Landing in East Anglia at Hunstanton, at Yule in 855 he was crowned by Bishop Humbert on a sacred hill at Bures St Mary in Suffolk. After he had reigned for fourteen years, the country was invaded by a superior Danish force. After a short war, Edmund's East Anglian army was defeated decisively by the Danes in 869, in a battle at Snarehill, near Thetford.

Edmund was not captured, but honour dictated that he should negotiate with the Danish leaders at Haeglesdun. Then he was taken prisoner and ritually executed, perhaps as a sacrifice to Tyr or Odin. He was tied to an oak tree, scourged, shot full of arrows, speared with javelins and then beheaded. The body was then left behind, still tied to the tree, whilst the

head was cast into a thicket of thorn bushes. Some time later, the Danish forces having moved on into Cambridgeshire, some of Edmund's followers discovered the body, but the head was missing. Later, through a revelation, they found the head, guarded by a grey wolf, the totemic beast of the East Anglian royal dynasty. Head and body were buried nearby, and a chapel was erected over them. The location of this holy place is not known for certain. Traditionally, it was Hoxne in Suffolk, and, in 1870, St Edmund's Monument, a stone cross on steps, was set up in a field there to commemorate the event. More recently, opinion has favoured the present-day Hellesdon in Norfolk, or, alternatively a field called Hellsdon at Bradfield St Clare, around 8 miles (13 km) from Bury St Edmunds.

Around the year 880, Edmund's followers took the head and body to the former royal seat of Beodericsworth, which had been founded by King Sigebehrt *c.* 630. Edmund was buried there with great ceremony, having been declared a saint by King Alfred the Great, who designated him the patron of England. In 945, King Edmund, who saw St Edmund as his kinsman (or perhaps, in the Germanic Pagan tradition, saw himself as his reincarnation), gave a tract of land to the monks who kept the shrine. Later, this became the town of St Edmundsbury. In 1010, in another war with invaders from Denmark, when Thetford and Cambridge were destroyed, St Edmund's body was removed from Beodericsworth and taken to London for safe keeping. But in 1013 it was returned to Suffolk, and later King Canute had an elaborate and expensive new shrine built for the divine king at Beodericsworth. In 1021, the Benedictine Order took over the shrine, the town was renamed St Edmundsbury, and the relics of other ancestral heroes and saints were collected together there. Then, in 1032, a circular chapel was built to house the relics of Edmund. During the reign of Edward the Confessor, the abbey was given large tracts of land in Suffolk, which led to the county being called *Selig Suffolk* – holy Suffolk. Later, this was corrupted to the present 'Silly Suffolk', which has a quite different meaning.

Between 1066 and 1085, the abbey and town were reconstructed as a geomantic grid (for further details of this, see Pennick and Devereux, *Lines on the Landscape*, Robert Hale, 1989). The barons in opposition to King John swore a solemn oath at the shrine of St Edmund on his patronal day, 20

November 1214, which led to the creation of Magna Carta. But in 1217, the remains of Edmund were stolen by Viscount de Melun, who took them to France. Two years later, at the seige of Toulouse, de Melun lost them, and they came into the keeping of some local monks. By 1219, the skull and bones of St Edmund were enshrined in the Basilica of St Sernin at Toulouse. Then, in 1275, when there was no hope that the relics would come back to England in the foreseeable future, St George became the country's patron saint in place of St Edmund.

The shrine of St Edmund was a place of popular religion, where Christian ceremonies and observances were carried out side by side with Pagan ones without conflict. Pilgrims who came to the shrine were able to avail themselves of the miraculous power of the relics and sacred objects kept there. The power of the divine king was employed mainly in the healing of illness, the promotion of fertility in women, and the pardoning of transgressions. Among the most powerful of the magic objects kept at St Edmundsbury was St Edmund's Pardon Bowl. Whoever drank from it, 'in the name of God and St Edmund', automatically received a pardon for 500 days' worth of sins. At his tomb, the sword, war-banner and shirt of St Edmund were preserved as relics, to which magical powers were attached. Another of St Edmundsbury's important relics was the magic skull of St Petronella, which was there as a charm against headache. If a person suffering from the ague (malaria and other diseases of the Fenland damp) laid his or her hands upon the skull, then it was believed that a cure was certain. Close to the abbey, near the south gate, was the Hospital of St Petronella, a centre of healing for pilgrims.

Other important bones were kept in St Edmund's sanctuary, including the remains of another East Anglian king, Anna, who reigned from 635 to 654, and those of his son, Jurmin. Also, the skull of St Botolph, the guardian saint of ships and city gates, was shown to believers. It had been sent to Bury around 960 by King Edgar, who had ordered the skeleton to be split up to provide relics for the abbeys at Bury St Edmunds, Thorney and Westminster. In times of drought, Botolph's skull was exposed to the elements to bring rain. Other relics at Bury included those of St Humbert (St Humber), who was the patron of hunters in East Anglia. In its heyday, as a sacred place in

England, Bury St Edmunds was second only in importance and wealth to Glastonbury.

South-east of the abbey, between No Man's Meadows and Southgate Street, was once a field called The Haberden. The land had been granted to the abbey in 1281 by Henry fitz Nichol de St Edmunds, on condition that a white bull should always be kept there. This animal was maintained specifically for a ceremony known as The Oblation of the White Bull. Until the Reformation, and perhaps later, whenever a married woman wished to become pregnant, this ritual was conducted. Ceremonially, the woman went to the field where the bull was kept. Then they decked the white bull with ribbons and garlands of flowers, and brought it out. It was led in procession through the principal streets of the town, with the woman alongside, stroking its flanks. Attended by all the monks singing, and an enthusiastic crowd, the procession traversed Church Street, Guildhall Street, and Cook Row, and came to the gates of the church. Then, the bull was taken back to The Haberden and the woman entered the church, made a vow at the altar of St Edmund, kissing the holy stone and asking the saint for the blessing of a child. Foreign ladies could make the oblation by proxy.

The abbey was destroyed during the Reformation, and what relics remained were lost. The buildings were largely demolished for building materials, and the remains turned into houses. Today, the site of the shrine of St Edmund, once the patron saint of England, is not even marked amid the ruins of the abbey church. The most holy shrine in eastern England has been reduced to less than a shadow of its former glory, Christian worship now taking place in the cathedral nearby, which was established in the twentieth century in the old abbey pilgrimage church of St James. But in 1901, the bones of St Edmund – except the skull – were returned to England, and kept in the private chapel at Arundel Castle. The skull remains in France, so the restoration of the shrine at Bury St Edmunds is still some way off. Until it is restored, Bury's civic motto of 'Shrine of the King, Cradle of the Law' will not ring true.

The other famous and powerful shrine in East Anglia is at Walsingham in Norfolk. Today, it is the most important centre of pilgrimage in Britain. This is because it was the first place in the world that an apparition of Our Lady was seen. In the year

1061, Richeldis, the lady of the manor of Walsingham, had three separate visions of her. In them, she was told to build a replica of Mary's house in Nazareth, according to certain canonical dimensions. This was done, and Walsingham became the first Marian shrine. Of a quite different character than St Edmund's shrine at Bury, Walsingham became the model for other shrines at which the White Lady appeared and was identified as Mary. Destroyed during the Reformation, it was re-established in the twentieth century, albeit as two separate shrines, one Catholic and the other Protestant.

Pagan and Magical Traditions

Throughout the medieval period, the Christian Church was quite different in character from its contemporary form. The well-known minimalist Protestantism of the Puritans and their successors had not then come into being, neither was Catholicism like it is now. The Catholic Church in its present form dates from the Counter-Reformation of the sixteenth and seventeenth centuries. Before the Reformation and Counter-Reformation, the Catholic Church embraced many traditions, customs and observances that stemmed directly from Pagan usage and beliefs, both from the classical Paganism of Rome and the northern Paganism of the Celts and Germanic peoples. Ocasionally, there were purges against the more obviously Pagan observances, but such zeal was generally short-lived, and things usually reverted to normal after a few years.

In the Middle Ages, the East Anglian monks Guthlac and Wulsi were famed for their oracular pronouncements, and at Bawburgh there was a holy healing well connected with another element of vernacular religion. There, St Wulstan was worshipped as spiritual guardian of the holy well. He was neither monk nor priest, and his sainthood was never bestowed by king or church. He had been a well-guardian who, according to an eighteenth century chronicler, 'lived chaste without a wife, and peformed his promise by fasting on Fridays and saints' vigils … He died on the third of January, 1016, and became God of the Fields of Norfolk'.

The nature of Wulstan as a holy man is quite different from that of the saints that the church liked to promote. After his

death, Wulstan was invoked to ensure the fertility of fields and flocks. Rather than being in the Christian tradition of pious clergyman, Wulstan stands squarely in the Pagan tradition of the apotheosized cunning man. Christian saint or not, he was revered and worshipped. Perhaps this is because magic was the preserve of monks and priests as much as secular wizards. Although officially church doctrine was set against the practice of magic, in reality many medieval clergymen, including abbots and bishops, were noted magicians. Furthermore, certain monasteries were known for being Black Schools where the magical arts were taught, and whose libraries contained the choicest and rarest tomes of magical lore. In northern Europe, the cathedral schools of Hólar and Skalholt in Iceland had a strong reputation for this, and the books penned there circulated the coastal regions of the North Sea.

Also, the power of the centralized church itself was frequently challenged. In 1208, in the time of King John, the Pope, dissatisfied with the King's wish for independence, put an interdict on England. The churches were closed, bells were not rung, weddings were celebrated as hand-fastings under trees without Christian clergy, and the dead were buried in unconsecrated ground without Christian rites. Vernacular religion readily took the place of Catholicism. In the next year, because John refused to accede to the Pope's orders, England was excommunicated from the Catholic Church. Then, in retaliation, King John expelled all Christian priests from the country, and confiscated Church property. Then came a period of unparalleled vitality and prosperity. Freed from the burden of church taxation, and the strictures of a greedy clergy, the people of England were able to express their natural Paganism. The first reference to magic in the province dates from this time. In 1209, a Norfolk woman, Agnes, wife of Odo, accused a person called Galiena of sorcery. Galiena was found innocent of the charge after 'the ordeal of iron'.

At this time, John of Devizes recorded the pluralistic and lively renaissance that the city was experiencing under excommunication. When he visited London, he was astonished to find that the city was full of the sort of people continually harassed by the Christian clergy, now able to conduct their lives freely: actors, jesters, Moors, pretty boys, belly-dancers, singing-girls, quack doctors, sorceresses, magicians, gay people,

mimes and others whose lifestyles were condemned by the
Church. These people, he said 'filled all the houses'. Merchants
from Lithuania and other Pagan states in the Baltic traded at the
Steelyard in London, and the time appears to have been a happy
interlude of freedom and prosperity, the very image of 'Merrie
England'. Later, when Rome had re-established the power of its
Church in England, John was vilified by the propagandists as an
evil, scheming, traitor. The popular *Robin Hood* stories portray
him thus. However, he is remembered with affection in East
Anglia. His sword is kept as municipal relic at King's Lynn, and
people still seek his treasure which was lost in the Wash near
Wisbech. In Cambridge, during the years when the church was
closed, King John established the great Midsummer Fair on
Midsummer Common, which still flourishes today. At the
opening each year, the mayor throws hot coins to the crowd,
symbolizing the fiery sun at her height in the heavens. When
John died, a horse was sacrificed at his funeral, indicating that
he was a king in the tradition of the Elder Faith. There has
never been another King John of England.

Later, when the Church was re-established, it was not
popular, and conflicts often became violent. In June 1272, there
was a rebellion against the clergy in Norwich. During the
Tombland Fair, people objecting to the unfair tolls imposed on
tradesmen by the Church, attacked and burnt the cathedral,
killing many monks in the process. For this outburst of
resistance, the city was excommunicated for a period, and
subsequently, many citizens were hanged. Five days after the
Tombland riot in Norwich, the monks of Colchester attacked
some townspeople, who retaliated with a major riot against the
abbey there. In 1327, after the monks had carried out an armed
attack upon the townspeople, the Abbey of Bury St Edmunds
was stormed, looted and burnt, with great loss of life. Similar
running conflicts existed wherever large monasteries were
situated in towns.

Considering the bad relations between clergy and populace,
the Church grandees often thought it sensible to keep the
priests separate from secular society, away from the attractive
traditional Pagan practices and festivals that were observed as a
part of everyday life. In 1364, Simon Langham, Bishop of Ely,
censured the clergy in his diocese for attending the drinking
parties called Scot-Ales, 'Priests are not to mix with actors,

mimes or jesters, nor to play dice,' he said. It was thought best that priests should only come every Sunday to the church to conduct services. The rest of the time, the ancient sacred place was free for all of the traditional activities that were the social and sacred fabric of everyday life.

2 The Witch-Hunts

Herb-Doctors and Magicians

England has a number of parallel magical traditions, all of which have contributed to East Anglian practice. Very important is the eclectic tradition of herbalism, which was, until quite recently, inseparable from magic. Like every branch of useful knowledge, the herbal tradition has never been static: herbs have been imported for centuries, and herbal knowledge, too. Even in Anglo-Saxon times, practitioners of *Wortcunning* used whatever was available. The mandrake was introduced around the eleventh century, a century in which the spicers and pepperers of East Anglia were importing and selling exotic spices for culinary and medicinal uses. In the thirteenth century, tradesmen began to specialize in specific kinds of herbs and drugs, supplying doctors and wizards alike. Because many herbs were not indigenous to England, doctors, wizards and wise women needed to possess the ability to cultivate important magical and medicinal herbs themselves, and to prepare medicines and potions from them. The knowledge of Jewish doctors, with their cosmopolitan connections, was also an important element in English herbalism. In the middle of the thirteenth century in Norwich was a notable herb garden 'appertaining to Solomon the Physician son of Isaac the Physician'. Unfortunately, this important link was broken in 1290, when all Jews were expelled from England by King Edward I.

During the Middle Ages, magicians of every kind could be found everywhere. For instance, in 1406, King Henry IV was informed that the diocese of Lincoln was 'infested by sorcerers, wizards, magicians, necromancers, diviners and soothsayers of

every sort'. Later in the fifteenth century, during the Wars of the Roses, rival claimants to the throne retained wizards who used battle magic. In 1441, the 'witch of Eye', Margery Jourdemayne, was charged, along with the Duchess of Gloucester, with using a wax poppet to bring about the death of King Henry VI by magic. King Henry VI himself commissioned two alchemists to make money for the war effort, and, on at least one occasion, consulted a wise woman. In East Anglia around this time, folk magic absorbed useful and relevant material from the Hermetic grimoires of wizards, and astrological and alchemical texts that were circulating among the learned. Certain material from texts like *Clavis Solomoni* (The Key of Solomon) and *Cyprianus*, the most powerful magic book of Denmark, entered East Anglian tradition.

The two great annual fairs at Cambridge, the Midsummer Fair and the Sturbridge Fair, always attracted booksellers who brought the latest publications from Holland and Germany to sell to the university academics. The spread of printing enabled a wider dissemination of such esoteric knowledge, making works of astrology and classical magic widely available. Later, printed broadsheets, chapbooks and almanacs carried information useful for vernacular magicians. Until the eighteenth century, everyone believed not only in the existence of magic, but also in its effectiveness. It was only over its meaning that people differed. Those who believed magic was invariably harmful used the press for provocations against practitioners of magic, and ultimately, they were responsible for the witch-hunts.

The official opinion of what magic was, what magicians did and what it meant came from people with a literary education; the academics, priests and lawyers. Without exception, they were schooled in a Biblical interpretation of existence, whose world view was in many ways quite different from that of the indigenous oral tradition of the country. Following Biblical descriptions of such things, the English literati lumped together all sorts of unusual and exceptional human powers and abilities under the single description 'witchcraft'. In Biblical terms, this meant powers believed to be derived from the Judaeo – Christian Devil, Satan, in opposition to their Father-God. Drawing on the notorious Biblical maxim 'Thou shalt not suffer a witch to live', the legal mechanism of witch trials enabled the lawyers to persecute scapegoats drawn randomly from a number of different types of

people. Among those whom they killed were women with house animals in the Pagan tradition, folk magicians, midwives, assertive women, eccentrics, and retarded, disabled and unpopular people. The law, in attempting to suppress pluralism on a collective level, on the personal level killed people as witches.

One element of persecution came from the institutionalization of medicine. In 1512, a law was passed making the practice of midwifery illegal without a licence from the local bishop's court. It also restricted the practice of surgery to graduates of Oxford and Cambridge Universities. Because these universities only admitted men, it was made illegal for women to practise medicine. In 1518, the College of Physicians received its charter, which attempted to prevent the practice of medicine by 'ignorant persons ... common artificers as smiths, weavers and women boldly take upon them great cures and things of great difficulty in which they partly use sorcery and witchcraft ...' The law was relaxed in 1542, when 'divers honest persons as well men and women, whom God hath endowed with knowledge and the nature, kind and operation of certain herbs, roots and waters ...' were exempted, so long as they did not charge a fee. But in 1544, Dr Thomas Gale, later physician to Queen Elizabeth I, wrote that the sick people in St Bartholomew's and St Thomas's Hospitals in London 'were brought to that mischief by witches, by women'. Around the same time, in 1541, another Act declared it a felony to exercise the art of sorcery to discover treasure and stolen goods. The agenda was set.

With the collapse of the Roman Catholic religion in England, many of the Pagan folk observances which formerly had been conducted as part of the cult of saints and holy places, continued to be carried on, now without Church approval. Protestants saw them as either the remains of Catholicism, or remains of Paganism, both of which they hated and feared. Thus they attempted to eliminate them, by any means necessary. In this way, many of the old Pagan practices which had survived assimilation into the Catholic world were lumped together with divination, magical healing, spells, curses, and the use of other occult powers, and called witchcraft.

Faced with such a complex and bewildering mixture of elements from different magical and religious systems, the Protestants opted for the easy way out, and called it all

witchcraft – especially when women were doing it. In 1562, the Cambridgeshire doctor, William Bullein, published a book entitled *Defence against all Sickness, Sornes and Woundes that dooe daily assault Mankinde*. In it, he wrote

> I did know within these few years a false witch called Mother Line, in a town in Suffolk called Perham, which with a pair of ebony beads and certain charms, had no small resort of foolish women when their children were sick. To this lame witch they resorted to have the Fairy charmed and the Sprite conjured away: through the prayers of the ebony beads which she said came from the holy land and were sanctified at Rome. Through whom many goodly cures have been done, but my chance was to burn the said beads … I knew in a town called Kelshall in Suffolk, a witch whose name was Mother Didge, who with certain Ave Marias upon her ebony beads and a wax candle, used this charm following for St Anthony's fire …

In the year before witch-hunting began, folk magic, eclectic as ever, was using anything available, including remnants of Catholic practice, no longer available from the Protestant priesthood.

At this time, popular pastimes, such as dancing, wrestling, fortune-telling, gaming and divination, were conducted in the churchyards, often at the same time that the priest was conducting a service inside. They had been no problem for the Catholics, who had made the revels part of the saints' festivals. But now, the true Pagan nature of the festivities was reasserting itself. It was customary for travelling players, wandering minstrels, mimes, mummers, tumblers and jugglers to put on their shows in the churchyard, probably as their forebears had done in former times when the churchyards had been Pagan frithyards. But, under the new Protestant regime, the official attitude towards such things was complete disapproval. Writing in *The Anatomy of Abuses*, published in 1583, when English witch-hunting had already begun, the Protestant fundamentalist Stubbes recorded in great detail and with great distaste the activities of the lively and exciting Pagan revellers of his time:

They bedeck themselves with scarves, ribbons and laces all hanged over with gold rings, precious stones and other jewels; this done, they tie about either leg twenty or forty bells, with rich handkerchiefs in their hands ... Thus, all things set in order, they have they their hobby-horses, dragons and other antics, together with their bawdy pipers and thundering drummers to strike up the devil's dance withal. Then march these heathen company towards the church and church-yard, their bells jingling, their handkerchiefs swinging about their heads like madmen, their hobby-horses and other monsters skirmishing among the throng; and in this sort they go into the church ... though the minister be at prayer or preaching) dancing and swinging their handkerchiefs ... Then, after this, they go again and so forth into the church-yard, where they have commonly their summer-halls, their bowers, arbours, and banqueting houses all set up, wherein they feast, banquet and dance all that day and (peradventure) all the night too. And thus these terrestrial furies spend the Sabbath day.

Puritan Protestant propagandists like Stubbes argued that all folk traditions were unchristian and therefore ought to be wiped out. The Puritan Protestants therefore instituted a programme of elimination of all Pagan, Catholic and non-Protestant observances and practices. The English witch-hunts were the cornerstone of this programme. Although magicians had been prosecuted before that time, witchcraft was made a capital offence in England in 1563. Then, an Act against 'Conjurations, Inchantments and Witchcraftes' prescribed the death penalty for the first offence of anyone found guilty of using 'Witchcraft, enchantment, charm, or sorcery, whereby any person shall happen to be killed or destroyed'. In a paranoid atmosphere of suspicion, when England was threatened by Roman Catholic subversion from within and a Spanish invasion, then any untoward event, inexplicable illness or accident, was liable to be blamed upon an outside agency, rather than to chance or bad luck.

Important and irrevocable changes to life occurred in the 1500s. The Romanies arrived in England, bringing with them

Indian and eastern European herb-lore. Also, many new plants were imported from the Americas. These included many important vegetables and drug-plants that transformed the culinary and medical arts in Europe. They included tomatoes, tobacco, potatoes, sarsaparilla, cascara, curare, coca, ipecacuana and guaiacum. The use of these new herbs and drugs also brought new experiences, favourable and unfavourable. Suspected initially as demonic, these plants soon proved their value, and became assimilated into the repertoire of cook and medic alike. But possession of these unusual plants, as well as strange animals new to Europe, also brought suspicion upon anyone who owned them. At one time, even potatoes were suspected as being agents of the Devil!

East Anglian witch-hunting began in earnest in 1566, the year that the first major witch trial in England took place. At Chelmsford in that year, three women from Hatford Peverell, Agnes and Joan Waterhouse, and Elizabeth Francis, were accused of having owned, in turn, a cat called Satan, which was supposed to have been the cause of several misfortunes. In the light of later recorded East Anglian cat names, it is likely that the cat was called Saturn and not Satan. But in an age of paranoia, even a cat's name could be seen by humourless Puritans as the Devil's work, so Agnes Waterhouse was hanged, Elizabeth Francis received a year's imprisonment, and Joan Waterhouse was freed. In 1579, in another witch trial, Elizabeth Francis was also hanged for witchcraft, along with Ellen Smith who owned a strange black animal upon which neighbours blamed the death of a child.

In 1582, at St Osyth in Essex, Ursula Kemp and Elizabeth Bennett were executed as witches. Ursula Kemp was a midwife whose crime was 'unwitching' sick people from illness. Their remains were found at St Osyth's in 1921. The elbows and knees of the two women's skeletons were riveted through with iron pins, to prevent them walking as living dead. In 1583, when fourteen men were drowned in a shipwreck near Wells-Next-The-Sea, Norfolk, the disaster was blamed on witchcraft rather than bad weather. Old Mother Gabley of King's Lynn was blamed for 'boiling or rather labouring of certain eggs in a pail of cold water', which was supposed to have caused the ship to founder. Perhaps this ominous accusation describes no more than the well-known method of testing whether eggs are good or

bad. But it is also possible that she was practising egg-divination, perhaps concerning the fate of a ship at sea in the storm. Somehow, however, it was interpreted as having some connection with the shipwreck, and she was duly punished with death.

Another inhabitant of the town, Margaret Read, was one of only three women to be burned as a witch in England. She was killed in 1590. The brickwork of a house in the Tuesday Market place in King's Lynn bears a carved Egyptian diamond pattern in which is a heart. It marks the place where her heart, exploding from her body as she burned at the stake, splattered against the wall. Unlike most supposed witches, who were hanged, Margaret Read was burnt because she was found guilty of killing her husband by witchcraft. Legally, husband-murder was classed as the crime of petty treason, for which the penalty was burning. Interestingly, the other two English witch-burnings also took place in East Anglia. Mother Lakeland was burnt at Ipswich in 1654, and Mary Oliver at Norwich in 1659. Both were supposed to have bewitched their respective husbands to death. If there had been any other evidence for murder, such as poison, it is certain that they would not have been charged as witches. It seems that the charge of witchcraft may have been used as a catch-all for suspects against whom there was no evidence.

In 1589, there was a mass trial for witchcraft at Chelmsford, when ten people were accused. One of them, Joan Prentis, owned a ferret, her 'bid' or familiar, to which magic powers were ascribed. She hanged for it, as did Joan Cunny and her daughter Avice, who were alleged to have owned some toads and a pair of unusual animals called Jacke and Gill. These they were supposed to have sent to attack cattle and demolish firewood stacks. The possession of sacred house animals was once widespread in Europe, and the presence of bids in the house is clearly part of this Pagan tradition. In East Anglia, in former times, an old wise woman owning a bid was called an Old Biddie, for she had the power of 'bidding' her spirit animals. Now biddie is a pejorative term used to insult old women in general, whether or not they have the power. It was women such as these who were persecuted in the witch-hunts. In south Germany until the 1950s, and perhaps later, certain farms possessed a house snake, whose presence was deemed necessary

for good luck and prosperity. Interestingly, these were not local snakes, but Aesculapian adders, a southern European species. Similar house snakes, the zeltys, are part of the Lithuanian Pagan religion, playing an important part in New Year ceremonies.

A proportion of rural people have always had an affinity with animals, and have possessed an ability to communicate with them that is denied to most of us. Magically, the true bid is a spirit animal that expresses in physical form the inner nature of the species, providing us with otherworldly guidance and psychic protection. It was for this uncanny spirit alliance with house animals that many women were murdered in former times by the witch-hunters. Also, almost all of the witch-hunters came from the educated classes, where only servants would look after the cats, dogs, horses and other livestock. Coming from the animal-less world of books and prayer, these lawyers and priests had no affinity with the animal kingdom, and suspected animal familiarity as demonic.

Inexplicable illnesses were also the signal for the witch-hunters to move in. In 1589, at Warboys in Huntingdonshire, a girl suffering an epileptic fit was enough for accusations of ill-wishing to be levelled at an elderly neighbour called Alice Samuel. The parents of the girl, Jane Throckmorton, called in a doctor from Cambridge, who, unable to find any obvious causes for the fit, suggested that it was magical in origin. Such accusations came from doctors who did not have the humility to recognize the limitations of their medicine. When they were confronted with conditions with which they could not cope, many doctors blamed the illness on witches. A month after the diagnosis of witchcraft, Jane's four sisters were also having fits, which led eventually to Alice Samuel being arraigned for bewitching them. The whole family, mother, father and daughter, was arrested and taken before the Bishop of Lincoln, who handed them over to the secular authorities for trial. After ill-treatment, Alice admitted that she kept 'dun chickens' as familiars, and all three were hanged for witchcraft on the Huntingdon scaffold in 1593.

The sheriff, Sir Henry Cromwell, confiscated the property of the murdered Samuels, and made a fund from the proceeds to pay for an annual sermon against 'the detestable sin of witchcraft'. This was duly preached each Lady Day at All

Saints' Church in Huntingdon by a Fellow of Queens' College, Cambridge. This lasted until 1814, when it was discontinued. Such propaganda preached in churches by respectable academics kept alive a belief in the official explanation of witchcraft. The involvement of Cambridge University was not accidental, for the Platonists at Cambridge were among the last intellectuals who supported witch-hunting. Academics like Henry Holland of Magdalene College, later rector of Orwell, provided theoretical justification for the witch-hunts. In 1590, in *A Treatise of Witchcraft*, Holland purported to show how the Devil was at the root of all bad happenings, and how the witches were his agents.

In 1603 under the influence of the misogynist Protestant fundamentalist King James I, witch-hunting was actively promoted in England, and in 1604, any attempt to cure illness by unauthorized means was officially classified as witchcraft. In 1608, another Cambridge academic, William Perkins, a Fellow of Christ's College, wrote in his *A Discourse of the Damned Art of Witchcraft*, how the death penalty was an essential punishment for all witches. 'The ministers of Satan', wrote Perkins, 'under the name of Wisemen and Wisewomen are at hand, by his appointment, to resolve, direct and help ignorant and unsettled persons ...' Later, in 1626, when Mary Smith was hanged as a witch at King's Lynn, the Reverend Alexander Roberts wrote an account and analysis called *A Treatise of Witchcraft*, which stoked the fires of prejudice still further. The worst was yet to come.

The separation of folk medicine from official medicine was taking place at the same time. In 1617, the Apothecaries' Company was set up, split off from the Company of Grocers which the apothecaries had formerly been part of. In 1618, the *London Pharmacopeia* was published, which was to be obeyed by all apothecaries in Great Britain by royal order. Wise women and cunning men who were not part of the system were now running the risk of breaking the law if they did not follow the prescriptions. Now it was easier than ever to prosecute them for practising witchcraft.

3 Later Witch-Hunting
and the Travelling People

The Witch-Finder General

The second wave of witch-hunting occurred during and after the Civil War, when many old scores were settled under the guise of religious zeal. In East Anglia, the majority of executions were due to the lawyer son of a Christian priest from Great Wenham, Matthew Hopkins. As the self-styled 'Witch-Finder General', Hopkins conducted a reign of terror in the years 1644 to 1646. In naming himself 'Witch-Finder General', Hopkins was emulating the notorious German self-styled *Malefizmeister* ('Witch-Master') Balthasar Ross, who conducted a murderous travelling inquisition around Fulda from 1602 onwards. The notorious career of this English witch-hunter began in March 1644, when Hopkins persecuted a group of women that met close to his house in his home town of Manningtree. This group, he claimed, met every six weeks on a Friday night and 'had their several solemn sacrifices', which Hopkins, as a fundamentalist, naturally assumed were to the Christian Devil.

If the whole thing was not fabricated by Hopkins to justify his paranoid delusions, it is possible that these women were conducting either traditional or self-created Pagan rituals that had nothing to do with Christian demonology. But once the women were arrested and tortured by sleep deprivation and other cruelties, they would confess to anything just to stop the agony. Only when they had confessed to being agents of the Christian Devil would Hopkins's torture stop. By torturing those whom he had seized, Hopkins and his assistants, Mary Phillips and John Stearne, were able to extract the confessions

they wanted. Because the authorities paid him a fee for every 'witch' he caught, it was in his interest to find as many as possible. Many historians have considered money his main motivation, but although financial gain played a part, religious fanaticism was at the root of his witch-hunting.

In his short career, Hopkins brought death to a remarkably large number of people. In 1644, forty people were hanged for witchcraft on the old moot-hill of Dinghowe near Bury St Edmunds, and in another trial, at Chelmsford in July 1645, thirty-two women whom Hopkins had arrested were brought before the magistrate. Nineteen were sentenced to death immediately, and were killed publicly in a mass hanging. Those not condemned at once were remanded in custody until the next session, which some never lived to see, having been done to death in prison in the interim. The others, all but one, died later on the gallows. The kind of people hunted by Hopkins were the weakest members of society, perfect scapegoats without the power or often even the intelligence to resist a cunning and eloquent lawyer. It seems that Hopkins used his knowledge of the earlier witch-hunts to good effect. The first person he accused of being a witch was a one-legged, toothless 81-year-old woman, Elizabeth 'Mother' Clarke. Her own mother had been hanged as a witch in the previous witch-craze. After harassment and torture, Elizabeth Clarke implicated a neighbour, Anne West, for supposedly having sexual intercourse with the Christian Devil. Perhaps this was used as a pretext to persecute a woman whose sexual behaviour offended prudish Puritans. Anne West's daughter, Rebecca, was also accused, but was later freed in a plea-bargaining deal in which she denounced other women to Hopkins in return for her own freedom. She was the sole survivor of the Chelmsford persecution.

As in other witch-hunts, people who possessed house animals were suspected of being witches by Hopkins and his cohorts. People with a more humane perspective criticized this as preposterous. Writing in 1646, the vicar of Great Staughton in Huntingdonshire, John Gaule, commented that every old woman with 'a spindle in her hand, and a dog or cat by her side, is not only suspected, but pronounced a witch'. After being tortured, Faith Mills of Fressingfield in Suffolk confessed to Hopkins that her pet birds, Tom, John and Robert, had forced a

cow to jump over a stile and caused a cart to refuse to move. She was hanged, as was the Widow Weed of Great Catworth in Huntingdonshire. Weed had two dogs, called Pricill and Lily, whose very possession led to her death. The names of animals seem to have held a particular fascination for witch-hunters; the more bizarre, the better. Pets with names like Griezzell Greedigutt, Sacke and Sugar, Ilemanzar, Peck-in-the-Crown, Jarmara and Pyewackett were enough to send an old woman to the scaffold. Today, the name Pyewackett is often given to pedigree cats.

No one was safe, for the accusation of witchcraft, against which there was no legal counter-argument, was often used to settle old scores. At Brandeston in Suffolk, John Lowes, a Christian minister, fell into the hands of Hopkins. After torture, he confessed to using black magic to sink a ship off Harwich, even though none had sunk at that time. He was sentenced to death at Bury St Edmunds, and hanged. Clearly, Lowes was legally murdered for supporting the king in the Civil War, for Hopkins was one of Parliament's men.

At witch trials, accusations and counter-accusations were bandied about as accused people attempted to implicate others, and sometimes the stories were worthy of Baron Munchausen. Before the time of Hopkins, in 1657, Margaret Pryor of Longstanton near Cambridge accused some Quakers of having turned her into a horse and then having ridden her to Madingley Hall. Several Cambridge professors and the Puritan writer John Bunyan believed her implicitly and wrote in defence of her claim. At one Cambridge witch trial, Mistress Lendall told how Old Strangridge, a local cunning man, had flown over Great Shelford on a black dog, tearing his breeches on the church weathercock. For this, she was hanged as his accomplice. All too often, such fantasies were taken as fact by the learned judges, who, in the climate of hysterical terror may have feared that they would also be branded witches if they should seem sceptical. On rare occasions, the charge was dropped, as with Thomasina Read of Haddenham, Cambridgeshire, who was accused of witchcraft, but freed. The vast majority were not so fortunate.

Hopkins was a self-publicist who wrote to magistrates offering his services to rid their districts of witches. He was able to play on the conspiracy theory, explained in detail by Henry Holland, that witches were agents of the Devil, sent by him to

disrupt and overthrow society. As 'Witch-Finder General', Hopkins claimed to have in his possession a document he called the 'Devil's List', which contained the names of all the witches in England. This no one else had. Also, as his fame spread, Hopkins was actively invited to visit other towns to find witches there. With his assistants, he undertook a witch-hunting tour of Norfolk, Suffolk, Cambridgeshire, Huntingdonshire, Northants and Bedfordshire. Of course, he found plenty of witches. At Bury St Edmunds alone, sixty-eight were killed as witches. It was only his death, of tuberculosis, in 1647, that put an end to this infamous episode of judicial murder that had resulted in the death of around 300 victims.

Sometimes, people were accused of attacking Hopkins magically. It is not surprising that real practitioners of magic, fearing attack, should try to fight back magically. But whether Anne Leech and Elizabeth Gooding did attempt to conjure up a magical bear into existence to attack him is uncertain. They were punished for it, anyway. In times when the witch-craze reigned, it was dangerous to talk about unusual experiences. In 1647, Adam Sabie of Haddenham in Cambridgeshire was brought before the justices at Ely, charged with worshipping a spirit that had appeared to him spontaneously 'in the likeness of a child', who told him, 'Fear not, Sabie, I am thy god.' In the climate of witch-hunting, the witnesses of epiphanies, who in other times would be considered blessed, were prosecuted.

After Hopkins, although witch-hunting was less organized, it continued sporadically. In 1662 at Lowestoft, two women, Amy Duny and Rose Cullender, were arrested and sent to Bury St Edmunds for trial as witches. Amy had been a child-minder, and a child in her care had suffered fits. At the trial, the judge, Sir Matthew Hale commented, 'That there are such creatures as witches I make no doubt at all. For first the Scriptures have affirmed as such. Secondly the wisdom of all nations has provided laws against such persons, which is an argument on their confidence of such a crime.' The unfortunate women were hanged, 'having confessed nothing', on Dinghowe. The hill is now called Betty Borough's Hill after the last woman executed there as a witch. A pamphlet about the Lowestoft case, published in 1682, revived the witch-hysteria once more, and, across the Atlantic, was partly responsible for the notorious witch trials in Salem, Massachusetts. In East Anglia, women

continued to be burnt for husband-murder. Amy Hutchinson was publicly burnt alive in Ely in 1750, and Margery Beddingfield at Rushmere, near Ipswich, in 1763.

Later East Anglian persecutions were local isolated instances, often perpetrated without legal sanction. As before, some victims were practitioners of the magical arts, though most were attacked for other reasons. In 1699, at Coggeshall in Essex, Old Widow Colman was accused of possessing magical poppets.

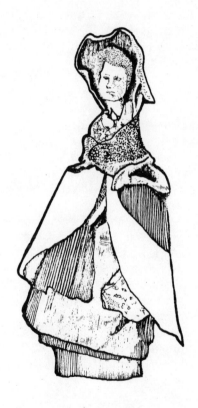

Magic poppet of the eighteenth century,
with a written spell on paper, discovered
in a house in Bury St Edmunds and now
displayed in Moyse's Hall Museum,
Bury St Edmunds

The local priest made her confess to being a witch, and then she was lynched by a mob who threw her into deep water. It is not unlikely that she was a poppet-maker, for magical poppets were being made at that time. One can be seen in Moyse's Hall museum in Bury St Edmunds. Some who were persecuted as witches were women who asserted their independence too strongly for patriarchal liking. Close to Christmas, in 1748, Alice Green of Monk's Eleigh in Suffolk was accused of being a witch. She had dared to appear in church wearing a black silk dress, so she was thrown into the river by a mob under the guise of witch-punishment. Strangers, too, came in for inhuman treatment. In 1825, at Wickham Skeith in Suffolk, local people attacked a pedlar, Isaac Stubbins, believing that he had bewitched two people to insanity. Hands tied, he was thrown three times into a pond. But before the villagers could kill him, the local vicar and churchwarden stopped the torture, and Stubbins escaped.

Disabled people were also treated shamefully under the pretext of witch-punishment. In the seventeenth century, Hopkins had killed women like Mother Clarke, and in August 1865, at Sible Hedingham in Essex, a similar instance occurred. An 80-year-old deaf and dumb French fortune-teller known as Old Dummy, was accused of bewitching a certain Mrs Smith. His neighbours dragged him out of the Swan public house and threw him into the nearby stream, believing that an ordeal by water would determine whether or not he was guilty. Floundering in the water beneath a hail of stones, Old Dummy had no chance. When he was pulled out, he was nearly dead. They took him to the workhouse, where, within a few days, he did die. However, unlike earlier persecutions, this witch-hunt was illegal, and the perpetrators of the crime, the said Mrs Smith and a man called Stammers, were found guilty of manslaughter, and sentenced to serve six months' imprisonment with hard labour.

Travellers and Transients

Immigrants were important in bringing magical elements into the East Anglian tradition. The Romany people are famed for their magical traditions, and they have travelled through East Anglia for almost five centuries. The first Romany people

arrived in England around 1500, probably from Scotland, and they were persecuted immediately. Then, in 1530, all 'Gypsies' were ordered to leave the country. The 1530 Act of Parliament stated: 'People calling themselves Egyptians, using no craft nor fact of merchandise have come into this realm and gone from shire to shire and place to place in great company, and used great subtle and crafty means to deceive the people ...' It seems that the 'subtle and crafty means' referred to by the drafters of the Act of Parliament were considered to be magical. However, the law was practically unenforceable and usually ignored. But, occasionally, zealous officials rounded up Romany people for deportation, as at Huntingdon in 1544, when they were transported forcibly to Calais. Around the same time, others were deported to Norway. Then, under Cromwell's regime, when all 'social deviants' were considered a threat to public order, things got worse, and mass executions of Romanies took place. At one assize in Suffolk, thirteen were hanged together in a manner reminiscent of Hopkins's witch-hunts. Other unfortunate Romanies were transported to the West Indies to work as slaves along with Irish and West African captives.

Having migrated from India several hundred years earlier, the Romanies were startlingly different from the indigenous population. They had dark skin, wore oriental clothes, and spoke a 'secret language' locally called Pedlars' French, unintelligible to English people. They also practised a form of Pagan religion, which today would be called Hinduism. They were thus subjected to racial abuse, xenophobia and religious intolerance. However, they were useful as scapegoats, as all of the ills that befell a community could now be blamed upon them. Wherever they wandered, the Romanies were accused of stealing produce, washing, animals and even children, terrorizing housewives, and carrying cholera, smallpox, influenza and the plague. They responded to this persecution by counter-threats of curses and other magical acts that were part of their religious repertoire. The Romanies were known for their magical abilities which were derived from their indigenous Indian traditions, to which had been added certain magical techniques from eastern and central Europe, which they had assimilated during their travels westward. It is probable that several types of divination, including tarot cards, were introduced into the East Anglian province by Romany

fortune-tellers who worked the fairs. It is clear that there was considerable contact between practitioners of the Nameless Art and Romany magicians.

In the Civil War, Scottish prisoners of war were brought to the Cambridgeshire Fens by Cromwell to work there as slave labourers on drainage projects. Some of their magical techniques became incorporated into the Nameless Art. Two centuries later, Irish refugees who fled to East Anglia from the catastrophic potato famine of 1846 brought with them elements of the Celtic fairy faith, which were also incorporated into local lore. In the great ports of King's Lynn, Great Yarmouth and Ipswich, seamen of many lands were coming and going, bringing new things and ideas into East Anglia. The slave trade, too, brought Africans to King's Lynn. But not all travelling people were foreigners, forced out of their native lands, or voyaging across the seas on business. On the roads at any one time, there were large numbers of pedlars and journeymen, travelling tradesmen who sold items and performed services in a society where the retail trade was not yet fully developed, and where the craft tradition was not yet destroyed.

These highly mobile members of trades and practitioners of crafts, travelling in search of new employment, were supported in their travels by trade guilds and individual brother tradesmen, who could recognize them through a system of secret passwords, signs and recognition-sticks, as well as by the letters of introduction that they carried. These secret passes were often called The Ship or The Horse, being the means by which the journeyman could travel. When the craftsman died, he was burned by his comrades at his funeral. To travel as a journeyman is a form of initiation, where one finds oneself, practises one's calling, and sees something of the wider world.

Travelling as a journeyman was not without hazards. Moving from village to village and town to town without certain lodgings or possessions, it was possible to be mistaken for a beggar. But, unlike the vagrant, the journeyman could trust his adoptive family, his fellow craftsmen, to provide for his needs. In exchange for hospitality and employment, many journeymen carried knowledge of the lastest new techniques, which they handed on to those guild-brothers whom they visited. Also, those who were literate brought notebooks and literature. Sometimes, a journeyman would leave something more tangible

than the products of his trades behind him, like the turf labyrinth at Saffron Walden, made, it is said, by a journeyman shoemaker. From the seventeenth century, veteran soldiers, who had fought abroad in the service of the Crown in imperial and continental wars, were given the right to practise as journeymen shoemakers. They travelled the country, carrying their cosmopolitan knowledge and stories to all who would listen.

In addition to journeymen, there were merchants travelling to fairs, who would always sell their wares along the way to anyone who had money. One of the largest fairs in England was in East Anglia, on Sturbridge Common, to the east of Cambridge. The secret knowledge of the astrologers, palmists, tarot-readers, illusionists, snake-oil salesmen, healers, flim-flam men, story-tellers and players travelled with them. Seasonal migrations of harvest-workers, some of whom were Romany, swelled the movement of people, and magical knowledge, across the land. Even those without a trade, looking for casual labouring work, the 'trampers' – tramps – had their own secret codes and signs.

The Hard Times of Old England

Conditions of life were harsh in East Anglia in former times, shortages were endemic and famines were frequent. Grinding poverty was an everyday reality. Sometimes, even the little food available was sold elsewhere by greedy landowners. This happened in Suffolk in 1631, and food riots were the result. In East Anglia, in the hundred years between 1660 and 1760, there were famines and food riots in 1662, 1663, 1674, 1681, 1693, 1727, 1740 and 1757. Under these conditions, it was not uncommon for starving mobs to loot the local storehouses for food, only for the 'ringleaders' to die later on the gallows in the official vengeance that followed.

In 1756, the gentry of Suffolk, led by Admiral Vernon, decided to set up parish 'Houses of Industry' which were the earliest workhouses. Then, poor people were compelled by law to enter the workhouse, where families were split up, and conditions were appalling. As the Cambridge 'Beggar Poet', James Chambers, wrote at the time:

If I fail in my task, I lose a hot dinner;
Perhaps at the whipping-post then shall be flogged,
And lest I escape my leg must be clogged.
While tyrants oppress I must still be their slave,
And, cruelly used, tho' well I behave:
Midst swearing and brawling my days I must spend,
In sorrow and anguish my days I must end.

Most workhouses came into being through the activities of
churchmen, who were hated as a result. Inside, the inmates
were forced to attend Christian worship because those who
refused to pray were refused food until they did. Consequently,
outside the workhouses, church attendance was low in East
Anglia, and religion was a matter of folk tradition. But as local
charities for the poor, such as provided bequests of fuel in
wintertime, were only for those who went to church, some were
compelled by circumstance to attend. The parson was also often
the local squire – the so-called *squarson*, and was hated
accordingly by the lower orders. All men who met him had to
'touch their caps' to him, and women had to curtsey. When the
common land was enclosed, the clergy benefited with fine new
houses, whilst the very means of subsistence was taken from the
poor. These same clergymen were also the local magistrates
who enforced the harsh Game Laws against poor people trying
to supplement their meagre diets by hunting small animals, now
criminalized as poaching. The enclosures also meant that wood
was scarce, and cow dung was used as fuel. The
Cambridgeshire fens were known as 'the place where the cows
drip fire'. An East Anglian rhyme for the period, *The Parson's
Creed*, gives a good idea of how many people felt about the
clergy:

Money, O money,
Thy praises I sing.
Thou art my Saviour, my God and my King.
Money, O money,
'Tis for thee that I pray,
And give thanks to God
Three times a day.

As in former times, resistance against the Church took the

form of sporadic outbursts of rage. For example, in 1792, the slogan of the Norfolk rioters was 'No king, no clergy!' There are also tantalizing glimpses of the activities of the lawless herring-shovellers who worked in the kipper-making industry, known as the Roaring Boys. Those of Hickling made a bonfire of their parson, and this also occurred elsewhere, as a Lowestoft folk song recalls:

> The Roaring Boys of Pakefield,
> O how they all do thrive.
> They had but one poor parson,
> And they buried him alive.

Until railways were built, parts of East Anglia were remote and relatively cut off from other parts of England, enabling local traditions to develop and thrive. In the eighteenth and nineteenth centuries, the village of Briston in Norfolk was an 'open parish'. There was no major landlord or squarson at Briston, and hence it gained a reputation for freedom and independence. Every 26 May, 'the wildest of the wild' and 'the most virile folk' would visit Briston for the cattle fairs, when all sorts of 'illicit trades' were practised. Poor people who went there were not transported back to the workhouse in their own parishes, so they lived in shacks that they built on the edge of the commons. Unlike in most villages, the people of Briston could speak their mind without fear of persecution by squire or parson. Many were reputed to be magicians and healers, who could ply their craft without official hindrance. One cunning man was famed far and wide, and visitors came to him from London to be cured of warts. The Briston spring, too, had medicinal waters. Places like Briston and the nearby 'lawless place' of Edgefield served as reservoirs of alternative, magical and revolutionary beliefs and practices. Neither Church nor State had power here until the establishment of the police force.

Other causes of unpopularity of the Church of England were the Church taxes and the courts administered by the Church. Until the middle of the nineteenth century, Church courts continued to deal out punishment to villagers. In 1849 at Fen Ditton near Cambridge, Edward Smith, a local gardener, was forced to do penance in the church for allegedly slandering the rector's wife. The church authorities fined him £42 7s 6d, then

an enormous sum, and made him recant publicly in the church. His penance was interrupted by the villagers, who first jeered, then wrecked the pews and threw church ornaments around. Smith was carried shoulder-high in triumph to the Plough Inn, whilst another posse of jeering villagers chased the rector and his wife home. Church taxes, too, caused hardship until they were abolished in the 1930s. After the Great War, many East Anglian farmers refused to pay their Church taxes, and there were many seizures of property. A memorial at Elmsett, erected in 1934, commemorates a farmer whose livelihood was destroyed by Church taxation, and who was forced to emigrate to New Zealand. Because of the hardship caused by Church tithes, and the number of businesses it destroyed, it was finally abolished in the 1930s, and the power of the Church was at last broken.

4 The Wise Women
and the Cunning Men

The Roots of Modern Wisecraft

The period of wisecraft relevant to the modern era can be dated roughly between 1780 and 1930. The era of the witch-finders was past, and, although there were occasional outbursts against local people accused of being witches, the days of official persecution were gone. With the reintroduction of the fairy faith through Irish immigrants, attitudes altered. Seemingly supernatural misfortunes were blamed less upon witchcraft, and more upon the activities of the little people. Now, the result of personal squabbles involving alleged witchcraft would most likely end in court, where the attackers would be prosecuted. This happened in 1803, when Ann (Nanny) Izzard of Great Paxton, Huntingdonshire, was accused by her neighbours of being a witch and repeatedly assaulted. Then it was her assailants who were prosecuted, as with the persecutors of Old Dummy at Sible Hedingham. In 1879, at East Dereham, when William Butler attacked Christiana Martins and her mother, believing them to be Toadswomen who had bewitched him, he was arrested, and the police superintendent wondered whether he was mad. By then, the expansion of enormous industrial cities like London and Birmingham had altered the attitudes of those in power, and hence the legal profession was no longer interested in pursuing magicians or witches. The authorities cared little, believing that their powers were illusory. This change came at the same time as institutionalized discrimination against dissident Christians, Roman Catholics and Jews finally ceased, and instead, disbelief, in the form of militant atheism

47

was seen as being the danger to society.

Attitudes to magic were changing, too. On one hand, the separation between the ruling classes and those ruled meant that the folk beliefs of the lower orders were largely ignored by academics and lawyers. No longer could they be seen as a devilish threat to Protestant virtue. On the other hand, there was a growing interesting in formalized magic. Towards the end of the eighteenth century, schools of magic were set up in London, openly teaching material that previously had been available only through unreliable secret channels. From 1784 onwards Ebenezer Sibley published his *Celestial Sciences*, which recommended techniques for practising various forms of magic, and also raising the dead by necromancy. Then, in 1791, *The Conjuror's Magazine* appeared for the first time. It contained material on ceremonial magic, astrology and alchemy. Even books formerly condemned as diabolical could now be published. In 1797, the Danish magic book, *Cyprianus*, was printed for the first time, and in 1801, Francis Barrett, who ran a magic school in Marylebone, London, published *The Magus* which revealed many secrets of the goëtic art. A few years later, important texts on astrology and divinatory geomancy were published in London. These included *The Philosophical Merlin, Napoleon's Book of Fate, The Straggling Astrologer* and *Raphael's Witch*. Subsequently there was a continual succession of magical and astrological texts available to the reader, which has continued unbroken to the present day.

Magical texts became available in printed form, and, because of a better understanding of magic in general, fortune-telling lost its reputed connection with ill-wishing and black magic. When Scotch Jenny, the celebrated fortune-teller of Peakirk, north of Peterborough, died in 1798, the local newspaper commented 'she will be a great loss to the ladies in that and neighbouring villages, as in all their losses and disappointments in love, or in any other affairs, they always resorted to this wise woman of Peakirk'. Sometimes, though, although they were no longer persecuted as witches, wise women fell foul of the law. In 1822, Lucy Barber, the wise woman of Market Deeping, near Peakirk, was taken before the magistrates for obtaining payment for foretelling the future. Promising never to charge money again, and on returning the fee to her client, Lucy Barber was discharged.

In the nineteenth century, and up to the Great War, when unusual folk-customs or magical practices were noticed by those in positions of authority, they were routinely condemned as barbarous and savage relics of heathenism which had no place in the new Victorian world of empire, industry and muscular Christianity. Only professors of the new science of folklore took an interest in what was going on. So gradually, almost everything that the authorities deemed to be threatening to public order or morals was stopped. The writer of the handbook *Wisbech Hundred* in 1850, expressed the official Victorian attitude to perfection: 'The utility of marts and fairs is now almost wholly superseded; and those of Lynn and Wisbech have degenerated into a mere gathering of freaks of nature, "harlotry players", dirty exhibitions, conjurors, wild beast and ragamuffin life in all its gipsyism.' So, by 1894, it was regretted by many that the old ways were being obliterated fast. In that year, George Day wrote in *The Essex Naturalist*, 'School boards and railways are fast sweeping away every vestige of old beliefs and customs which in days gone by held such prominent places in social and domestic life.' Six years later in the *Eastern Counties Magazine*, Emily Frances Cranworth wrote that the rural people of East Anglia had a 'child-like faith in the unseen world, and the nearness to the spiritual life in which they live', but that this private inner life was countered by a public face where 'everybody is mortally ashamed of believing in the supernatural world nowadays'.

One by one, unusual local customs whose meaning was obscure were stopped by the authorities. For example, in Great Yarmouth in former times, at certain seasons in Kitty Witch Row, the narrowest lane in town, a strange ceremony could be seen. 'Kitty Witches', women dressed in men's clothing, their faces smeared with blood, would rush from house to house, demanding money for drink. Also suppressed was the celebration of *Tander* each 11 December in Peterborough, where men dressed in women's clothing, and women in men's, drank hot elder wine and performed a mumming play. Many other colourful and magical parts of traditional life succumbed. The practice of the Freemen of Huntingdon, who dragged a horse's skull around the Freemen's boundary now and again, was considered a relic of barbarism, and was terminated. The parade of the Straw Bear at Whittlesey in early January was suppressed by the magistrates in 1910. Fortunately, the custom

started up again in 1980 and flourishes today.

Goodwomen, handywomen and headwomen who practised folk medicine and worked as midwifes in the community were vilified by the male medical profession as being superstitious 'old wives', as though women's experience in women's matters was worthless. Where they continued to practise their traditional craft, handywomen were subject to prosecution for not being qualified doctors. The motive of many doctors who condemned them appears to be more about destroying the competition than a concern for the welfare of women in childbirth.

Compulsory education in England after 1870 attempted to inculcate the prejudices and beliefs of the Christian Victorian ruling intelligentsia into every child. One message received by impressionable young minds was that their folk heritage was something of which they ought to be ashamed. They were taught to disrespect their ancestral heritage as inferior and outmoded. Their teachers compared their own indigenous tradition with a distorted misinterpretation of the African Paganism that Christian missionaries were dedicated to destroying. Therefore, the old ways were condemned as degenerate and evil, which meant that they ought to be eliminated as quickly as possible. A recorded example of the results of this new education took place in Whittlesford in Cambridgeshire, in 1878. Susan Cooper, a wise woman, died on 25 April that year, at the age of eighty-three. Just after her funeral, when the gravedigger had finished filling in her grave, the children ran out of the nearby school. Presumably instigated by their teacher, they proceeded to trample the grave, so that the witch's imps could not get out.

But, as in the times of the attempted suppression of official Paganism, and the later witch-hunts, official disapproval could not eliminate what many believed to be a valuable art. In every age, the wise woman and the cunning man are those people who put things together, seek, speak and teach, going where others dare not. Facing hardship, disease and death, practitioners of the Nameless Art undergo the ordeals of the threshold, encountering religious experiences outside and beyond those preached by priests. We enter other dimensions beyond the realms of death, and return with otherworldly gifts. Ours is an art which arises spontaneously from the human condition, and therefore cannot be extirpated from human society. It is a

magical current which comes from the land, a dynamic, living craft that retains its power. Through every period of disapproval and misunderstanding, the Nameless Art has survived underground, continuing locally without leaving any traces except some fragmentary stories and the names of a few of its more notable practitioners. Among them are Bet Cross of Longstanton, Widow Hamilton of Thriplow, Old Nanny Howlett of Wicken Lode, Old Sue Isbill and the Toadswoman Tilly Baldrey of Huntingtoft, Miss Disbury of Willingham, Miss Mullinger of Monk Soham, Grace Pett of Ipswich, Mrs Goodby and Granny Gray of Littleport, Old Mother Redcap of Wallasea Island and Mother Staselson, who 'wore a scarlet cloak'.

The name Old Mother Redcap is a generic title for English witches and ale-wives, such as the famed fifteenth-century tavern landlady Eleanour Rumminge. The arts of brewing ales and making herbal medicines are part of the same body of skills and knowledge. Historically, wise women bearing the title Old Mother Redcap are known from Cambridgeshire, Cornwall, Essex, Lancashire and Sussex. Red Cap was also the name of familiar animals, and a famous fighting cock that beat all comers at Diss Fair in 1817. Until the 1920s, the Essex Old Mother Redcap lived in a house called Tyle Barn or Duval's (Devil's) House on Wallasea Island, a place noted for having no resident frogs, toads or snakes. Old Mother Redcap was remembered for sitting in her house, peeling potatoes and chanting the spell, 'Holly, holly, brolly, brolly, Redcap! Bonny, bonny.' After her death, the place was frequented by the spirit of a familiar, and was thus extremely dangerous to anyone who went there. Cattle went down with 'mad cow disease', and anyone rash enough to stay there was haunted by a voice saying 'Do it! Do it!', which was taken to mean suicide. Like other witches' houses, Old Mother Redcap's was clearly a place of power so active that only a wise woman or cunning man could survive there. The house was bombed by the German air force in World War II, and its ruins were washed away by a catastrophic tidal wave in 1953.

The most famous Cambridgeshire wise woman in former times was Daddy Witch of Horseheath, a village celebrated for its wise women. Daddy Witch lived in a cottage on a patch of ground almost encircled with water, a kind of moat called Daddy Witch's Pond at a place named Garretfield. The name 'Daddy' does not infer maleness, for Daddy Witch was certainly

a woman. 'Daddy' is an old name for the male principle in English magic, and it is likely that Daddy Witch was a devotee of the Horned God known as Herne or Cernunnos. She had a magic book, which locals called *The Devil's Plantation*, which must have been her version of the East Anglian magic book, *The Secret Granary*. This was used by others, like the nineteenth-century miller William Webb and the wizard Claypole. It still flourishes in certain circles today.

Daddy Witch, according to her chronicler, Catherine Parsons, was in her prime among the many witches and wizards who periodically attended the 'frolic and dances' held at midnight in lonely fields by the 'Master Witch', the Magister of the Horseheath district. These ceremonies were strenuous affairs, for witches and wizards returning after the dance were remembered by those who saw them as being in 'a terrible state of perspiration'. In the nineteenth century, Horseheath Fair was known for a witch who danced the hornpipe 'better than any man or woman for miles around'. The tradition of Pagan sacred dance, which continues today, re-titled English Country Dance, was naturally done well by a witch who understood its ritual meaning. At the fair, 'all men, young and old', were eager to dance with her, obviously for reasons of personal empowerment in addition to her undoubted skill as a dancer.

When Daddy Witch died in 1860, as a Pagan she was not interred in the churchyard, but was buried in the middle of the road close to her house. For many years, before modern road surfacing obliterated it, her grave was notable for a consistent dryness when other parts of the road were wet. This was said to be caused by the heat of her body. In the nineteenth century, another Pagan, who lived by the Green in Horseheath, for religious reasons refused permission for her husband to be buried in the churchyard. But she was overruled by the authorities, who demanded his body for burial. The bearers carried his coffin from the house, but, after a short distance, they could no longer carry the weight, and were forced to lay it down at a stopping place. Believing it to be unnaturally heavy, they received permission from the vicar to open it. When they did so, it was found to be full of stones. The body had been buried elsewhere, thwarting the Church's attempt to bury it in church ground.

It is often stated by unthinking writers that witches, Romanies

and other Pagans were *refused* burial in churchyards, being buried instead in the liminal realm of the crossways, as some kind of punishment for their deviance from the Church. Until 1823, people who committed suicide were buried at crossroads. There are many examples of this including, Robert Brommer, who was buried in an Ipswich crossway in 1509, and Dr Jonathan Watson, who was interred at a crossroads near Holbeach three hundred years later. Executed outlaws and highwaymen, too, were buried in the crossroads. But the interpretation that Pagans were refused burial anywhere else appears flawed, as belief in the Christian religion has always been just one of many options in a pluralistic world, and it is not an inevitable consequence of being born in England. It was never compulsory to be buried in ground consecrated by the Church, and it is clear that no adherent of the Elder Faith wants to have a funeral conducted by a Christian priest, any more than by a Rabbi or an Imam. In 1607, at Soham, Henry Seaman was buried standing up. Two minstrels played music before the burial, at which no priest officiated. Afterwards, the minstrels played all day, and a great feast was held. At Shudy Camps, also in Cambridgeshire, in 1699, Ferdinando Salmon was buried in the Bee-Garden belonging to George Bayley. Also, some who were buried in church ground refused the presence of a minister. In 1733, John Underwood of Whittlesey was buried in a green coffin in a funeral conducted without Christian clergy, at which no bell was tolled, but instead Horace's Pagan *Ode for the Dead* was read. In 1947 a farmer called Reynolds was buried in the churchyard at Beeston in Norfolk. A megalith was placed on his grave to ward off the evil spirit that had plagued him throughout his life.

It is Romany tradition, too, not to be buried in a churchyard. The Romany burial grounds at Strethall in Essex, used by the Dymock, Gray and Shaw families, and Mussel (Mousehold Heath) near Norwich, are the most public of these places. Certain Romany families buried their dead at the place where they died. The plates and crockery belonging to the deceased were smashed and the fragments strewn on the grave. Then a thorn bush was planted on the grave, as a marker and spirit plant. Both Romany and Anglian Pagans prefer to be buried as close to a hedge or wall as possible, hence the East Anglian expression 'lying by the wall', meaning dead. To be buried

outside the churchyard at a special place of Pagan sanctity is a
positive wish by one who walks the paths of light and dances the
circles of life.

Daddy Witch's successor was known as Old Mother Redcap.
Like many practitioners of the Nameless Art, the Horseheath
Old Mother Redcap was a notable person in her own right. She
always wore numerous skirts, one of which was draped around
her waist, and a 'poke bonnet', which appears to have been her
badge of office. At one point, a 'black man', perhaps a Romany,
was seen visiting her cottage. He brought a box, and she was
seen to sign a book in receipt of it. It was said to contain some
'imps' in the form of animals that had been the bids (familiars)
of another wise women who had just died. She is thought to
have lived at Castle Camps nearby. That a black man was the
agent of the transfer is an interesting insight into the pluralistic
world of magicians in an era when even 'foreigners' from other
villages were feared and shunned by ordinary folk. The animals
that the black man brought to Old Mother Redcap were a cat, a
ferret, a rat, a mouse and a toad, called Blue Cap, Jupiter,
Bonnie, Venus and Red Cap. The hutch in which they lived was
wrapped in a red underskirt, which, with the red cap, is part of
the 'regalia' of the wise women of this part of East Anglia. This
Old Mother Redcap died in 1926.

In East Anglia, perhaps as the result of the witch-hunts, the
distinction between pets and familiars became blurred. In 1915,
Catherine Parsons described one of the Horseheath witches,
'Old Mrs C.', as owning an 'imp' that sat on top of the salt box in
her house. Visitors described it as something like a mouse, with
very large eyes. It lived in the chimney, the same place favoured
by Lithuanian house snakes. Perhaps it was an exotic breed, like
a Chinchilla, which no one recognized as being anything other
than demonic. As house guardians, these animals were believed
to keep watch on visitors, in order to report any happenings of
interest to their owner.

At Willingham, near Cambridge, the male witch Jabez Few,
who died in the 1920s, owned a number of white rats that he
controlled as familiars. Occasionally, he used these bids to play
practical jokes upon his neighbours, even pitting one against a
cat in a closed room. When the door was opened, the cat was
seen clinging terrified to the curtains, whilst the rat was
unaffected.

The control over animals that practitioners of the Nameless Art possess is part of the long association of animal trainers with magic which has other applications in horsemanship and the circus. Modern commentators, who conjecture that people like Old Mother Redcap and Jabez Few were merely practical jokers who used their animals as 'stage props' to deceive their credulous neighbours have missed the point. People like Jabez Few had real abilities, however they used them. These abilities came in part from the practice of magical techniques which were the stock-in-trade of several societies as well as individuals.

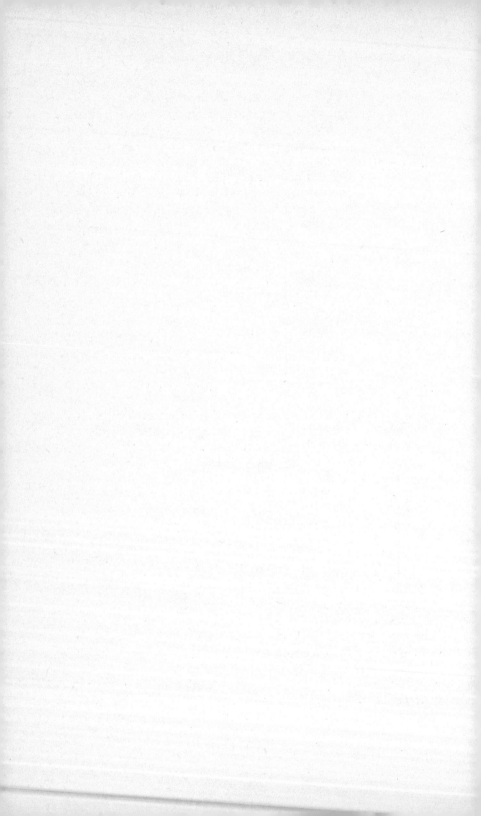

5 The Useful Magic of East Anglia

The Horseman's Word

Allied to the possession of familiar animals is another aspect of
the craft of the wise, the manipulation and control of horses by
physical and magical means, which was too useful to be
condemned as an evil relic of barbarism, yet retained occult
elements that made it frightening to outsiders. So it was left
alone, to continue as a secret art, transmitted from practitioner
to disciple when necessary. Certain secret societies existed to
preserve and transmit this useful knowledge outside the usual
official channels of church, school and university. The horse is
the sacred animal of Woden, and the legendary powers of magic
flutes made from horse bones come ultimately from this
shamanic source. Although horse eating was forbidden by a
Christian law of the year 787, because it was a feature of Pagan
sacred meals in devotion of Woden, it is said that until shortly
before the Great War, East Anglian wise women would feast
ceremonially on horseflesh. Many accounts of witches, cunning
men, Toadsmen and members of the Horsemen's Guild tell
how certain people had extraordinary powers over horses. They
could tame the fiercest horse just by whispering the
'Horseman's Word' into its ear, stop a galloping horse in its
tracks, or calm an excited horse with ease. Also, horses that
refused to move could be started miraculously, or, alternatively,
horses belonging to someone who had offended the
horse-master would be stopped dead until he or she willed it to
move once more.

A story from Horseheath tells how a carter once got stuck
near Money Lane, and, realizing that his horses were stopped by
an unseen agency, called for a witch to liberate them. The witch

told the carter to whip the wheels, not the horses, and the cart moved at once. Sometimes, horses stopped dead outside a witch's cottage, as an accidental result of the activities within, perhaps the preparation of herbal potions. When this happened, it was necessary to summon the wise women to release them so that they could continue their journey. Often, when horses stopped for no apparent reason, and refused to proceed, carters would blame the local witch. A man whose cart got stuck in Silver Street in Cambridge was so upset that he threatened to get a gun to shoot the horses, believing this would also kill the unknown witch whom he blamed for the problem.

Around 1900, in Histon, near Cambridge, a wise woman was annoyed when the van driver, who should have delivered flour to her, went straight past her house without stopping. In the afternoon, when he was passing the cottage on his return journey, she came out and caused the horses to stop dead in their tracks. Then she went indoors, and he was powerless to get them moving again. At nine in the evening, she came out again, whispered to the horses, and off they went. At the same period, at nearby Willingham, Miss Disbury, a wise woman, had similar powers over horses and other animals. At Longstanton, Bet Cross was famed as a horse stopper and starter, as was the Norfolk wise woman Mother Staselson, whose power was ascribed to her possession of 'the evil eye'.

Sometimes, the horseman would demonstrate his powers to the incredulous. A typical trick was to thrust a pitchfork into a dung-heap and harness a pair of horses to it. Then, the order was given to the horses to pull, but, pull as they might, they could not drag the fork from the dung-heap. Then, as demonstration of his mastery, the horseman would walk over to the horses and whisper in their ears, at which they would easily pull out the fork. A correspondent to *East Anglian Notes and Queries* in 1908 told of an even more spectacular demonstration that he had witnessed. As a 'token of his powers', he tells us, a horseman went into a stable and 'the place at once burst into a blue flame without burning, while the horses "put their forefeet in the mangers" and showed other signs of fear'. This is an instance of another sort of magic.

The application of these powers were the craft secrets of the Horsemen's Guild, otherwise called The Society of the Horseman's Word, which appears to have existed in Scotland as

well as East Anglia. Its ceremonies and rituals, made public in part in 1950, reflect those of other initiated esoteric orders, like the Freemasons and the Bonesmen. The order is hierarchical, divided into six grades, whose names reflect the stages of the Miracle of Bread. They are called The Plough, The Seed, The Green Corn, The Yellow Corn, The Stones, and the Resurrection. Initiation was only available to men, aged above sixteen and below thirty. The Horseman's Oath was very similar to those of other craft orders. In it, the initiate swore that he would 'hele, conceal and never reveal any part of the true horsemanship which I am about to receive … I solemnly swear and vow that I will neither write it nor indite it, nor carve it on wood or stone, nor yet on anything movable or immovable under the canopy of heaven, nor yet so much wave a finger in the air to none but a brother horseman …'

Having sworn the oath of allegiance to none but his fellow craft brothers, the new horseman was given the secret 'Horseman's Word', and thus began his training in the grade of The Plough, where he was given the rudiments of horse control. Later, he would ascend the grades, finally passing through the ordeal of The Stones to reach the final grade of The Resurrection, where he would be a fully empowered horseman. When machines took over the functions of the horse on the farm, mystical horsemanship became almost obsolete, and most chapters of the Horsemen's Guild were disbanded. But the related arts of Toadsmanship, and the rites of the mysterious Ancient Order of Bonesmen, are still practised today in secret in East Anglia.

Royal Patronage

Also from nineteenth-century Norfolk comes an account of the relationship between a wise woman and Queen Victoria's son, the Prince of Wales. When the Prince bought Sandringham in 1863, his agents evicted several wise women who had lived in a group of cottages that they wanted to demolish. Only one was permitted to remain, at Flitcham, and the dwellings of the others were replaced by servants' quarters. The remaining wise woman, whose name is unfortunately forgotten, was left alone because her reputed powers were so great that the agent was

afraid to evict her. She had a remarkable knowledge of herbal cures, and was known to wander miles in search of a certain herb she needed for a specific cure. She was resorted to as a herbalist who could cure ailments intractable to official medicine. Like many wise women, she procured abortions with the use of herbs, and was adept in the use of rue tea.

In 1880 the Prince of Wales was taken ill, and, when conventional medicine proved ineffective, he resorted to the wise woman of Flitcham, who prepared mandrake wine to effect a cure. Later, when he became King Edward VII, he took the title 'Protector of the Craft'. This is usually assumed to refer to the worshipful craft of the Freemasons, of which he was an initiate, but equally it may have a wiccan meaning. What is certain is that the ancient skills and wisdom of the Old Wives were respected and used by the highest in the land when nothing else would work.

The Power of the Toad

The technique of becoming a Toadsman or Toadswoman as practised by Tilley Baldrey of Huntingtoft was published in 1901. In her method, the would-be Toadswoman or man would catch a hopping toad (a Natterjack, now extremely rare) and carry it in his or her bosom until it had rotted away to the backbone. Then he or she would take the bones and hold them over running water at midnight. Then came the moment of initiation, when supernatural forces would pull the initiate over the water. 'Then you be a witch,' she said, expressing the alternative name of the Toadsman, the Toad-Witch. It is said that if strong winds or a storm should arise, strange sounds be heard or weird sights be seen, then this is a sure sign that the Toadsman or Toadswoman has conducted the ceremony properly, and has received the powers. Among these powers are the ability to see in the dark, and to see the wind as well as to smell it. But the most useful, and dangerous, ability that the toad's bones bestows is the power over other people. Unfortunately, there are few who, given possession of this power, can resist using it for selfish ends.

A Cambridgeshire custom for gaining the toad's bone is to put a dead toad in an anthill until the ants have eaten it away to

the bones. Then collect the bones together and taken them at midnight to a stream that runs from north to south. Throw the bones into the water, and those that float upstream against the current are the magic bones. These are often the pelvic bones of the toad, though which bones they are is determined by the stream-divination, not their own physical form. Once taken, they can be strung on magic necklaces as amuletic charms, or, carried in a special way, as the means for horse-charming.

When prepared properly, the toad's bone gives the Toadsman power over horses and pigs, and women, while the Toadswoman has power over horses, pigs and men. It also endows the power to see in the dark, and to drive a vehicle across a muddy field where others would stick. The toad's bone is used to empower the jading- and drawing-substances used in horse magic. To claim the power of the Evil Eye, nine toads were captured, tied together on a string, and left to die. Then they were buried in the ground. After this, the magician's eye would become 'evil', giving them the power to 'overlook' someone, to bind them and perhaps even kill them without disease, just as the toads had died. It is said that the profession of the Toadsman is an extremely dangerous one, for many in the past have been driven to insanity by the exercise of these powers, and a violent end is to be expected.

The powers of the Toad-Witch were very dangerous to those who crossed her in any way. Dola Baldrey, Tilly's husband, ran away with another woman, Neoma Cason, to live with her in a village 16 miles (25 km) away. Tilly used her Toadswoman's powers to bring him back. Magically, she forced him to trudge the sixteen miles backwards, arriving at her house bedraggled and exhausted. Four people in the village witnessed this remarkable feat of magical compulsion. 'That was a masterpiece, that was, and no mistake,' one was heard to say. Tilly Baldrey employed the same power that the Ipswich cunning man, Old Winter, used to compel people to move against their own will. Taking a lock of his lover's hair from Dola, she proceeded to burn it ceremonially to get revenge. When Neoma Cason was told she was cursed, she was terrified. She went to a cunning man to get the magical spell removed, but, she was told, the only way to do this was for her to recover the ashes of her burnt hair. Of course, there was no way that she could gain entry to Baldry's cottage, and, believing she was

doomed, went into a decline and died. At her funeral, Tilly Baldrey arrived as the coffin was being lowered into the ground, and threw in the ashes of her hair.

It is clear that in former times it was thought that toads contained human spirits. In south Germany, wax images of toads were left at shrines by women wanting to become pregnant. Sometimes stolen toad-images can be found on sale, blasphemously, in antique shops. It seems that the women who made and deposited the red wax toad-images were conjuring human spirits into their wombs through their means. Sometimes, also, a dead person can be reincarnated as a toad. Around 1870 at Croft in Lincolnshire, the spirit of a dead man returned home as a toad and sat under his chair. To remove it, they took the toad to an apple tree, and left it there with its legs tied together until it died, releasing the spirit to another existence.

The Bone-Magicians

From the eighteenth century, and perhaps earlier, there have been a number of secret societies in East Anglia. In their methods of initiation and internal structure, they parallel the craft of the Masons, though they have no connection with that craft. It is likely that, like Freemasonry, they are derived from the more ancient trade and religious guilds of the Middle Ages. They range from the Oddfathers, who conducted initiations of 'Fresh Men' as Freemen of Sturbridge Fair, to the Bonesmen. Unlike the self-initiated Toad-Witch, who could be male or female, membership of these societies was restricted to men, who had to pass through a ceremony of initiation to be admitted. Perhaps this male-only result was an artefact of the witch-hunts, in which women's mysteries suffered a greater degree of destruction than those of men.

Ostensibly, the mark of the Bonesman is one who carries the knucklebone of a sheep or man as an amulet against cramp. But there is a more esoteric meaning to this. Certain East Anglian cunning men taught that ashes of burnt human bones mixed with ale produce visions in the drinker, for a certain part of the spirit of the dead person remains so long as a fragment of his or her bone still exists. They also believe that spirits of the dead can be

called up by playing a certain tune on a bone flute. The mysteries of the Bonesman are more obscure than those of the Horseman's Society, for they had less immediate practical value. However, the Bonesman's art was necessary in the magical rites and ceremonies used in making things from bone, in the erection of buildings, and in certain forms of medicine-making. The Bonesman knew when and where to use skulls and bones in any new construction. It was he who laid the horse skull in the foundation, or beneath the church pews. It was the Bonesman who laid floors made from the leg bones of sheep, cattle or horses, embedded bones in the chimney-breast and roof, and was consulted as to where and how else bones should be used.

To be initiated as a Bonesman, the postulant was brought blindfolded at midnight on a Thursday to an old graveyard. There, by torchlight, he was shown a pile of bones and a skull or perhaps a whole skeleton, lying upon a gravestone. On three sides of the stone stood three officers of the Ancient Order, the postulant making the fouth, and the skeleton 'the dead fifth'. Then one of the three, known as the Senior Warden, would solemnly ask the neophyte to tell them whether the bones were the remains of a king, an earl, a free man, a slave or a beggar. The postulant would hesitate lest it were a trick question, and finally, after prompting, he would say that he could not tell the difference. To this, he received the reply, 'Whether he was a rich man or a poor man, they are the same now in death. So in life, the character of being human is the only one of any importance.'

After other rituals and teachings, the initiate Bonesman was then taught the secret signs of recognition, and the secret hand signals, most of which have never been revealed. Among the few which have been authorized to be spoken about publicly are the following. For 'no', the Bonesman puts the tip of his middle finger under his thumb, and flips it out. For 'yes', the palm of the hand is turned outwards, with its edge upwards. For the sign of something good, the Bonesman places a thumb on one cheek, his fingers on the other, and draws them down to his chin. The sign for something evil, on the contrary, is made by spreading the fingers across the face, and then dragging them off. Through the use of these hand signals, the Bonesman can communicate with others without non-initiates knowing what is going on. The complex hand signals used by Tic-Tac men at

the Newmarket horse-races are a parallel of the Bonesmen's Signs, and may have a common origin in the medieval guilds. Among other things, the maxims of the Bonesmen warn us that we must never burn bones, for it will bring bone-ache to the burner. When he dies, a Bonesman must be buried, not cremated, and his magic bones and regalia must be interred with him. Because of their connection with graveyards and bones, and their secrecy, East Anglian Bonesmen were feared, and suspected of practising necromancy. As the seventeenth-century Norwich philosopher, Sir Thomas Browne, wrote, 'To be knaved out of our graves, to have our skulls taken, are tragic abominations.'

Despite this, human bones were once the stuff of patent medicines. The first medicine ever patented in England, in 1673, called Goddard's Drops, contained human bones. *Bates' Dispensary* gives the recipe for Goddard's Drops, which included 'Human bones ... well dried', which were ground up and distilled in some way to make an 'evil-smelling oil' which was used for treating gout. According to William Salmon, the editor of *Bates' Dispensary*, for the gout of a particular limb, Goddard's Drops made from human bones of the corresponding limb should be used. At one time, the skulls of executed criminals were in particular demand for remedies. In the late seventeenth century, the celebrated physician, Dr Salmon, used human skull in his celebrated 'Swallow Water', made from, among other things, the distillate of '12 Swallow birds and Mistletoe'. Clearly, at that time, there was little distinction between magic and medicine.

Outside the realm of official medicine, these magical remedies were usually made up and used by wise women, although there was a prohibition against any woman becoming a Bonesman. The use of bones in remedies was always frowned upon by many people, and the practices of the Bonesman appeared to drift more and more away from the acceptable. A document of 1910, entitled *Report on the Practice of Medicine and Surgery by Unqualified Persons*, published by the British Government, stated 'Old women called wise women, who, although as a class are rapidly in a state of dissolution, sold secret salves, ointment, charms, etc., often of *a disgusting character*, for the treatment of abscesses, whitlows, gatherings and scalds' (author's italics). At least one function of the

Bonesman was to provide materials for these women, and when this sort of folk medicine finally dwindled away, the Bonesmen continued in a 'speculative' form until the present day.

The Cunning Men

In former times, the power that people acquired to control animals was often employed to give them power over humans, too. Tilly Baldrey's compulsion of her husband Dola is a masterful example of the power. In the early nineteenth century, the cunning man Old Winter of Ipswich had such hypnotic abilities. On one occasion, he caught a thief with some firewood he had stolen, and forced him to walk round in circles for hours carrying it until he fell with exhaustion. Another time he caught a man stealing vegetables from a doctor's garden. Winter used his powers to compel the thief to sit immobile all night in the cabbage patch.

Another practice of wise women and cunning men is counter-magic, taking bewitchments or imagined spells off other people. In this, we (the practitioners of the Nameless Art) use binding, reflective and containment magic. One of the most famous cunning men of eastern England was Cunning Murrell, who lived at Hadleigh in Essex from 1812 until his death in 1860. A seventh son of a seventh son, Murrell is remembered as an excellent practitioner of counter-magic. Cunning Murrell travelled only by night, and, like many cunning men and wise women, carried a strange 'badge of recognition'. Regardless of the weather he always carried an umbrella, reflecting the 'Brolly, brolly' chant of the Wallasea Island Old Mother Redcap. Also, in the Molly-Dancing tradition of Plough Monday in nearby Cambridgeshire, the umbrella-man was an essential part of the team.

Among Murrell's other magical paraphernalia were a magic mirror with which he claimed to look through walls, and a copper talisman which he used for divining whether people were dishonest or honest. He overcame spells with bottle-magic using a specially made iron witch-bottle. But not all cunning men were invariably successful in countering magical spells. When Neoma Cason resorted to the local cunning man for counter-magic against Tilly Baldrey's curse, he was unsuccessful, and she died.

In 1903, another failed attempt was recorded, when a correspondent in *St James's Gazette* wrote: 'A few months ago we were shown that even at this age belief in witchcraft prevails in rural England. A Bottisham, Cambridgeshire, carter, believing his horses bewitched, procured from a "wise man" of his district a countervailing charm. It was a "broth" for his horses compounded from horseshoes, nails and iron filings, by drinking of which one of the animals died.'

The antecedents of contemporary wicca come from this period, and perhaps from this region. In the latter part of the nineteenth century, 'Old George' Pickingill (or Pettingale) was reputed to be the 'witch-master' of Canewdon in Essex. This is a village that, like Horseheath, has long been connected with the craft of the wise, for legend tells that there are always seven witches resident there. Pickingill is said to have been in charge of nine covens of witches, which operated in different parts of England. In the east, they were reputed to be in Norfolk, Essex and Hertfordshire, but they were also farther afield, in Sussex and Hampshire. Whatever the reality of the other witch covens, locally 'Old George' had a reputation for menacing people with threats of magic for his own gain. He is believed to have died at Canewdon in 1909.

Pickingill was one of the last of this kind of cunning man, who could operate unselfconsciously in everyday society. During the early twentieth century, everyday life was changed by events into something quite different from the conditions in which the Redcaps, Winters, Baldreys and Murrells operated. During and after the Great War, belief in folk magic suffered a massive decline. Young men who had experienced the horrors of the trenches, and seen hell on earth, were no longer afraid of the reputed powers of witches and wizards. The wonderful modern technical age of machine-guns, aeroplanes, cinematography, wireless telegraphy and poison gas was at hand, and magic, so it seemed, was now an absolute relic of superstitious former times, superseded by rationalist technical progress. But things did not quite work out like that....

6 The Otherworld

Gods, Goddesses, Demons, Monsters and Spirits

East Anglian people have always observed their own polytheistic faith in tandem with the dominant Christian religion. In some periods this has manifested itself as dual-faith observances at church festivals, sometimes unconsciously as part of folk-custom, and sometimes, as today, as a self-consciously religious system. The memory of these Pagan gods and goddesses has always been retained however, for instance, in the days of the week that are named after them. However, this book is the first formal description of the pantheon of East Anglia, as it exists today. It stems from my studies over twenty-five years, drawing upon both the oral tradition and documentary sources. Not unexpectedly, the East Anglian pantheon is derived from the Germanic and Scandinavian religious tradition, and it has close parallels with folk tradition in Denmark, Holland and Germany. In common with all European Pagan traditions, East Anglian religion has a pantheon of gods and goddesses who individually are personifications of the powers of the material and non-material worlds. People who recognize these deities are those who assert their own individuality and independence in harmony with the ruling inner principles of life, personified as the goddesses and gods of East Anglia. It is these principles which we commune with in our sacred observances, and upon whose powers we call during spiritual activities.

As in other areas of existence, there are some qualities and powers that are beneficial to humans, and others which are dangerous or destructive. The benevolent deities are those who promote continuance, increase and support. When they are invoked, it is a general principle that they will assist humans

whether or not they get acknowledgement or recompense for their help. They are the deities of the common good, who will not stand for selfishness. The White Arts that they support do great good, because they do not subvert the free will of others. The malevolent deities, those that promote or assist the powers of decrease, dissolution and destruction, however, are harder. Unlike the benevolent deities, they permit their devotees to subvert the free will of others, bringing about imbalances that lead to ruin. But, when one invokes them, then they do expect some kind of recompense, and it does not do to ignore this, for it can result in the magician's own break-down. A few deities are neutral, conducting processes that are incidental to human concerns and expectations.

The chief god of East Anglian belief is the Great God Termagant. He is the god of right orderliness, defence and maintenance of the cosmic order, the ancient northern European supreme deity Tîwaz. Unlike the Norse god Tyr, of whom he is the English equivalent, Termagant is not portrayed as having lost his hand in the mouth of the Fenris-Wolf. He represents the unimpaired power of defence and offence, hence his epithet *Magant*, 'The Great God'. He is the ruler of the year, whose most sacred day is Tiugunde Day, 13 January, and whose weekday is Tuesday. Termagant's sacred metal is iron, his colour red, and his magical weapon is the sword. He also carries the magical sign called the Egershelm, symbol of impenetrable protection, which is his shield. When we make this sign, it is empowered with the spirament of Termagant, whom we call upon for protection in times of problems, and to eliminate harmful powers.

Thor, the northern god of thunder, is revered in the East Anglian tradition, as is the god of thought, memory and cunning, Woden. Thor's sacred weekday is Thursday. Unlike in Norway, where Thor was the chief god, in East Anglian tradition he plays a rather secondary role to Termagant. Thor's magic weapon is his mell, the great bronze hammer that is a powerful destroyer of demonic powers and beings. Metal representations of Thor's hammer are worn as powerful talismans against harm. It is traditional for sea-fishermen to wear a certain ear bone of a sheep, called a 'Thor's Hammer', as an amulet against misfortune at sea. As a wall-anchor, his fylfot symbol is also used to guard buildings against demonic attack.

The northern god Woden is primarily the deity of far-seers, his one eye representing the possession of a power of vision that is half outwards and half inwards. His holy weekday is Wednesday. Today, with the return of the runes to East Anglian magic, he has resumed his position as deity of runemasters. But unlike Termagant and Thor, Woden is an ambivalent deity, who can bring disaster as well as success. When he personates the destructive principle, Woden is called Old Nick, who is sometimes wrongly considered to be synonymous with the Christian Devil, the principle of absolute evil.

The goddess Frea is the deity of human sexuality, love-making and sensual enjoyment. Her sacred day is Friday. She is the goddess of the secret ecstatic sexual technique called Drewary, practised as part of the Nameless Art, which has always taught that sexual relations with others are a pleasurable means of communication in themselves, and when conducted between magical partners, a means of spiritual expression in emulation of the goddess. According to oral tradition, in former times the art of Drewary was taught to all practitioners of the Nameless Art. Among other techniques, Drewary uses prolonged intercourse at the edge of orgasm to bring about erotic and spiritual ecstasy. Frea's sacred plant is the Freethorn (the Hawthorn or Whitethorn, *Crataegus monogyna*), whose flowers' musty scent recalls the secret perfume of the goddess's most sacred place. The cat is sacred to Frea, as are the amber pebbles which can be found occasionally on East Anglian beaches.

Bale is the god of illumination, light and fire, whose most sacred day is May Day, when the Balefire is lit in his honour. Unlike the other major deities, Bale, who was known to the Scandinavians and Baldur, has no weekday named after him. He is the guardian of steers, sheep and swine, who are purified by his Balefire smoke in the 'Merry Month of May'. In East Anglia, his celestial counterpart, the sun, is called Phoebe, and referred to as *she*. In the tradition of Germanic and Baltic religion, the sun is female, as she is in East Anglia. Her sacred day, of course, is Sunday. Lady Moon, whose aspects are discussed elsewhere in this book, is the ruler of the night, the mirror of Phoebe. Her day is Monday. Saturn, or Sater, who is remembered on Saturday, is the principle of male dignity in old age, wisdom and forbearance. He is a minor god in the East Anglian pantheon.

Wayland, the divine smith, is the deity of smithcraft in traditional society. In the modern era, as the annihilator of inability, he is the patron of manufacturing industry and technology.

An important and once much-loved East Anglian giant is Tom Hickathrift, a defensive figure, said by some to be the old god of the Celtic Iceni tribe that once dwelt in this region. Portrayed carrying the axle of a cart as a club, with a cartwheel as his shield, Hickathrift is guardian of the ancient road called the Icknield Way. In the midsummer ceremonies of Huntingdonshire, he is represented as the black-faced Old Hub, a name derived from his use of the wheel-shield. A powerful image of him in combat with the demonic Wisbech Giant can be seen in the pargetted front of the old Sun Inn in Saffron Walden. Close to Cambridge are the Gogmagog Hills, named after another legendary giant who resides there at Wandlebury, an ancient hill-fort which is named after another being in the East Anglian pantheon, the demon of darkness, Wandil.

The classical goddesses known as the Fates are described in East Anglia as The Weird Sisters. Three in number, they are personifications of the past, the present and the future. They are said to spin, weave and tear the fabric of reality, determining our individual and collective fates. The Good Ladies are connected with the beings called variously in different parts of the province: Fairises, Fairisees, Frairies, Feriers or Ferishers. These are the East Anglian dialect words which in standard English are rendered as *fairies*. Although Fairises were recognized earlier, the fairy faith in East Anglia is of Celtic origin. It was brought here in the eighteenth and nineteenth centuries by Irish people who came here as seasonal labourers and permanent immigrants, many fleeing to England from the corn famines and finally the tragic potato famine that reduced once-prosperous Ireland to ruin. The most commonly used name for the fairies, Fairisee, is sometimes rendered in books as 'Pharisee' as if it had some connection with the ancient Jewish religious order. However, in the light of the Irish origin of the fairy faith of East Anglia, it is most likely that the name Fairisee is a version of the Irish *Fir Sidhe*, 'the fairy man'.

When the full-blown fairy faith was introduced from Ireland, it took hold immediately, striking a chord of recognition in East

Anglian people. Also, because mischief and supernatural nuisances were now ascribed to the fairies, belief that witchcraft was behind such things rapidly faded away. Instead of fearing witches, now the shepherds took to pouring libations of the first milk of each ewe to placate the fairies. Wives took to leaving the door open when making bread, so that any passing fairy could look in, see the dough and bless it. For this service, wives began to leave out food for the little people. Also, wise women and cunning men were seen in their own right, rather than as the secret hand behind misfortune. No longer did witches borrow horses and 'hag-ride' them all night, leaving them exhausted in the morning. Now, it was seen to be the Frairies who did this. But the holeystone on a string remains the magical prophylactic against such events.

However, although they were recognized after Irish people pointed them out, the East Anglian Frairies and Fairises have their own distinct character. In Norfolk, they are always dressed in white, and dwell in underground houses. Some Suffolk Ferishers reported from Bury St Edmunds in a story in *The Ipswich Journal* in 1877 were said to be as big as mice, dressed in blue coats, with yellow trousers. They wore red caps, with tassels hanging down behind! Suffolk Fairises were said to steal wheat from barns. They cannot bear dirt or disorder, and punish those who are sloppy or careless, unlike their supernatural cousin, the Buttery Sprite, who relishes chaos and filth. In the nineteenth century, for some reason, the houses in Tavern Street, Stowmarket seem to have been especially favoured by the Ferishers. On occasion, local people would gather there and hide to watch them dance. It was reported that these Ferishers had sandy hair and a pale complexion, and made sparks appear beneath the feet of those who disturbed them. For those who do not like, or fear, the Fairises, there are protective remedies. If you fill your pockets full of bread, they will not trouble you. Also, wear a daisy chain, which, as a symbol of Phoebe, the sun-goddess, will ward off the little people. Other East Anglian inhabitants of the fairy kingdom are the White Lady, the Princess of the Brilliant Star and the Good Ladies. Other earth beings include the Weirdelves and the Weird Lady of the Woods. If one meets them, then it is likely that one will receive a wonderful, otherworldly, gift. Under certain circumstances, the White Lady is sometimes seen as Our Lady,

the Christian Mary. Her most important apparition-place is the shrine at Walsingham, the first place in Europe where she appeared in this form. The shrine continues to draw pilgrims today.

Practitioners of East Anglian spirituality know that the earth is our mother and sustainer, without whom we would be nothing. Just as we honour our own progenitors, so we honour Yarth, Mother Earth. This earth is not an inanimate piece of matter spinning through space without meaning, but a living being whose inner essence is manifested through the myriad forms of life that she sustains. These life-forms can take material or non-material forms, each being determined by the character of the element to which it belongs. In common with the ideas of western tradition, East Anglian magic acknowledges the existence of four elements: Earth, Water, Air and Fire. Their usual correspondence is with the cardinal directions: Earth is in the north; Air, East; Fire, south, and Water, west. There are other correspondences used in East Anglia for specific functions, but those given here are the most universally applicable.

The earth sustains the earth sprites or earth elementals, who manifest themselves as Woodelves, Fairises, Hytersprites, Yarthkins, the Pigwidgeon, the Belweather, Black Shuck and other helpful or demonic forms. The Hytersprites, or Land Wights, are the guardian spirits of the land. Collectively, they are the Wanens, equivalent to the Norse Vanir. The Hytersprites have the power to assist or destroy humans, depending on how they are treated. They are sandy-coloured and green-eyed, and fly around in the form of Sand Martins. Where they are acknowledged with offerings of food and drink, presented in pleasing and beautiful ways, they will nurture and assist the land. But in those places where the spirits have been driven away, bad luck, barrenness and evil doings will take their place. Such places, no longer tended by their spiritual guardians, are *gast*. Bad places in the landscape, that is, places where humans feel psychically unwanted, are inhabited by Yarthkins. These are earth spirits that show hostility to human interference. If one is foolish enough to disturb the Yarthkins, then it may well prove unwise. Unlike Hytersprites, Yarthkins are not approachable through offerings. If one is forced to deal with them, then they must be contained by magical remedies,

including sprite traps, mirrors, egg-posts, staves and blocking-stones.

Where human ignorance or greed has not driven them away, each village is supported by its spiritual guardians who band together to form the Ward. This is a group of psychic watchmen which protects a village or town by night both from internal troubles and external dangers. Each dusk, the sprites that compose the Ward assemble at a sacred place in the village, and then travel by way of their sprite-paths to their watch-places. Some people say that the Ward-sprites are guardian-spirits of individual people in the village, both living and dead. Their watch-posts are the sacred stopping-places of the geomantic landscape, the ward hills, stones, shrines, crosses and holy trees by the roads and paths that lead to and from the village. At night, if it has human acknowledgement and support, the Ward creates a protective magical ring around the town. It is a protection against psychic attack from both the human and non-human realms. Unfortunately, acknowledgement of a village's Ward seems to have almost died out, and most settlements can be regarded now as Wardless, and thus totally vulnerable to psychic attack and demonic interference.

But, in East Anglia, there are also the more demonic or malevolent beings that appear sometimes at night to terrify people. Some are connected specifically with certain locations, whilst others have a more general distribution. One specific demon-beast is the Galley Trot, a ghost which haunts churchyards and places where people were executed, including crossroads. It is sometimes seen in the form of a monstrous dog, like Black Shuck, who appears on roadways, gates and at crossing-points. Connected with Black Shuck is the Shuck Monkey, a phantom beast somewhat like a dog, but with hideous monkey-like features. The Fenris-Wolf, the giant, demonic, destructive wolf-principle of Norse tradition, is said to haunt the area of Wolferton in Norfolk, where his howls can be heard above the wind on stormy nights.

Yarth, or Mother Earth, upon which we walk, is sometimes called Will's Mother, being the ground upon which the spirit known as Will appears. Will is the fire-demon better known as Will o' the Wisp, called in different places the Hobby Lantern, the Lantern Man, Jinny Burnt-Arse, the Corposant or The Syleham Lights. This is a phantom light, seen at night especially

in fenland districts. It appears to wayfarers, exhibits a seemingly conscious behaviour, and leads them astray from the pathways. Will leads them 'around Will's Mother's and back again', i.e. on a fruitless, roundabout journey. People who are confused in this way are 'Will-led', if he does not lead them to their death in a fenland river or drain. Another fire-spirit is Old Clim, who lives in and guards the chimney. In the Middle Ages he was assimilated with the Catholic saint, Clement, but since the Reformation has assumed an independent existence once more.

Old Clim is the benevolent patron of blacksmiths, an aspect of Wayland. But there is also a malevolent East Anglian fire-demon, known as the Firescratch, who has occasionally been invoked by magicians who wanted to bring down fire upon enemies. The Firescratch is the personification of wild-fire, and is very dangerous indeed. Another sort of fire-spirit are the Northern Lights, known in East Anglia as the Perry Dancers. They are said to be benevolent celestrial spirits in combat with the unquiet dead. The congealed blood of those wounded falls to earth, where it is seen in the form of pebbles, or 'blood-stones'. The spirits of storms and the wind are often personified as the Wild Hunt, where Woden rides through the land with his forty-one followers, gathering up the souls of the unwary who are unfortunate enough to get in the way. Other sorts of wind are personified as the Guster, the Blaster, and Roger's Blast.

Other demonic beings and monsters that appear in different parts of East Anglia are called Old Scarfe, the Bogy Beast, Malekin, Grimer and Old Scratch. If you go to Geldeston, you may be plagued by an apparition of The Hateful Thing, and at Barsham, Old Blunderhazard may appear. To see one of these is to receive an omen of death. Sometimes, supernatural beings may not be visible at all, like the 'invisible presence' encountered in the yard of St Andrew's church at Brettenham in Suffolk. The Yarthkins are malevolent earth sprites which inhabit certain areas of ground. If they are disturbed, they bring trouble to the person who has done it. The Buttery Sprite is a demon that haunts badly-run public houses and restaurants. It appears like a poltergeist, destroying breakable things, draining away drink and fouling food. In former times, parents would threaten troublesome children with the demon called Miles's Boy, who, riding through the night, would stuff them into a huge

sack and ride away with them. In November, the water-horses emerge from the sea that covers the lost lands around Dunwich, Easton Bavent (Lowestoft) and Corton. They emerge from the water to frolic on the beach and in seaside fields. If a person can catch one, then they are the finest steeds of all. But if they are ridden near the sea, they will dive back into it, taking their rider with them, to be eaten by the phantom water-horse.

Worse than these incidental demons are the destructive principles, known as Tantrabolus, Wandil and the Demon Rantipole. Naturally, the principle of destruction is represented in the East Anglian pantheon. Tantrabolus, the personification of dissolution and ruin, is often seen as being synonymous with the Christian Devil. To many, Tantrabolus is the epitome of evil, a wholly dangerous being who can bring great harm to those who come to his notice. Others view Tantrabolus as representing the thwarter of proper processes, the built-in failure rate of existence. Another awesome demon, Wandil, is the East Anglian wintry personification of cold darkness, the icy winter that threatens never to lose its grip. The Demon Rantipole is the personification of the principle of rage, unbridled, uncontrolled anger, whose unleashing leads to the destruction of all around. In former times, disease was ascribed to demons, and who is to say that the bacteria and viruses that cause illness do not fulfil every traditional criterion of the demon? Influenza, whose modern name infers astrological influences as its cause, was formerly called Old Hin.

The Anglian founders of the province counted the deified King Uffa as their spiritual leader and, later, other Anglian kings, queens and princesses were apotheosised. The sacred king, St Edmund, was the greatest of these. Most of the Anglian ancestral guardians were absorbed by the Catholic Church into its pantheon of saints. St Botolph, whose relics were preserved at Bury St Edmunds, is the guardian of entrances. Nearly all churches dedicated to Botolph are next to the gates of cities and towns. Norfolk's own St Wulstan, guardian of the holy well at Bawburgh, became 'god of the fields'. Other royal and ancestral beings sainted and invoked for boons are St Withburga, St Petronella, St Humber, St Guthlac and St Etheldreda. Ancestor- and hero-worship is an important component of all spiritual traditions that are not dislocated from reality. Uffa, St Edmund, Hereward the Wake and Egil are among those

semi-legendary figures from East Anglian history who have entered the realm of the ancestors. In later times, King John and Oliver Cromwell have achieved cult status. The cult of Horatio Nelson that was formerly very powerful in Great Yarmouth is a perfect example of this form of worship in more recent times. In this process, the hero enters the pantheon and assimilates those desirable qualities that are necessary to heroes. Thus he is more than a historical character, having taken on archetypal qualities that elevate him into the supra-human realm of principles and gods, a role model to be emulated by would-be followers. It is through an understanding and use of these archetypal powers that we can be fully human. This is the final aim of the Nameless Art.

7 *Space and Time*

The East Anglian Directions

In navigation at sea and location on land, we divide the horizon into eight sectors, or airts, to make the compass rose. This has the cardinal directions of north, east, south and west, and the intercardinal directions of north-east, south-east, south-west and north-west. The airt-lines which are formed by the intercardinal directions divide up the four quarters of the earth and heavens. The northern quarter runs from north-west to north-east. The north is the primary direction in the Nameless Art. It is the sacred direction of the deities in northern tradition Paganism, a divine quality co-existent with the gods, a sacred virtue rather than just a compass direction. The divine presence and 'north' are inseparable. The Nowl, the pole star Polaris, is the marker of this airt, the leading star of seamen, the direction towards which the gnomons of all sundials point, and towards which garden rigs (rows) are orientated. Magically, this is the sector of the element of earth. The eastern quarter covers the north-east to the south-east. This is the region ruled by the element air. The southern quarter stretches from south-east to south-west, and is of the element of fire. Finally, the western quarter goes from south-west to north-west, being ruled magically by the element of water. The square that can be made by connecting the lines towards these intercardinal directions is the four-square pattern that we use in house orientation and creating the sacred grid for magical purposes.

Because Phoebe – the sun – appears to move through the sky, each direction corresponds to a specific time of day. This is the principle of the sundial; when we tell the time by the sun, we do so by noting her direction on the compass rose. The most basic

example of this is that when the sun stands due south, it is noon (midday), regardless of the season. Other times of day, taken by the sun, are also fixed. Due east is 6 a.m. on the eastern airt-line; due west, 6 p.m. on the western airt-line, and so on. The compass directions where the sun rises and sets, however, vary with the seasons. At the vernal and autumnal equinoxes, when the length of day and night are the same, the sun rises in the due east and sets in the due west. At these times the period of daylight lasts exactly half of the 24-hour cycle. At the winter solstice, day length is the shortest, and both sunrise and sunset are at their most southerly points, and, at the midsummer solstice, day length is the longest, and both sunrise and sunset are at their most northerly points.

Between the extremes of the solstices, the sun rises and sets progressively northwards after the winter solstice and southwards after the summer. Because the sun rises and sets on certain days at certain fixed points when we view it from a certain place, notable landmarks on the horizon can be used as markers of these days. Hence, it was customary in former times to make artificial markers for the sunrise on days like May Day and Lammas. When the sun rose over the appropriate marker, then the day had arrived. This is the principle of the stone circle as a marker of the year-cycle, with its different seasons and festivals. Although many have been destroyed by farming and development, many such ancient markers still exist within the landscape, and are recognized by people with local knowledge.

As we perceive the apparent motion of the sun, Phoebe takes the direction we call sunwise, or clockwise. This direction is very important to the Nameless Art, for it represents all things being done with great orderliness, which are therefore in harmony with the natural order. The opposite direction, known as widdershins, is unlucky, and if used unthinkingly or in an unskilled manner, is considered to be the epitome of destructive magic. We consider it to bring bad luck if we wind wool or anything else widdershins. Ropes on board ship are always coiled sunwise, and anything that we need to stir or mix, whether it be a cup of tea or a cake mixture, we do sunwise. We also dance in circles sunwise at our sacred festivals throughout the year. However, there are certain occasions when widdershins movement is necessary, such as in inducing trances and invoking certain internal energies. But this is not an everyday necessity.

Real Time and the Tides of the Day

The abandonment of real time is one of the major symptoms of the alienation from the natural world which characterizes modern life. Time measurement, where midday (12 o'clock) is when the sun stands at its highest point, and other times are related to it, has long been altered away from a direct experience. Firstly, the concept of mean time was imposed. This effectively replaced time-telling by the sun with a theoretical, clock-regulated time-keeping. This removed direct observation and rendered sundials, which measured the actual basis of time, inaccurate! Then, with the advent of railways and centralized government control, time zones were instituted. In England, this was based on the mean time calculated at the meridian of London. Finally, with the creation of the Greenwich Meridian in 1886, a worldwide system of zones, based around the Greenwich meridian and meridians of 15° and multiples of 15° from it, was set up. According to this system, every place within that time zone, stretching from 7° 30' on either side of any designated meridian, was at the same mean time. This meant that places near the boundaries are up to half an hour out by the sun from the time zone, those 7° 30' east of the meridian being half an hour in front, and those 7° 30' half an hour behind by the sun. Western Europe, excepting the British Isles, is in a time zone which is actually based upon solar time in the middle of Europe some twenty-five miles to the east of Szeczecin in Poland. When we use British Summer Time, we are measuring our days by the theoretical position of the sun in Poland!

If real local time were used instead of centralized time, then this sort of absurdity could not be contemplated. It is a measure of our society's separation from Nature that government-directed alterations in time are accepted as normal, without opposition. Sacred and magical activities, by their nature, are always present, with all that that implies. If they are to have any meaning, they must be related directly to local time, not the artificial time zones. So, when we work with magical processes and sacred places, we must use local time, or our actions will be out of step with the inherent natural qualities of time. Our activities are determined by local time, not the artificial time-measurement decreed by the State. To do otherwise is to deny the special qualities of those times which these systems claim to observe.

There are two kinds of phenomena we call the *tides*. There is the twice-daily influx and ebb of the sea, which is related to the movements of moon and sun, and the eightfold division of the day. The eight Tides of the Day are based entirely upon the position of the sun. They have never been absorbed into the system of mean time, time zones and so-called daylight saving changes in the clock. Each tide is a period of three hours, beginning at a half-hour so that a specific time or 'o'clock' hour is at the middle of the tide. Thus, times are specific points within the tides of the day. Time and tide wait for no man. The tide of Midnight begins at 10.30 p.m. The mid-point of the tide is at midnight, 12 o'clock, also called Bull's Noon. The tide ends at 1.30 a.m. The next tide is called Uht. It runs until 4.30 a.m. the time of Rising, the traditional time to get up out of bed in the summer half of the year. The next tide is Morningtide. Beginning at 4.30, its mid-point is 6 a.m., when the sun stands due east. Morningtide ends at 7.30, Day-Mark, traditionally breakfast-time. Next comes Undernoon or Forenoon, which runs until 10.30 a.m. It is followed by Noontide, whose middle is 12 noon, when the sun stands due south at the highest point in the day. Following Noontide, beginning at 1.30 p.m., is the tide of Undorne or Afternoon, which ends at 4.30 p.m. Then comes Evening or Eventide, whose centre-point is 6 p.m. when the sun stands due west. At 7.30 p.m., supper-time, Night-tide begins. This runs until 10.30 p.m. when we are back to the tide of Midnight once more.

The lunar cycle has four phases, each of which have corresponding qualities. The phases are usually called New Moon, First Quarter, Full Moon and Last Quarter. However, there is often confusion over what exactly New Moon is. Astronomically, New Moon is the time when no moon at all is visible. In the Nameless Art, we call this period the Dark of the Moon, and the first, thin, crescent, the New Moon. The first crescent we can see in the evening sky marks the first noticeable effect of the waxing moon, which is the period of growth, when, each night, the moon appears to be larger than the night before.

Half-way through the growth cycle is the Half-Moon, known technically as the First Quarter. From here, the waxing cycle continues until the moon appears as a complete circle. This is Full Moon, when the moon is at its maximum, but also the time when it begins to wane or decline in size. Half-way through its

The Wheel of the Day, showing the direction of the sun at
each time and tide

decline is the Half-Moon again, now called Last Quarter. Then
the moon becomes sickle-shaped again, facing in the opposite
direction from when it was waxing. It dwindles each night until
it is invisible once more during the Dark of the Moon. Full
Moon is traditionally a time of magical workings, when the lunar
power is at its most potent. Workings for increase should be
made during the waxing moon, and workings for decrease
during the waning moon.

The whole cycle is a very striking phenomenon, one of
Nature's most remarkable celestial sights, though few people
take much notice of it, or consider that it has much relevance to
everyday life, especially in contemporary industrial civilization.
However, all liquids on earth are under the influence of Lady
Moon, from the tides of the sea to the fluids in the human body.

All are affected by the lunar cycle, whether we are aware of it or not. Traditionally, and partly because the menstrual cycle appears to be related to that of the moon, the lunar mysteries have been largely female. When the tide is flowing – coming in – it is a time of increase. According to folklore, water boils faster in the cauldron, and feathers in pillows and eiderdowns fluff up. It is a time when one should not cut one's hair. Before the advent of centralized abbatoirs, East Anglian farmers would always slaughter their pigs when the tide was coming in. Natural births have been noted to take place with the flowing tide, whilst ebbing tides are connected with deaths. In some seaside places, it is said that the spirit of a dying person cannot depart until the tide is ebbing. The incoming tide on rivers, which sometimes takes the form of a small tidal wave, is called the Eager, from the northern tradition god of the sea, Aegir.

8 The East Anglian Sacred Year

The County Calendar

The East Anglian country calendar possesses ceremonies and rituals which express and celebrate those times in an explanatory and symbolic manner. In the modern consciousness, only Christmas, New Year, Easter, Hallowe'en and Guy Fawkes' Night are still of any significance separate from secular public holidays. We still celebrate Plough Monday and some other feast days such as Candlemas, Midsummer, Lammas and Martinmas locally, though once they were universal, Christmas and Easter, the festivals of midwinter and spring, are still religious in character, being the Christianized Pagan celebrations of Yule and Ostara. New Year has always been a purely Pagan festival, though, like Christmas and Easter, its celebration is highly secularized. May Day, too, is purely Pagan, though its appropriation as a trade union festival of socialism, and its later adoption as a movable public holiday has denatured it outside the Pagan community. Midsummer was formerly a fire festival, the time of gathering herbs, and purifying the house with herbal smoke.

November Eve, Hallowe'en, was a festival of the Elder Faith that was redefined by the Catholic Church as All Saint's Day and the following day of All Souls'. But, under Christianity, it retained its character as the festival of the dead. When Catholicism was largely extirpated in England, the festival reverted to its Pagan roots, and so it remains in our tradition. Close to November Eve, Guy Fawkes' Night was set up in the seventeenth century as a political-sectarian festival, originally anti-Catholic in character, becoming later the archetypal English fire-festival, Bonfire Night. The downgrading of sacredness, leading finally to the abolition of Sunday as a

83

rest-day, has meant that nowadays these sacred days are only observed by followers of the Elder Faith. Few others recognize the cycle of the year, being bound, unknowingly or willingly, to the industrial agenda of placelessness and time-denial. Sadly, a large proportion of the populace is removed from any awareness of the natural cycle of the year, and this is reflected in the emptiness of national festivities. However, among those who know, the festivals maintain their ancient sacred power.

The Sacred Festivals

Yuletide

The festival of Yule is an extended season of festivities that celebrates the winter solstice. This is defined as the southernmost rising-point of the sun, its lowest point in the sky at midday and its most southerly setting-point. On this desperately short day, Phoebe's vigour appears to be almost at the point of extinction. But this is not the time of despair it might seem to be. On the contrary, it is a time for celebration, for Yule is the point of her rebirth and renewal. The name of the festival, Yule, denotes the Yoke of the Year, which is the balance point through which we must travel across the lowest ebb of sunlight. Because it is such an important festival, we observe many customs observed at the East Anglian festival of Yule. Generally, they symbolize the time of the shortest day, when Phoebe sheds her least light upon the world. This is the time of light in darkness, warmth in coldness, life coming out of death, greenery flourishing amid barrenness, plenty in the heart of dearth and the hope of return of brightness in the darkest time of despair.

The symbol of the new light of Phoebe victorious underlies Yule. Her greatest symbol of light in the darkness is the Yule Fire which we must keep burning continuously through the twelve days of Yule. In burning for twelve days, the fire symbolizes the eternal light of the sun shining through the twelve months of the year. At sunset on 24 December, we light the Yule Fire from the carefully preserved remains of the previous year's wood. It is started with a spell 'I charge this log that it shall burn brightly and well on the wide hearth of this hospitable mansion, shedding its glow of warmth and

friendliness to all within.' If we live in a place where it is not possible to burn a Yule Log, we keep candles burning continuously during the twelve-night period to echo the light of Phoebe victorious.

Yuletide in East Anglia is actually a succession of festivals that we celebrate as separate specific observances on successive days. Each has its proper traditions that reflect its quality. We begin the Yule cycle by keeping the actual midwinter solstice (21 or 22 December, depending on the year), commencing on the eve after sunset on the 20th. Traditionally, this is the time of purification and renewal, where we abandon doubt and fear, casting out old unwanted things and trusting in the gods for the forthcoming year. In modern times, this rite has been transferred to New Year's Day, when new year's resolutions are made. Pagans in Cambridge celebrate it with a scot-ale.

In former times, gambling was illegal throughout the year, but at Yuletide, the time when the Lord of Misrule was in the ascendant, it was permitted. For several centuries, playing cards and dice was a strictly Yuletide practice for the law-abiding. The custom continued longest in Cambridge – there, until the early years of the nineteenth century, inns and shops ran 'ticket raffles' where the allocation of prizes of food, drink and clothing was decided by dice. In this way, through the Yuletide lottery, a certain redistribution of wealth took place, part of the Yuletide custom of giving presents, but according to the will of the gods as decided through the divinatory device of dice.

The Yule festivities continue with Christmas Eve, Christmas Day and Boxing Day. The major event of the feast of Yule is literally the feast, which is an image of paradise, in which all manner of food and drink is taken in profusion. It is the major sacred meal of the year. The festival then continues with New Year's Eve and New Year's Day and progresses until Twelfth Night, when the decorations of Yuletide are taken away and burnt. Then, work begins again for men on the next day, with the ceremony of Charming the Plough, which in the last two centuries has been held on Plough Monday. On this day, in many East Anglian villages, the Plough Boys continue the age-old tradition of carrying an old horse-plough from house to house, asking for largesse. The point of this ceremony is to show the plough to all inhabitants, impressing upon them the essential nature of the Miracle of Bread that the plough makes possible.

At each house or inn, it is customary to give food and drink to the Plough Boys. Plough Monday marks the beginning of men's work in the new year. On the next day, women's work begins, on Distaff Day, whose observances have faded nowadays. In Whittlesey, the Straw Bear dances the streets at this time.

The Yule Tree or Christmas Tree is the best known symbolic decoration of Yuletide. However, although it is authentically Pagan, it is not an ancient East Anglian tradition, having been imported from Germany in the nineteenth century. More traditional is the use of hulver (holly, *Ilex aquifolium*, the Yule Boy), ivy (*Hedera helix*, the Yule Girl), and all-heal (mistletoe, *Viscum album*). A man brings them into the house after sunset on 24 December. The Kissing Bough is another Yuletide symbol, in the form of a globe of evergreens, often made today as the flat holly wreath. We weave the globular Kissing Bough from osiers (willow withies), then bind it with evergreens, usually box or rosemary (*Buxus sempervirens* and *Rosmarinus officinalis* respectively). From red ribbons in the middle of the globe we hang red apples, whilst beneath we suspend a sprig of mistletoe. To make the Kissing Bough, we hang it from the ceiling by a hook. But it should be hung elsewhere once complete.

We decorate and empower the table bearing the food and drink of the Yule feast by an Apple-Gift. This is an apple into which three ash twigs have been pushed, making a tripod. From beneath the apple hang hazelnuts, whilst yew twigs, bearing leaves, make a spray on top of the apple. The whole ensemble symbolizes sweetness, fertility and immortality. The traditional sigil (alphabetic or pictographic characters which epitomize the quality of a specific idea or power) of Yule is an enclosure containing an inverted pyramid of six points, representing the seeds protected against the cold, or people sheltering from the wintry conditions. This can be pricked or stamped into kitchels, or made in icing on Yule cakes. The recipe for kitchels and other seasonal foods can be found in Chapter 14.

Traditionally, we mix Yule Puddings on Stir-up Sunday. In former times, with larger families, the mix was enormous by modern standards; it contained enough ingredients for thirteen spherical puddings, one for each of the Twelve Days of Yule. The thirteenth should be given away to the poor in the spirit of Pagan charity. The Yule Pudding is composed of thirteen ingredients, which must be stirred sunwise for nine turns by

every member of the household. This must be done in decreasing order of seniority, so that the smallest child is the last to stir the pudding. Whilst the pudding is being stirred, we add nine silver coins to the mix, invoking the lunar power of growth. Symbolically, the Yule Pudding signifies the round earth, containing its natural harvest of grain and fruits, to which is added the handwork of humans in the form of fermented liquor and precious metals. Finally, like the yew twigs on the Apple-Gift, the sprig of holly which 'tops out' the pudding represents the World Tree.

New Year

New Year is a calendar festival, less significant than those that mark the transit of the sun, yet it is no less important magically. At New Year, we open the front door to receive it, and the first thing done through the door should be to take in a gift, or something beautiful and useful:

> Take out, then take in, bad luck will begin:
> Take in, then take out, good luck will come about.

Like Midsummer, New Year is also a time of purification. We clean the house carefully and all dirt, rubbish and ashes are taken away. After the house has been cleansed, we bring in silver, bread and coal from outside, signifying wealth, plenty and warmth. Then, we take fire, in the form of a candle, from room to room, and make smoke (burn incense) to re-empower the house for the newly arrived year. When we see her appearance, we greet the first new moon of the year with nine bows, and turn the coins in our pockets.

Tiugunde Day

Twenty days after Yule, on 13 January, is Tiugunde Day, sacred to the Great God Termagant, ruler of the year. It is the mid-point of winter, the old Norse festival of Midvintersblöt, half-way between Winter's Day on 14 October, and Summer's Day on 14 April. This is the proper day for the custom of Wassailing apple trees for a good harvest in the coming year.

Witches' Night (Candlemas)

In the Cambridgeshire Fens, we observe the festival of Witches' Night or Candlemas on the eve of 2 February, beginning at sunset on 1 February. Like Hallowe'en, Candlemas is a post-Catholic festival, which is the continuation of the old Pagan holy day of Imbolc, the festival of the waxing light. Usually, this is the coldest time of year, the very heart of winter. But the days are getting longer, as the old East Anglian weather-saying explains: 'As the light grows longer, the cold grows stronger.' Candlemas is seen as the first herald of the coming springtime. In East Anglia, this festival has become of less importance than in Celtic lands. There, Bride, whose day this is, is a threefold goddess whose attributes are the power of healing, fire-craft, and poetry. At Candlemas, the goddess is transformed from her aged, winter, aspect as the black-clad Hag, carrying her black rod of barrenness as guardian of the mysteries of death and the underworld. She becomes renewed as the virgin bride, a new manifestation of the Solar Goddess, Phoebe, springing from seeming death into life. The traditional sigil of Candlemas is a five-branched stave, signifying an upraised hand with spread fingers, or an illuminated candlestick.

The Three Blind Days

These are the first three days of March: 'First comes David, then comes Chad, then comes Winnal, roaring mad.' Often they are days of storms, especially the third, when, according to the saying, 'There is always a tempest on St Winnal's Day.' Seed should not be sown, neither divinations performed nor magic conducted on the three Blind Days.

Spring Day

Spring Day is the vernal equinox, otherwise Eostre or Ostara, the Germanic festival appropriated by the Church in a modified version as Easter. Falling on a day between 21 March and 23 March, Spring Day is the changeover point between the dark and light halves of the year. At the equinox, the sun rises due east and sets due west, which gives exactly twelve hours of daylight. This is the time of conception, when the light has its

annual triumph over darkness. At this time, it is the tradition in Norfolk to eat a plum pudding called the Harvest Strengthener, in a cermony to empower the growing herds, flocks, trees and crops to flourish and produce bounty in the autumn. Because it is a time of growth, Spring Day's traditional sigil is a circle with two sprouting 'horns'.

Summer's Day

14 April is the day when summer is said to arrive. It is the old Norse festival of Sommarsblöt, when the summer half of the year is welcomed. In this reckoning, the summer lasts until 13 October.

May Day

May Day is the beginning of the summer quarter of the year, the time of vigorous growth and sexuality. It is the day of the virile deity of light, Bale. May commences at sunset on 30 April, May Eve, which is a time of magic, when bonfires are lit. We jump through the Balefires' smoke and flames to drive away harmful sprites and bad luck during the incoming summer season, and to promote fertility. We build up the Balefire from the wood taken from nine different types of tree, and it is kindled upon the sacred grid of nine. We make the grid by drawing out a yard square on the ground and then dividing it into nine smaller squares. The eight outer squares are dug out and removed, but we leave the ninth at the centre as the Middle Ground or Hearth of the World. Traditionally the East Anglian Mayfire is kindled on the middle ground by twirling an ashen spindle in an elm log. The male ash and the female elm emulate the heat of love-making, producing the fire of summer. In ancient times, all of the fires in the village were put out on May Eve, and then re-lit from the central Mayfire. The village of Belton, near Great Yarmouth in Norfolk, and Belsar's Hill in Cambridgeshire are former sacred sites of such an annual Balefire.

May Eve is the time when the Maypole tree is cut and brought back to the village. The traditional sigil for May Day is the northern tradition Tree of Life with six side branches. The night of May is traditionally the time for us to enjoy the first outdoor love-making of the year, and hand-fastings celebrated

at this time of love and the 'common-law marriages' that must be renewed annually each May Day. At Wandlebury, south of Cambridge, the Devil's Dyke Morris Men dance as the May Day sun rises, hailing the return of summer. After sunrise, we continue the ceremonies. Once the fires have been re-lit from the central Balefire, the festivities of the Maypole can take place. East Anglian Maypoles are traditionally dressed birch poles, for the birch is the tree of purification, and the revellers dance around it in mimicry of the twirling fire-spindle used to ignite the Balefire.

Sadly, in the seventeenth century, the effects of Puritan Protestantism in the shape of Oliver Cromwell's repressive republic was effective in destroying or seriously truncating the May ceremonies in many parts of East Anglia. Later, the merrymaking of rural working people at May Day was restored by urban workers during the Industrial Revolution as the Labour Day of the proletariat. The blossom, bunting, flags, garlands and May Bushes which formerly bedecked houses and carts in the pre-industrial towns were recalled by the red flags of socialist and trade union banners, and the May songs by anthems of class solidarity. But in rural East Anglia, which the Industrial Revolution largely passed by, the ceremonies restored after the fall of Parliament's republic may still be enjoyed in certain villages on May Day.

On May Day ('Garland Day'), it is customary for girls to dress their best dolls in their finest clothing, and to carry them round the village in a garland covered with cloth, asking who would like to see the May Ladies. For a gift of sweets or money, the girls show the dolls, bringing good fortune upon those who see them. Sadly, modern attitudes have hardened against such delightful practices. In 1960 in Swaffham Prior, for example, the police banned Garland Day because the children were not authorized by law to collect money. But still,

> The First of May is Garland Day
> So please remember the garland.
> We only come but once a year,
> We only come but once a year!

Mother Shipton's Holiday

Although Whitsun was once an important Church and secular festival, the institute of the late summer Bank Holiday has all but eliminated it from the English year. Formerly, it was a time of merrymaking, with the construction of love arbours and maze-dancing. On the Wednesday in Whitsun week, the Cambridge washerwomen used to go to Laundress Green to celebrate Mother Shipton's Holiday, named after the famous Yorkshire seeress. There, they drank tea laced with rum, in her memory. The symbolic work of the washerwomen, who in cleansing fabric perpetuate the Web of Wyrd against dissolution, links them to the middle one of the three Weird Sisters, of whom Mother Shipton was a personification. It reminds us that in former times, actions now considered tiresome chores, like washing clothes or cleaning, were also endowed with a symbolic, spiritual function.

Midsummer's Day

The solstice of midsummer is the high point of the light half of the year. It is the longest day, when the sun rises at its most northerly point on the horizon, reaches its highest point in the south at midday, and sets at its most northerly. It marks the mid-point of the season of summer, which runs from May Day until Lammastide. We commemorate it by kindling bonfires, which we locate on the windward side of the buildings, gardens or fields to be protected by the sanctified smoke that blows over them. Of course, the midsummer bonfires are not set so close to buildings that they set fire to anything. To purify them and bring good fortune, we carry blazing brands or torches sunwise around buildings, gardens or fields. One of the characters of this day is Old Hub, the attendant of the torch-bearer. He is guised by a person with a blackened face, who chants:

> Here comes Old Hub,
> Over his shoulder he carries a club

Houses should be purified by simpson (groundsel) smoke at this time. In former times, guns were used to make a loud noise, and fireworks are appropriate today. It is recorded in the *Assize*

Rolls of Huntingdon of 1679, that at Waresley, people were firing blank charges from guns on Midsummer Eve to frighten away fairises and evil spirits. Much later, in 1830, there were prosecutions of people who kept Midsummer by guising. In that year, Thomas Wade of Stilton, Huntingdonshire, was presented for trial by grand jury, charged that 'in a certain street ... unlawfully and to the great terror and disturbance of divers liege subjects ... did walk up and down by having a pair of painted rams' horns on his head and a green veil over his face, at the same time also making divers strange and frightful noises'.

Midsummer is a time of fairs that celebrate the solar apex. The great Midsummer Fair held on Midsummer Common at Cambridge, is the largest in East Anglia, having flourished since the time when the practice of Christianity was suspended in the reign of King John. Midsummer is the time for gathering herbs, which are the culmination of their powers until 29 June. Midsummer's sigil is an open curve.

Lammastide and Autumn

Lammas, the old Loaf-Mass, is the festival of the First Harvest, celebrated on 1 August, with its eve from sunset on 31 July. The season of autumn begins at Lammas, and in former times was the season for the 'hiring fairs' where workers would be taken on for the coming year, or contracts renewed. Lammas proper is the day that the first barley, wheat or spelt is cut, and the first loaf of the new harvest is baked from it. It is the major harvest of The Miracle of Bread celebrated in the song 'John Barleycorn'. The grain harvest proceeds after Lammas until the final sheaf is cut, from which the Corn Dolly is made. Then, in East Anglia in former times, the Horkey feast was held. The last sheaf was brought to the farm in a cart, decked with vegetation. As the cart passed through the village, women threw water over it. The dolly was taken ceremonially into the barn where the feast was to be held, and set up in a place of honour. At Hengrave, a pair of horns, painted and adorned with flowers, was carried round the table before the Horkey supper. Then, the workers and their families would enjoy the largesse of their employer. After the feast, the dolly was taken into the farmhouse, to be preserved until the next year. Lammas's traditional sigil is a semicircle bisected by a line, resembling a crossbow.

Occurring around 21 September, the autumnal equinox is the time of the Second Harvest, that of the fruits of tree and hedgerow. This is the mid-point of the season of autumn, marking the transition from the light half of the year into the dark half. As with the other equinox, sunrise on this day is to the due east and sunset due west. From this equinox until midwinter, darkness is growing, and the days are waning in length. All but the everygreen trees begin to lose their leaves, and green plants grow pale and wan. Hence, the traditional sigil for this time of year is a stylized dying plant.

Winter's Day

14 October, Winter's Day, marks the beginning of the winter half of the year. After Winter's Day, long-distance voyages should not be undertaken, summer activities must cease, and preparations for the coming winter must take priority. This day is the old Norse festival of Vinternatsblöt.

Hollantide

November Day, 1 November, or Hollantide, the old Celtic festival of Samhain and the Christian All Saints', is the transition point between the seasons of autumn and winter. Now is the Third Harvest when in ancient times, it is told, all those animals not required for work or as breeding stock were to be slaughtered. Their meat was then smoked or salted to be kept as winter provisions. Hallowe'en is the solemn Festival of the Dead, the time when we remember our ancestors, whose lives, though finished now, are links in the chain of the unbroken line of life of which we are the current representatives. If they had not existed in the past, we would not be here today. So, at Hallowe'en, we acknowledge our forebears, and, in turn, hail our descendants, those who will come in centuries hence, but whom we can never see or know.

We observe November Eve, Hallowe'en, after dark on 31 October. This is the proper time for our festival of remembrance of death and the departed. It is the night when our ancestral spirits can manifest their presence through our ceremonies. Traditionally, we can achieve this by means of divination, when we can employ various methods to discover the

trends for the coming year. The guising masks we wear at Hollantide help to obscure our worldly personas, bringing us back into the archetypal world of spirit on the night when the crack between the worlds is opened. In guising, we assume for a while the characteristics of an otherworldly being, becoming one with our ancestors whose presence we now acknowledge.

The Harvest Cycle

The complete annual cycle of the harvest is known esoterically in East Anglia as The Miracle of Bread. Reflected in the life of John Barleycorn, recounted in the mystic ballad of the same name, this cycle is the underlying structure of the initiated grades of the Society of the Horseman's Word, and a number of other lesser-publicized secret East Anglian orders. Each of the significant events in the cycle is known as one of the Stations of the Year, of which there are eight in total. Seven of the Stations are represented by the major festivals of the Pagan year, whilst one, the unknowable, must by its nature remain forever undefined. Because the cycle of the year is reflected in the cycle of the day, the Stations of the Year also have a corresponding time of day. This enables each day to be viewed as a microcosm of the year, in which a cycle of corresponding contemplation and sacred devotions can be devised:

Time	Festival	Station	Corresponding event in the cycle
16.30	(approx.)	I	Death/Rebirth – the parent plant brings forth the seed and then dies
18.00	Equinox	II	Calling – the ripening of fruit and harvest
21.00	Hallowe'en	III	Awakening – letting go: the seed falls to earth
00.00	Yule	IV	Enlightenment – rebirth of the light in the darkness
06.00	Equinox	V	Reconciliation – apparently dead, the seed comes to life again
09.00	May Day	VI	Mystical Union – the plant is in full vigour, and in harmony with the environment
12.00	Midsummer	VII	Sanctification – the flower opens and is fertilized
15.00	Lammas	VIII	Completion

9 Traditional Magical Crafts

Magical crafts are an essential part of the Nameless Art. They are the physical vehicle by means of which we contact the unseen world and bring about changes according to our directed will. Magical tools and paraphernalia are the essential things that enable the user who has proper knowledge to perform acts of magic. We do not view the material world as in some way inferior or subordinate to the spiritual one. Both the material and non-material worlds are part of a greater whole, and one cannot do without the other. Spirituality without a material support is barren and lifeless; similarly, materialism without a spiritual basis is equally destructive. In every aspect of the Nameless Art, it is important to exaggerate nothing, for all good lies in right measure.

Magical Woodcraft

The Wood-Taking Ceremony

Whenever we want to use wood magically, we must take it from a living tree or shrub. Wood which has been cut already is useless, because the person who cut it will, knowingly or unknowingly, have put their own magical intention into it. It is possible that this may interfere with or negate our intentions, and so it is not worth the risk. When we cut wood ceremonially, we infuse it with our own magic according to our personal will. This is an on-lay (a new magical virtue created by a magical operation) which augments the innate virtues of the wood. One must seek in local woodland and hedgerows for the appropriate tree from which to cut the wood. This search should be undertaken in a contemplative state of mind, with a relaxed

awareness of the presence of the properties being sought. Naturally, we must obtain permission from the landowner before taking any wood. Respect for the rights of others as well as our own rights lies at the root of the Nameless Art. Once the right tree has been found, one must approach it in a reverent manner.

All wood should be cut using the wood-taking ceremony. The best time to cut wood is at sunrise, high noon or sunset. The branch to be cut should face towards the direction that corresponds most closely with the use to which it will be put. Firstly, as with all magical processes, we make a spell of personal protection. Then, making the knife ready, the magician addresses the sprite in the tree with a spell such as:

> Karinder!
> Hail to thee, O Aspen Tree [or whatever kind of tree it
> is].
> Old Lady, give me some of this wood,
> And I will give thee some of mine,
> When I grow into a tree.
> Send your virtue into this branch,
> That your strength will flow through it
> For the good of all.
> Ka!

After this spell, we cut the branch, with a single stroke if possible. The cut is made from below, beginning underneath and with the cutting action upwards. Under no circumstances should the branch be permitted to fall to the ground. If it proves necessary to climb up the tree to get at the branch, then once it has been cut it should be passed to an assistant. We never throw down the branch, for if it should touch the earth before it is worked on magically, it will have no power. Once the branch has been removed, it is important to thank the tree for its gift. To do this, we address the tree sprite once more:

> Old Lady Aspen [or whatever species of tree it is].
> Accept my thanks
> For your virtue in this branch.
> That its power there will remain,
> Working for the good of all.
> Ka!

Finally, we leave a small offering to the tree as recompense for the wood. It can be a coin, a piece of red ribbon, bread and cheese, a libation of ale, or a candle lit in front of the tree. When we offer a candle, we commit ourselves to staying with it until it has burnt out. Burning candles should never be left in woodland, for there is the ever-present danger of fire. Once the wood-taking ceremony is complete, the wood can be taken away. Wood is versatile magical material. It is used for items ranging from small talismanic slivers to wands, long staves, magical tools, the posts around sacred enclosures, and building materials.

Staves, Rods, Flails and Slivers

The wooden staff has always been a symbol of power and office, and in former times there were official ceremonies to empower certain staves as emblems of authority. Duke William of Normandy (later William the Conqueror) carried a *baculus*, a wooden club, as magical symbol of his authority in the Battle of Hastings. In the medieval period, at Navestock in Essex, the ceremony of the Wardstaff was performed each year in connection with a system of law and order that resembled the old Germanic *Vehm*. An account from John Stoner, who lived in the sixteenth century, tells how on the Sunday before Hock Monday (the second Sunday after Easter), the Bailiff of the Hundred of Aungr would cut a willow bough from Abasse Roothing Wood, from which the Wardstaff was fashioned. This Wardstaff measured 69 cm (27 in) in length, and 20.3 cm (8 in) 'round in compass'. It was taken to the manor-house, where it was wrapped ceremonially in a 'fair lynnen cloth' and set upon a cushion in a place of honour. Then it was taken by the bailiff 'by sunne shining' to a place called Wardhatch Lane 'to watch and ward the said staffe'. Then all the tenants of the lands would be summoned, and each would present themselves to the lord, who 'in the presence of the whole Watch shall take the same staffe into his hand, and shall make uppon the upper rind of the same with a knife a score or notch as a mark or token declaring their lyall service done for that year in this behalfe'. The Wardstaff thus became the record of the 'fencible men' who had assembled there. These men were appointed to police the Hundred against robbers and murderers, and thus the staff,

magically empowered by their presence, was the emblem of law and order in the district. The ubiquitous presence of royal sceptres, Black Rods, army officers' batons, bailiffs' and beadles' staves show that, even in non-magical circles, the staff as symbol of office and power is still very much present.

A Whiffler, carrying his magical stave, who preceded the parade of Snap the Dragon in Norwich, clearing the processional route of people, evil spirits and bad luck. The ceremony of carrying the dragon through the streets was suppressed in the mid-nineteenth century

The classical magical tool of wood is the magician's wand or *sway*, fashioned from hazel or blackthorn. The wand symbolizes the conceptual cosmic axis called earth's hazel wand, that runs from the underworld to the upperworld, through this world on

which we walk. In East Anglia, the magic wand measures an ell (67.06 cm; 26.4 in) in length. We hold it in the direction that it grew, that is with its lower, thicker end in the hand. Some of our sways are made with a Deal Apple (pine cone) at the end. This can either be real or a carving, and is phallic in nature. The magic wand is used primarily to direct ceremonial power, the *Blast*, which is projected from the end of the wand during magical acts. Similar to the wand, but more flexible, is the willow wand, which is used to whip away harmful sprites. Willow wands were carried by the Whifflers who used to walk in front of the parade of Snap the Dragon in Norwich to clear the way. Related to willow wands are sprite flails. Sprite flails are made from nine bramble (blackberry) branches, each an ell in length, well covered with thorns. We tie the branches together with willow bark. It is best to make sprite flails at *Barsel*, in the springtime. We use the sprite flail like the willow wand, to clear pathways which no one has walked for a long time. Generally, the sprite flail clears unwanted on-lays from any place. We hold a sprite flail in the left hand, and make sweeping actions away from us in nines to drive away the unwanted sprites.

Magical staves, used, among other things, for delineating sacred areas, are best made from uprooted whole saplings, using the root end as the knob on top. When used in this way, the staff is an inversion of the way that the tree grows. Wood is used this way only when it serves as a magical protection, as in the dragon posts that hold up the corners of timber-framed buildings. Elsewhere, wood must be used upright in the direction of growth. We make croomsticks and other artificially distorted magical staves by deliberately pinning the sapling to the ground in a certain way as it grows, then harvesting it for use one, two, three or five years later. Croomsticks and staves created in this way are especially powerful, for they bear in their growth structure the intent of their maker. An alternative, but not as magical, way to obtain a croomstick is to look for a naturally distorted sapling.

The croomstick is a stave with a curved top rather like a shepherd's crook, longer than a walking-stick, which we use for various magical functions. These include viewing the sky, laying out magical enclosures, hooking down mistletoe and 'Witches' Brooms', and warding off psychic intrusion. Because the croomstick is used to view the heavens, its dimensions are

crucial. When we hold one at arm's length, we should be able to view one-sixteenth of the horizon through the space inside its crook-end. In this way, we can use the croomstick as a geomantic tool for determining the qualities of the eight directions.

The besom, or witch's broomstick, representing the tree of life, is made from various woods, all of which have a magical and symbolic function. The *stale*, the staff or handle, representing the cosmic axis, is from the ash. In East Anglia, we make the broom part from the twigs of a number of trees. This is the part that sweeps away evil spirits and bad luck. The twigs we take come from the hazel, birch and rowan trees. Hazel signifies the wisdom of initiation; birch, for purification; and rowan for healing and preservation. The twigs are bound to the broom-handle by strips of the flexible lunar Sally tree (willow). We think it best to cut the birch twigs in late September. It is unlucky to make a besom during the merry month of May or the twelve days of Yule. The besom should not be used at all during May. How the besom is handled is also symbolic; for example, the way that we lay the broomstick when we are not using it is significant. When it stands outside the door with its broom part upwards, then it signifies that the spouse is away, and the remaining one is free to dally with another. Apart from sweeping, the broom's best-known function is in the ceremonial dances that led to the famous depiction of the witch riding her broomstick. The traditional broom dance of Comberton in Cambridgeshire, notably danced in the 1930s by William 'Tulla' Papworth, is a continuation of this ceremonial dance in a less ecstatic, yet still authentic, form.

The dowsing rod is another kind of magical tool that we fashion from wood. In modern times, the magical aspects of the ancient art of rhabdomancy, divination by the rod, have been played down by practitioners, and the supposed scientific aspects emphasized. Almost all modern dowsers have abandoned the magical techniques formerly considered essential for the success of the rhabdomantical operation. However, despite claims to the contrary, dowsing for minerals or water remains essentially a magical practice. The eighteenth century country almanac, *The Shepherd's Kalendar* tells us the magical procedures that are necessary for us to follow when making and using a divining rod:

Cut a hazel wand forked at the upper end like a Y. Peel off the rind and dry it in a moderate heat; then steep it in the juice of Wake-Robin or Night-Shade, and cut the single lower end sharp, and where you suppose any rich mine or treasure is near, place a piece of the same metal you conceive is hid in the earth to the top of one of the forks by a hair or very fine silk or a thread, and do the like to the other end. Pitch the sharp single end lightly to the ground at the going down of the sun, the moon being on the increase, and in the morning at sunrise, by natural sympathy you will find the metal inclining, as it were, pointing to the place where the other is hid.

In East Anglia, it is traditional to cut the rhabdomantic rod in a wood-taking ceremony. It should be cut from a hazel tree with a single stroke at the time of a full moon, on a Wednesday, in the planetary hour of Mercury. Essex tradition says that it should be used only after sunset and before sunrise, and only on certain nights. These are: the first night of a new moon, or that preceding it; Epiphany; Shrove Tuesday; Good Friday; and St John's Day. Such a rod will find water or minerals. However, if we want to find lost property, then we must use a rod of yew wood. Essex dowsing-lore tells of seven different sorts of dowsing rod: the Divine Rod; the Shining Rod; the Leaping Rod; the Transcendent Rod; the Trembling Rod; the Dipping Rod; and the Superior Rod. The classical rhabdomantic rod is a single stave, like the magic wand, about an ell in length. When we use one, we carry it horizontally, with one hand grasping each end, holding it with a pressure that is sufficient to bend it slightly. When water is beneath our feet, we feel a turning force in the rod. This technique is not as popular as the use of the more familiar alternative to the rhabdomant's rod, the forked hazel wand. This is a Y-shaped hazel branch, each end of which is held in one hand. When the diviner encounters water, the hazel rod bends downwards or upwards. Both types of rhabdomantic rod signify water through their turning action, as a physical example of the 'turning magic' so prevalent in the northern tradition. Because dowsing is essentially one of the magical arts, like all magical procedures it should only be practised when there is a necessity and never just for show or curiosity.

Egg-staves are wooden staves that we set up at specific places for magical protection. Unlike wands and rhabdomantic rods, they are not carried. They are made from blackthorn, and should be about four feet high, with a small forked branch at the top. Into this we wedge a red-painted blown hen's egg, a white pebble or a quartz crystal. Then we push the egg-staff into the ground at a place where there is psychic interference. It will block the attack, the object in its cleft absorbing or reflecting the harmful forces coming towards it.

A small flat piece of wood on which we write sigils or magical letters is called a sliver or tine. We cut them ceremonially from a piece of wood which has been taken according to the wood-taking ceremony. Then we incise the magical sigils or spell using the ceremonial knife, and finally colour it with tiver (red ochre or red chalk). Then it is ready to perform its work. Slivers are best made with the wood of the yew tree, though other woods are used for specialist purposes. Magical slivers must be created with a certain aim in mind, and are intended to work for only a limited period. After it has served its purpose, it must be ceremonially destroyed, so that it does not continue to work when it is no longer needed. We carry slivers in the pockets for personal protection; they can be thrust into cracks in walls as a temporary protection for houses, barns, stables and garages, or thrown into the foundations of buildings to empower the workmen in their tasks.

Clothing and Personal Paraphernalia

Although practitioners of the Nameless Art may appear little different from anyone else one may encounter on the street, there are a number of items of clothing and personal effects that distinguish us from the average person. Some are visible externally, but most are not. One traditional mark of the cunning man or wise woman is when clothing is worn inside out or back to front. Odd socks, an underskirt worn as a top layer, or a scarf around the waist are other ways of wearing clothing magically. These practices are usually mistaken by others as signs of our absent-mindedness or carelessness, but it has nothing to do with forgetfulness. They have a magical function, whose symbolism is that of turning things around. By inverting the normal ways of doing things, we consciously set ourselves

aside from the everyday materialistic world. Also, when clothes are worn inside out, the wearer introduces an element of confusion which assists him or her in dealing with malevolent otherworldly entities. It can also be recognized as a 'badge of office' of the wise woman and the cunning man.

Similarly, in former times, red clothing was a sign of the magician. Several recorded East Anglian wise women were noted for their wearing of a red underskirt, a red cape, or a red cap. The title Old Mother Redcap, is significant. A red cap has always been the sign of a person wise in magical lore, and to wear a red cap is a sign not only that one has magical ability, but that one is offering that ability as a service to those who might need it. The person who wears the red cap announces herself as a person who is set aside from 'ordinary' society, a follower of the Elder Faith. The Elsinore Cap, made from felt composed of dog hair, was once a respected item of headgear. Three polecat, stoat or weasel skins, joined together and worn around the neck, are recognized in East Anglia as a ceremonial symbol of hereditary magical power.

The hand-knitted woollen sweaters known as ganseys once worn by East Anglian fishermen are perfect examples of functional clothing that incorporates magical, symbolic sigils into the overall design. Generally dark blue, a lucky, protective, colour, they are embellished by integral stitch patterns that identify the wearer's family or village. The patterns include cables, anchor, tree of life (flowerpot), herring-bone, hailstone, lightning, diamond and flag. Several can be traced to runic characters, whilst others are symbols of stability and continuity, serving to express the wearer's personal identity. In the event of a drowned fisherman's decomposed body being pulled from the sea, the pattern on the gansey would identify him.

Belts and girdles are bringers and sustainers of both physical and magical power, and wearing a belt around the body is a means of raising and controlling energy. Rings are similar in function. They surround a certain part of the body, bringing it, and the whole body, magical protection. There are various possibilities in the Nameless Art. Some people wear magic knotted cord or a girdle of animal hair or skin round the body. Whatever it is made of, the girdle should measure three fingers in width, and any buckle should be made with seven tags or tongues. In addition to their innate magical function, spirit belts

can be used to support pouches or pockets in which talismans, herbs and other magically powerful objects can be carried close to the body. Several traditional remedies use a girdle or garter of animal skin. A formula from the Cambridgeshire Fens employs a garter known as a York, made from eel skin, as a preventive and cure for rheumatism. We prepare eel skins in the springtime. They are sun-dried until stiff, then greased and worked to pliability over a round piece of wood. The skins are then tied at both ends and stuffed with chopped thyme leaves (*Thymus vulgaris*) and lavender (*Lavandula angustifolia*). Then the stuffed skins must be placed in linen bags laid between layers of fresh marsh mint (*Mentha aquatica*) and buried in the ground until the beginning of autumn. On Lammas Day, the bags are dug up, the skins taken out, lavender and thyme removed, and the garters polished on a smooth stone. Only then are they ready for use. The eel-skin garter should be worn just above the knee. Women wear them knotted on the right, and men, knotted on the left.

The knife is an essential tool. Although in the Nameless Art we do not use it in the same way as some other magicians, as a weapon against the demonic empire, it is essential to own a knife for wood-taking, herb-gathering, for cutting staves and slivers and for the carving of sacred sigils. Magical knives have a blade made of iron or steel, the metal of the Great God Termagant. Many magicians believe that it is better to make one's own knife rather than using one purchased in a shop or market. Second-hand knives should never be used, except those inherited from one's master, for there are certainly on-lays on all knives that have been used by others. The only way we can be really sure that a knife has never been used for anything else is to make our own. Even if we do not have the blacksmithing skills to forge our own blade, we can make our own magic knife from a blank piece of iron or steel, personally shaped and ground to sharpness. When we make knives in this way, we can empower them by singing a galster or magical chant as we make them, and we then know with certainty everything that the knife has ever been used for. A magic knife should have a handle made from a natural material, such as wood, bone or horn. Traditional handle-woods include rowan, hazel and ash, though we do not reject any serviceable native hardwood. Wood should be cut using the wood-taking ceremony. It is best that the knife-maker

should cut and season the wood him- or herself. Once it is ready, the knife is consecrated with seawater and smoke, and given a name according to the ceremony for making talismans. Now it is ready for use.

Sprite Traps

Sprite traps are a special kind of magical tool that we use to deal with psychic problems associated with harmful sprites, the unquiet dead and discarnate entities. The operative part is red thread. First, we cut a stave of blackthorn to an appropriate length. Next, we take a copper wire, preferably one which has never carried electricity, and make two circular loops, one large and one small. Then, we connect them to the blackthorn stave, binding them on with red thread. Next, we make a Dag sign, (the runic letter 'D'), out of silver or a silvery metal such as aluminium. This must be consecrated at midday. However, the parts should not be assembled immediately, as this must be done at sunrise on the day when the trap is set up. In a sunrise ceremony, we call on the powers of the trap to entangle, ensnare and entrap these harmful sprites. Then we set it up on the spirit way or path by which the sprites are causing their disruption. For example, this may be between a graveyard and a house, at the entrance to an abandoned church or cemetery or any other place where psychic imbalance is recognized.

At night, we set up a cleft blackthorn stave, in which we light a candle. This is set up in front of the trap, and attracts the harmful sprites. After an appropriate time, we examine the trap, and test it to determine whether the offending sprite has been entangled in it. If the test proves positive, then we take it away to a consecrated place to imprison the sprite permanently in a bottle. There are two different kinds of magical bottle used in East Anglia. The first kind are those prepared magically to ward off harm. They are used to enharden a place, such as a house, against unwanted psychic intrusion. The other type are those that contain entrapped troublesome spirits. They are the final stage in the process of trapping spirits that is part of the binding magic of the Nameless Art. The two kinds of witch bottles are described further in the chapter on House Magic.

When we get the trap back to our working-place, we cut the thread from it with a consecrated knife, and place the pieces of

thread in a previously consecrated Cambridgeshire Witch Bottle, a small glass bottle. As we put in each piece of sprite-bearing thread, we recite:

> Thread, tie up this sprite,
> Free us from its spite,
> Tangle up the bane,
> Let not a jiece remain.
> Ka!

(A jiece is the smallest piece of anything.)

With the final 'Ka!', we put full concentration into the meaning of the words, and the act of binding the sprite. Then we must immediately seal the bottle full of threads. We use a cork, and fill the top with red wax. Then we bury the bottle in an appropriate place, preferably planting a thorn bush on the site. Should the bottle ever be broken, then the angry sprite will escape and wreak havoc upon anyone within its range! If you ever find one, never break the seal to see what is inside. It might prove inconvenient.

10 Magical Items and Paraphernalia

Amulets and Talismans

Protective magic is very well developed in the Nameless Art. Basically, protective magic serves to ward off all kinds of harmful possibilities from both the person and his or her surroundings, as far as is possible. Naturally, all magical protection must be applied in addition to those normal precautions taken by any sensible person. It is no use if we cover a door with magically protective sigils and then leave it unlocked when we go out. We use two basic kinds of object in magical protection – amulets and talismans. An amulet is a charm, usually a natural object. Whether or not it has been consecrated, it exerts protection by the power of its natural virtues. Amulets are almost always protective in function, unlike talismans which can evoke and invoke powers for specific purposes. Amulets work best against destructive and disruptive forces like illness or bad luck. We also use them to ward off evil spirits and unwanted non-material entities. Amulets include stones, shells, feathers, roots, twigs, leaves, whole animals and parts of animals as well as other, less defined, objects.

A talisman is an artefact that a magician has charged with magical virtue by means of a ceremonial consecration. Each talisman we make is dedicated to a specific purpose by our conscious will. Its nature depends on the magical spells we make and the actions we take during its preparation. Because each talisman has a function and purpose known to the owner or wearer, it evokes corresponding powers within the wearer as well as the general invocation of external powers to which the talisman is addressed. As material supports for spiritual powers, talismans are usually objects created from wood or metal, or

sometimes spells written on parchment, bark or paper.

In making talismans we must ensure that the magical virtues of the material to be used match as nearly as possible the magical powers being evoked and invoked. Without this inner alignment of material and purpose, there will be a conflict within. For example, if the magic concerns Venus, then copper is the proper metal for this function, not gold or titanium. Also, when making the talisman, we must match the metal, wood or stone we use with a corresponding sigil. It is by means of the appropriate sigil that any talisman is changed. The magical act of drawing or cutting the sigil into the talisman will draw into it the magical virtue which the magician needs. It is best if the sigil is inscribed upon the talisman as part of the procedure of making it. In addition to their use in empowering talismans, we can use magic sigils by themselves as empowering marks on other objects – tools, vehicles or even buildings. Used appropriately, sigils serve to protect them and enhance their desired qualities.

Talismans may have many forms, but those that we wear tend to be of a decorative and practical nature: rings, bracelets, necklets, pendants and lockets. Rings, bracelets and necklets should be made of materials corresponding to the wearer's magical requirements. Necklaces carrying many amulets are popular and powerful. The amulets can include stones, beads, amber, silver, gold, teeth, claws and snake vertebrae. Those whose magic is linked to specific animal powers should use something connected with that beast. Of course, Toadsmen and Toadswomen should wear necklets of toads' bones, especially the prized magical pelvic bones. Sometimes, talismans and amulets will hang side by side on such a necklet. But often, it is just the terminal pendant that is talismanic. Such a pendant talisman can be an image of a deity, a medallion bearing an image or sigil, or a physical representation, such as a solar wheel or disc. Amulets can also be kept in a locket or *bulla*, a container, usually of precious metal, which is worn on a string or chain around the neck, or kept in a pouch when it is not possible to wear it. Amulets such as pungled (mummified) potatoes, used against cramp and rheumatism, may also be kept in the pocket in a pouch.

Anyone who wishes to make his or her own talismans needs a good working knowledge of the principles and practice of magic.

With any magical system, any mistake can prove troublesome or even disastrous. However, so long as we apply the basic principles properly, the outcome should be successful. The most important thing to bear in mind is the function of the talisman, and what you want it to do. You should ask what is the nature of the thing or person you wish to protect. Do you intend it to be passive or active? Should the talisman ward off bad luck passively, or actively attract good luck? Should the protection work by invoking invisibility, so that nobody notices it, and behaves as though it is not there? Or should it be one of defence, where people notice it in terror, and step back, as if from an armed warrior? You should contemplate these, and similar considerations, before you proceed.

The Nameless Art uses magical principles that stand squarely within the northern tradition of indigenous European spirituality, principles that hold good for any procedure. The construction of talismans is a good example of the method, which, with conscious awareness, can be applied to other magical tools and paraphernalia. In East Anglian magic, the operator's attitude is all important. Because magic works through the concentrated will of the magician, every action in the magical operation must be in accord. If we do not have this basic attitude when we work, then failure is certain. Everything that we do magically really matters. Even the way that we arrange tools, utensils, paraphernalia and materials is a ritual of awareness. Magic should not be undertaken frivolously, either just to see what might happen, or for the sake of entertainment, for the process of performance of the magical operation brings spiritual development, which can be blighted by a cynical or ironic attitude. We must handle all materials with respect, whether an eel skin, a woodlouse 'pill' or a fragrant herb. However long or troublesome the process may be, it is essential to keep concentration, not to be distracted or make a break in the proceedings, no matter how long it takes. During the ceremony, we must remain aware, mindful of the task in hand, its meaning and function. It is important to have no negative attitudes, thoughts or emotions, and not to feel bored with the process.

Timing is important, too. Talismans that we intend to protect or promote growth and expansion should be fashioned during the waxing moon, and at a planetary hour whose quality tallies

most closely to the required effect. Those to do with diminution and decline should be made during the waning moon. If a very complex and delicate operation is planned, then we can apply to principles of electional astrology to determine the astrologically most auspicious moment to enact the ceremony. As with all magical operations, before beginning the actual work of talisman making, we must cleanse and consecrate the work area, tools and materials to remove unwanted psychic influences, and to bring the necessary ones into our presence. This technique, using seawater, fire and smoke, is explained in the section on the 'Enhazelled Field', on pages 137-41.

The form that the magic enclosure takes is that of a temporary psychic barrier which protects and nurtures the worker and the materials being worked upon. The materials will have been gathered and prepared beforehand, using the appropriate magical techniques, and all necessary designs or inscriptions settled upon. Most important is the name that the talisman is to have. Like all things made by hand, a talisman is a unique object, ensouled with the personal power of the man or woman who makes it. Consequently, even if many similar ones have been made before, it is still 'one of a kind', born at a particular moment in a particular place. Because of this, it has its own personality, which is acknowledged by giving it a name. This has a venerable history in the northern tradition, being best known from the area of magically empowered weaponry, such as the Alamannic spear *Thor Rih*, King Offa's sword, *Skrep*, and the consecrated Viking banners *Ravenlandeye* and *Land-Waster*. Similarly, all other magically empowered tools and talismans should possess their own names. But, unlike the famous names of weapons, that cast fear into other opponents, the magic name of a talisman should never be divulged.

Once everything is set up, and the time is right, we make the talisman. All procedures necessary to complete and empower the magical object should be made now. Nothing should be allowed to distract the work of magic: any runes or sigils should be inscribed with full concentration, using, where appropriate, calls of their names and galster (magical song). As we call or sing, we visualize the corresponding magical virtues entering the work. When the talisman is finished, we acknowledge it out loud. The traditional East Anglian call of affirmation – 'Ka!' – is most appropriate. Next, we enclose the talisman in darkness,

either by being wrapped in black cloth or placed in a closed box. Then the cloth or container is rotated nine times, and we call upon the Old Ones to empower this gestating talisman. After this is completed, we bring the talisman back again into the light of day. This moment is its symbolic birth, and when we use electional astrology, this is the significant moment. Then, the new-born talisman is welcomed and given its name.

To name the talisman, we first pass it over a candle or a fire three times, calling upon the powers of light and life to bring its qualities to their full strength. Then, to name it, we sprinkle seawater over it, singing a galster like this.

> As I sprinkle water over you
> I name you [name],
> By air and water, earth and fire.
> Ka!

Now that the talisman has its name, a final operation is made that infuses it magically with the power it needs to perform its intended task. To do this, it is necessary to sing a spontaneous galster specially for each talisman we make. The galster can take any form we like, but it must declaim the specific function for which the talisman will be used, as in the following:

> [Name], who bears my will,
> I charge you to do as commanded,
> For the purpose of [say what it will do and where it will
> do it]
> May the talisman work my will
> In accordance with eternal law
> Ka!

Finally, as a finishing rite, we visualize three interlinked circles on and around the talisman. The talisman is now ready for use. If it is intended to put the talisman in a building, then three circles can be chalked on it close by, or carved in a place where they are not visible. When we find this sigil concealed, on old roof-beams and brickwork in traditional buildings, then we know that the talismanic magic of the Nameless Art was performed there by one of our spiritual forebears.

Finally, as with all magical operations, we must close down

the enclosure psychically, as we do not need it any longer. It is important to remember this magical housekeeping, to clear up any psychical on-lays we have created and no longer need. It is not responsible to leave magical detritus behind us. So the magical operation should end with a specific announcement of intention, something like:

> Now the work is finished,
> Where [name of talisman]
> Was brought out of the dark nothingness
> Into this world,
> In the name of the Old Ones,
> Ka!

Now, the talisman is ready for use, fully empowered.

Signs and Sigils for Talismans and Amulets

In East Anglian magic, we use numerous sacred symbols, most of which are common to other parts of the northern tradition. Most can be used appropriately as protective talismans. No one is more important than any other, for appropriateness is the only guide to their use. One practitioner may prefer one sigil rather than another for personal or aesthetic reasons, but the decision is wholly with the user. Clearly, though, there are guidelines. It would be inappropriate to use a solar symbol for moon-magic, for example, or a threefold one when fourfoldness is the guiding principle of the magical operation. However, beyond that, the Nameless Art invites creativity.

Threefold sigils express the threefold dynamic nature of the processes of existence: beginning, middle and end, or birth, life and death, for example. We use a number of threefold sigils, and all of them express this unity. The Trefot is a sigil composed of three angular hooks, signifying magical inspiration. As a heraldic device of Norse origin, depicted as three armoured legs, it is best known as the sign of the Isle of Man. The triple circle is formed from three interlinking circles which signify the interlinking of the three forces or states which rule existence and the universe; space, matter and energy; body, mind and spirit etc. Chalked or carved, it is a sign of consecration and banishing all harm. Allied to this is the three-leaved clover.

We use fourfold sigils to invoke completeness and wholeness. The Celtic Cross or sunwheel is a good example of this. It is a circle, divided equally into four quarters by an equal-armed cross. Its traditional interpretation is that it signifies the power of the sun goddess Phoebe, in its aspect of bringing sanctification, through enclosed and controlled sacred power. Related to the sunwheel is the Fylfot, the four-footed cross, better known by its Sanskrit name, Swastika. Another version of the sunwheel, it signifies the outgoing power of the sun, or the dynamic energy of Thor's hammer, both of which represent magical force directed by the will. Like the Trefot above, the Fylfot has two forms, the left- and the right-handed. East Anglian magic does not interpret them dualistically as good and evil forms, but as complementary opposites. The left-handed fylfot signifies the masculine, outgoing, power, and the right-handed, the feminine, ingathering, power. Unfortunately, its political use after 1920 has, understandably, clouded its use in magic. When we see two curved S-shaped iron wall-anchors overlapping on an outside wall of a house, making a Fylfot pattern, this is a charm against lightning. Related to this is the Celtic Rose, which is a swirling, four-armed, continuous line enclosing five dots of a nine-dot pattern. This has a complex geometrical construction and explanation that symbolizes the masculine, godly, force that is immanent within the goddess's feminine form.

Another fourfold sigil is the shape known as the Ingrune and its allied sigil, the Egyptian Diamond. The Ingrune, as its name tells us, is a runic character, which can be drawn in two different ways. Firstly, it can be an enclosed, feminine, 'diamond' shape, and secondly, if the ends are extended, a masculine, outgoing, pattern. When the geometry of the diamond shape is in the width to length ratio to 3:4, then it is the Egyptian Diamond, which contains some very interesting geometrical and numerical qualities.

If either the Ingrune or the Egyptian Diamond is repeated over and over again on a surface, then the Ing grid is formed. This is a pattern signifying universal expansion and protection. A variant of this is a grid formed of two squares superimposed over the Ingrune, subdivided into fifty squares in all. This sigil invokes the power of dynamic balance between two inter-changeable states, whose magical function is to resist attack by

both direct and devious means. The final allied sigil of this group is called God's Nail. This is also an outgoing Ingrune, at the centre of which is an eight-petalled flower. Although it is used in East Anglia, this is a Scandinavian sigil that represents the sun standing due north at midnight at midsummer north of the Arctic Circle. This is the time when the power of the pole star, known as the Nowl (the Nail) and the sun are in alignment.

Fivefold sigils symbolize the hand, and the human body. Hence, we consider the fivefold to be a metaphor for the human being. The pentagram, or Witch's Foot, is the pre-eminent magical sigil, appearing in all forms of the Western magical tradition. Its inner structure contains the harmonic proportional system that underlies all growth in the organic world, and hence it represents natural things in all their multiple forms. Consequently, it is the sigil we use most frequently as the symbol of modern Paganism. Like the pentagram, although not based on fivefoldness, is the spiral, which is also symbolic of the forces and patterns which underlie all growth. Used as a talisman, the spiral brings the user into harmony with the universal flow.

The hexagram, sometimes called The Star of David, is often associated solely with the Jewish religion. However, it is not exclusive to Judaism, being also a magical sigil of great antiquity in northern Europe, occurring, *inter alia*, on Alamannic jewellery and in ancient architecture. Being the interlinking of two equilateral triangles, it signifies the union of male and female, and that which is above with that which is below. As a symbol of conjunction, it is powerful magically in things that need balancing. Related to the hexagram is the Lucky Star. We draw this curved figure with a pair of compasses inside a circle. As the basis of triangular geometry, it encapsulates the underlying mystical structure of timber-framed buildings, and hence is used in house protection, where it is sometimes known as the Hex sign.

Sevenfold stars signify the seven planets of traditional astrology, thereby unifying and balancing the disparate qualities that they represent. Because the sevenfold star and the heptagram are difficult to construct, we use them more rarely than the five-, six- or eightfold sigils. However, the sevenfold star was popular in the nineteenth century as a protective sigil on carts and cast-iron coal-hole covers. The Heavenly Star is an

eight-branched figure which signifies the eight winds and the eight airts (compass directions) of the world. It thus symbolizes balance and expresses the cosmic order. A version of this is the Eight-Mark. We draw it by making a circle, then eight equal lines radiating from it. Each line should end in a circle the same size as the central one. It represents the centre point of the world, and is an appropriate sigil to mark a Nowl-stone (centre-point marker). When eight spirals are drawn together from a common centre, then the fire wheel is formed. This serves to increase the power of the spiral eightfold.

Nine is a very powerful number in the Nameless Art. A useful spell of increase says, 'By the power of three times three!' To create magical space in East Anglian magic, we use the grid of nine. This is a square subdivided into nine smaller, equal, squares. Inside each of these squares, which, among other things, can be seen to symbolize the seven astrological planets and the two lunar nodes, appropriate sigils are inscribed. The grid itself, painted like a chequer-board, is also a powerful talismanic sign. Sometimes, expanding on the 'power of three times three' principle, the grid of nine may be expanded ninefold to make the grid of eighty-one.

In East Anglian magic we employ a number of other sigils which are not geometric or numerical in structure, but which derive from actual or symbolic objects. Of these, the heart is the best known and the most widespread. It is a symbol of love, being the old sigil sacred to the goddess Frea. Said to represent the female pubic area rather than the body's blood-pump, it is the prime love talisman. Another universal sigil is the sun, which is sometimes depicted with a face and sixteen radiating rays. In East Anglia, we honour the sun as the goddess Phoebe, and sun sigils invoke her blessing of life and growth, which, on this planet, derive from her energy. The Sunray Pattern common on East Anglian pargeted walls is another way of invoking her protective powers.

The moon, mirror of the sun, is ever-changing through her phases of growth and diminution. As a talisman, sometimes a full moon may be depicted, but more often it is pictured as a crescent. Depending on which direction it faces, the lunar crescent depicts either the waxing or the waning powers. An image of the full moon acts as a reflector that resembles a mirror or witch-ball. Overall, the moon signifies ordered, sequential

change according to natural law. Allied to the lunar crescent is the horn. This is usually seen as representing the horn of plenty, the moon in its waxing, growth-filled phase. Symbolically, the horn holds the draught of inspiration, which is the bringer of plenty through the application of skills.

Depictions of horns, and swags of fruit and flowers, are an important element of pargeting-work on some traditional timber-framed buildings in Suffolk. The craftsmen who continue to create this unique plasterwork make magical protection for buildings that is also a work of art. Images of fruit and flowers serve the dual function of invoking the spirit of plenty, and of binding the evil forces of dearth and famine. Binding-magic is dealt with elsewhere in this book, but the twisted rope- and knot-pattern described there can be used also as a magic image rather than just a physical object. In pargeting-work, the Rope Pattern, which looks like an endless twisted skein of threads, is used to frame and complete panels that contain other sigils, such as the cranes of wisdom, trees of life, the alchemical rose and protective beasts. Runic forms like the Ingrune also have a binding effect when stamped in plasterwork.

The East Anglian tree of life is a runic form, depicted as a single stem that bears six, or sometimes eight, straight side branches. This is a sigil of stability and protection, calling upon the generative and regenerative power of nature to resist damage and destruction. In its form, it is allied closely to the witch's broomstick. The World Tree is often depicted as a tree of life growing from a pot or barrel. In talismanic magic, this form promotes spiritual and intellectual growth. The Thunderbroom depicts a kind of magical sweeping-tool, again allied to the witch's broomstick. It represents the goose-feather brush used in the Nameless Art to brush away bad luck and evil on-lays, cleansing away all harm.

Other sigils are more abstract in form. They relate to the runic tradition, taking the form of staves with various additions. They include St Olaf's Cross, the Egershelm, the Luckstave and the Lovestave, year signs and binding-knots. They are illustrated here. They should be empowered by the same magical process I give for talismans. I do not propose to describe the Sleepthorn, the Spellthorn, the Terror Stave or the Death Rune, other than to affirm their existence.

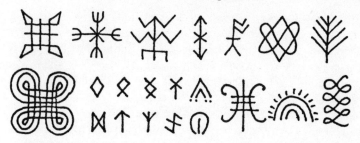

Signs and sigils of the Nameless Art. Upper row, *left to right*: 1 Sign of the Nameless Art; 2 Egershelm of Termagant, for impregnable defence; 3 Tree of Life of Hintlesham; 4 Ipswich warding sign, for protection; 5 Bury St Edmunds mason's mark; 6 Twin hearts, for binding love; 7 Northern tradition Tree of Life, eternal stability. Lower row, *left to right*: 1 Binding knot, for magical enclosure; (upper line 2–6): 2 Egyptian Diamond; 3 The Own (Odal) rune, for continuity of possession; 4 The Ingrune, for fertility and protection; 5 Heaven's Pillar (or the Windmill), the rune for eternal stability; 6 The Roof, or Growing Shoot, for protection and nurturing; (lower line 7–11); 7 The Day (Dag) rune, for far-seeing and protection of entrances; 8 The Tag sign (Tyr, the rune of Termagant), for defence; 9 The Sun rune of Phoebe, for strength and growth; 10 The Wolf rune, for binding and enclosure; 11 Frea's sign, for healthy sexuality; 12 Old Scratch's Gate, for blocking sprite-infested passages and doors; 13 The Rising Sun, used on the outside of the house in pargeting work; 14 Running Eights, for boundary protection of thresholds, stable- and garage-doors.

Lucky Hands and Alrauns: The Mystery of the Root-Doctors

The Lucky Hand is an amulet made from bracken. To make one, we uproot the fern on Midsummer Eve. Then, using our magic knife, we cut away all but five of the fronds, leaving the image of a hand with hooked fingers. Next, to preserve it, we dry and harden it in the smoke of the Midsummer bonfire, whose purifying fumes will endow it with the desired magic virtues. Then the Lucky Hand can be kept in the house as protection against all kinds of bad luck and ill fortune. Fern seed, properly the spore of the bracken, also has magical uses in the Nameless

Art. It is said that if one carries fern seed in the hand, one is empowered to divine valuable veins of metal in the earth, or to detect hidden treasure. Fern seed, like the Lucky Hand, should be collected on Midsummer Eve, at the Witching Hour (between 11.30 p.m. and 12.30 a.m.). The most powerful moment is at midnight itself. To collect the seed, we go to the place in silence, without speaking to anyone else about it. We spread a white cloth beneath the bracken, with a pewter dish laid on the cloth. Then, using a cleft stick of hazel wood, we bend the fronds over the dish, so that the seed falls into it.

From the sixteenth century onwards, the German woman-like roots called Alrauns were imported into Ipswich, Great Yarmouth and King's Lynn from the Hanseatic ports. They were sold at great prices to well-off wizards and witches. Alrauns are a magical by-way of mandrake lore, in which certain herbal roots are carved into human form to be used as talismans. The name Alraun is supposed to refer to the members of an ancient continental magical tribe or order. According to the Roman author Tacitus, they were the Aurinia of Aventinus, 'loose-haired, bare-legged witches who would slay a man, drink his blood from a skull and divine the future from his mangled remains'. Alrauns are also associated with another tribe of magicians called the Alyruninae. They were believed to have interbred with wood-spirits, and were said to have been related to the Huns. In Germany in the eighteenth century, certain wise women were called Alrune. They claimed that they were named after the Goddess of the Crossroads. The Alrauns themselves were created by wise women known as Alraun Maidens, who conjured certain spirits into them by occult means. In East Anglia, similar Alrauns were made from the roots of black bryony. Those made from plants growing beneath gallows or at crossroads were the most prized.

To make an Alraun, the wise women would carve a specially gathered herbal root into the shape of a human. They planted grains of barley in the carved roots in the places where the hair should be. The root was then buried in sand for three weeks, and when it was dug up, the grains had sprouted. Then the sprouts were cut into the shape of hair. Alrauns possessed great magical virtue, and had to be handled with the greatest reverence and care. They were usually kept wrapped in a white silken cloth, inside a wooden box. Ideally, they were to be

bathed every Friday. But if for some reason, the rites should be omitted, the Alraun would shriek in disapproval.

When treated with due respect, the Alraun was the family's protector. Only if it was neglected would misfortune befall every member of the household. Alrauns gave magical assistance during childbirth, and, used properly, it was said, had the powers of rejuvenation. They could serve to protect people against bad weather, and, when laid on the bed, could prevent the sleeper suffering from nightmares. Occasionally, people would use an Alraun to divine hidden treasure.

To own an Alraun, however, was always fraught with danger. The sprite that the Alraun Maiden had conjured into the root was sometimes transferred magically into a sealed glass bottle, where, hopefully, it could be kept out of harm's way. Although they were sold in England for considerable sums, in Germany it was said that unless one could be sold before the death of the owner, for less than it cost to buy, it could potentially bring disaster upon his or her descendants. Because of this, ownership of an Alraun was a burden as well as a boon. Places where people tried to get rid of their Alraun were said to acquire a sinister on-lay which was potent for years afterwards. Also, their magical qualities meant that they could not just be thrown away. People trying to rid themself of a troublesome Alraun might throw it into a river. But they would only find it waiting for them at home when they returned.

Nature's Amulets

Unusually shaped stones tell a tale to those who can read them. Under appropriate conditions, diviners can use them to foretell events, or to discern otherwise unknowable things. Fossils, especially, have wonderful shapes, which give them a special place in stone-magic. In former times, before it was recognized that they were the remains of extinct organisms, turned to stone, another world-view explained them as the products of the *vis plastica*, the divine creative aspect of *spirament*, a subtle force that resides deep down in the rocks, the bones of Mother Earth. Both theories are true philosophically. Through the processes of the *vis plastica*, or evolution, the rocks have provided us with wonderful magical stones.

These magnificent magical stones each have their own lore and magical virtues. Starstones, known to science by their Latin name of *Asteriae*, are pentagonal fossils, which bear the feathery impression of a five-pointed star upon them. Because they are a pentagram from nature, we prize Starstones as symbolic manifestations of otherworldly powers. When someone finds a Starstone, it is a sign that she or he has been blessed. It should be kept as an amulet, and never sold or put away. Ideally, one should be buried with one's personal Starstones.

The cone is a powerful form in the Nameless Art. The magical hats traditionally worn by witches and wizards are cone-shaped, and the explanation for this is that the cone is a concentrator of magical virtue. The intangible cone of power we raise in ceremonies reproduces this outer form on another plane of existence. Conical shells and stones are similarly concentrators of power. The black Kit-Cat Stones, which are short stumpy cones, are prized for their fine healing qualities. Another conical fossil possessing magical virtues is known as a Thunderbolt. Scientifically called *Belemnites*, they are the fossil remains of an extinct mollusc. Mythically, they are viewed as thunderbolts cast down by The High Thunderer – the god Thor – during thunderstorms. To the Fairises, they are sacred objects, providing light in the darkness just like candles. Coming from the otherworld, thereby containing magical virtue, they are used in healing-magic for both humans and horses, being used to remedy sore eyes and rheumatism. Thunderbolts are left overnight in water, and the water is used to treat the sick person or horse.

Toadstones are said to originate in the heads of toads, and as a consequence are prized by Toadsmen and Toadswomen. Scientifically, they are not jewels at all, but the fossil teeth of fish. Nevertheless, Toadstones of *Bufonites* are set into rings and lockets, or worn as pendants. Magically, they are indicators of psychic attack, for sensitive people can detect changes in their colour, or see them sweat a strange liquid, if this is happening. Also prized as a cure for poisoning and epilepsy, Toadstones indicate if any drink near them is poisonous. East Anglian Toadstones should not be confused with the waste stone found in veins of ore also called Toadstone. These 'dead stones' have no magical virtue, but as there are no mines in East Anglia, the two types of Toadstone cannot be confused. Another type of

fossil fish-tooth is the Tonguestone, from extinct sharks. Mythologically, they are related to the moon, falling to earth during eclipses. They are said to resemble the human tongue, and, just as poking out one's tongue at someone is a remedy against being overlooked, so using a Tonguestone as an amulet is effective against the Evil Eye. Tonguestones also have the more immediate effect of preventing muscular pains, cramp and rheumatism.

Worn as beads on a necklace are Screwstones, fossilized impressions of the stems of sea-lilies (*Crinoids*), which are columns composed of individual discs. Large Screwstones are often seen built into the wall of a house. The fossil *Echinoid*, called the Adderstone, an extinct relative of modern sea urchins and starfish, is held to be an effective antidote against snakebite. When ground, it can also be used to treat indigestion. But the Adderstone is said to possess a still greater power. In former times, it was believed that possession of an Adderstone gauranteed success in arguments and warfare. It is said that Adderstones are the sacred magical stone of the Druids, having originated as the petrified remains of the slimy froth-balls that vast assemblies of intertwined adders are said to exude at Midsummer. Related to the Adderstone is the Frairy Loaf. Scientifically called *Micraster*, this is the heart-shaped pentagrammic bread of the Little People, that we keep as a charm against shortages of bread. Similar fossils to Echinoids are the helmet-shaped Shepherds' Crowns, *Echinocorys*, prized as a lucky charm.

Precious stones are rare crystals of value that are particularly well connected magically. Twelve of the best-loved and most precious jewels are related to the sigs of the zodiac, the planets, and their corresponding days of the week and deities. They are listed in Section 4 of the Appendix. By knowing and understanding these correspondences, we can make jewellery which reflects the innate powers of the deities and times through the medium of crystals and their surrounding metals. Iron, the metal of our magic knives, is sacred to the Great God Termagant, whilst copper is ruled by Frea, tin by Thor, and lead by Saturnus. Gold is the metal of the sun goddess, Phoebe, whilst silver comes under the aegis of Lady Moon. Other, rarer, metals are ascribed to the earth from which they come.

11 The Magic of Everyday Life

The Mysteries of the Human Being

To the Nameless Art, the human being is not viewed as a single
entity, or even as a combination of a material body inhabited by a
separable spirit. East Anglian spirituality recognizes a far more
complex being, composed of many interlinked aspects. This
magical view questions the commonly accepted exoteric ideas
about individuality and our place in the scheme of things. The
most apparent aspect of the human being is the physical body,
which is composed of the four physical elements: fire, air, water
and earth. The individual human body does not stand alone, for
it is connected with the external environment. Life is dependent
upon the conditions being just right within relatively narrow
parameters. Our individuality within time is not separate, either.
Anybody living now is the direct, unbroken, continuation of his
or her mother and father, and, through them, their ancestors.
Life does not begin at conception, for the cells from which the
new person comes are part of the mother and father, being at
the beginning part of their living physical bodies. Furthermore,
even the concept of generations is flawed. The second
generation is present within the womb of the pregnant mother,
for viable eggs are present within the ovaries of every female
foetus. Our origin as individuals was within our grandmother's
womb. Thus, in a real way, each of us was present not only
within our mother and father, but also our maternal
grandmother. Therefore, in no way are we separate physically
from our forebears. We are part of a living continuum of which
they too were a part. This recognition, absent from modern
belief systems, is present in ancestor-worship and the

recognition that we can be a reincarnation of one of our ancestors.

To East Anglian tradition, the empowerment of the body – its very life – is understood in terms of the breath, which is the element of air. The human breath, which is life, is viewed as part of a universal cosmic breath that is present throughout the world, empowering many aspects of existence. This is not an unusual idea, for all over the world, traditional cultures have similar perceptions of this subtle 'cosmic breath' which pervades all existence. It is best known in the European tradition as Pneuma, Önd and the Aether. In the East it has other names: Ki, Ch'i and Prana, but the principle is the same. In East Anglian magic, it is called Spirament. Although it is essential to empower existence, Spirament is neutral in character. It is capable of picking up surrounding influences, behaving as a sort of medium for them. Thereby, Spirament is the magical medium which can be coloured and patterned consciously by the exercise of the will, or passively by the qualities of the places in which it occurs. It is the stuff of life and magic.

Within the body, we have consciousness and personality. Many people have attempted to analyse these faculties, and there are many descriptions ranging from the magical to the psychoanalytical. Most variants are valid attempts to understand a complex subject that cannot really be defined at all in words. Classified as aspects of Spirament are the mind, the power of reflection, thought and memory, the perceptive-cognitive power and the faculty of inspiration. Spirament also empowers the Fetch, which lies some way between individuality and separateness. Some view the Fetch as the Guardian Angel, or the Dis, a personal spirit that appears at the moment of birth and helps the individual to achieve certain tasks on a magical level. Sometimes, the Fetch may be seen in the form of an accompanying spirit-animal, or as a double of the person. When someone is seen in two places at the same time, one figure is actually their Fetch.

At death, the body loses its animation, becoming the Lich, the lifeless corpse. Then, the elements that compose the body are released back to the earth. This decomposition is also a process. First, the power of animation is lost, and the elements of consciousness and regeneration depart. In terms of the four elements, this is the loss of the breath – air – and warmth – fire.

Then, the liquids are lost, and the flesh is dissolved back into the earth. This is the loss of the element of water. All that is left is the earth, in the form of the essence of stone, the bones, which continue to exist long after the rest of the body is gone. They continue to retain some of the individual nature of the person to whom they belonged. Traditionally, it was through the medium of bones that the spirit of the departed person could be contacted. Also, bones are preserved as spiritual relics of the individual as part of ancient ancestor-worship. Skulls and bones of particularly inspirited or empowered people have always been recognized as receptacles of their special Spirament, and resorted to for healing and inspiration. Ultimately, it is the bones that contain someone's 'Luck', the power material that gives protection and good fortune.

In the days when the Catholic Church was dominant, it was customary to bury bodies for a few years in the graveyard, until the flesh had gone from the bones. Then the bones were exhumed, and deposited in the bonehouse or ossuary. There they remained until the bonehouse was filled, when all of the bones were buried again in a collective 'great burial', which took place approximately every twenty-five years. The remains of an ancient East Anglian bonehouse stand in the old abbey grounds at Bury St Edmunds. It is likely that the Ancient Order of Bonesmen once had something to do with these rituals. Cremation has no place in East Anglian tradition, being a relatively modern custom dating from the nineteenth century, though ultimately it is derived from Druidic and Hindu practices. Finally, the Shade is an after-death image that continues to appear in old 'haunts' or familiar places. This can be the same as a ghost or spirit, and it is in this form that the 'grateful dead' appear to reward those who have helped them to progress into the otherworld through kindness.

Inner Body Knowledge

As human beings, we *are* rooted in the earth, but urban civilization is very effective in obscuring the fact. Most people appear to be unaware of it. Traditional wisdom recognizes our relationship with subtle qualities in the land. This is expressed in the relationship between each individual and the land: it manifests its spiritual nature in different places by differing

spiritual qualities. We can have a personal spiritual relationship to these qualities. Ultimately, landscape is the basis of human culture. We are so held to it by myriad links, that without it, physical life, culture and consciousness are inconceivable. When we walk our own land, we are part of the landscape, and its total nature is present within our inner body knowledge. As part of our own country, we do not need a map or any external representation of the land. We know the names of our local places without recourse to written or printed records. Walking is the primary form of understanding the inner nature of our own earth, the Goddess of the Land. Each place has its own *anima loci*, its own history, geomythic qualities, legends, stories and anecdotes. Every part of the land has a name. The whole body of the land is infused with the names of deities, people, sprites, events, qualities and numinosity. So long as the names and form of the land remain within the consciousness of its inhabitants, the land is alive. As participants, we have a personal and collective cultural relationship to the landscape. Our imagined individuality is no longer so important; we are not separate. The reality is what we walk upon, see, touch, smell and experience. We are present, and this is the essence of the Nameless Art.

Furrows, Paths and Roads

Human-made lines across the landscape are on-lays, artificial constructions upon the natural world. Each type of line on the landscape has its own special quality, and so East Anglian dialect has many names for different sorts of pathway, that reflect their magical qualities on an inner level. An important distinction is made between paths that can be ploughed – Soft Paths – and those which must under no circumstances be dug up – Hard Paths. Temporary and permanent paths have quite different characters, and unmetalled ones differ from those with a permanent surface. Those that are unmetalled have a more spiritual quality than those made for vehicles. It is on such roads that the most magical experiences can take place. A green road is a 'Slade', one used by people on horseback is a 'Spurway', whilst a public road, which has a metalled surface with a camber is a 'Ramper'. The actual process of making them is still recalled in the name of some lanes; the 'Scores' of Lowestoft and the 'Rows' of Great Yarmouth. Other temporary lines on the

landscape are those made for working the land, without which there would be no human existence. In former times, before the mechanization of agriculture, those engaged in The Miracle of Bread used appropriate elements of the Nameless Art to accomplish their tasks. There was no separation between the magical and the practical: it was just the right way to do it. This was the knowledge that could never be extirpated as witchcraft by religious maniacs – only by the irreversible changes brought by machines.

The first magical act of The Miracle of Bread is in ploughing the field, making furrows across it in order to plant the seed. The art of the Dodman was the customary rule of thumb practice of 'setting a rig', to make the first furrow straight when ploughing with horses. First, two willow sticks, each called a *dod*, were cut with a shut-knife. Then one was set up at each end of the furlong. The ploughman tied a piece of straw to each dod to make it more visible. Next, he lined up his horses at the first dod stick, and, looking towards the dod at the other end, lined up upon a tall object in the distance beyond it, a back-marker called 'the furthest beacon'. Then he would draw the straight first furrow in that direction, until he reached the dod at the other end. The other furrows were ploughed alongside, on the same orientation. Planting potatoes in the garden also involves a magical technique of orientation, though because the potato grows below the ground in darkness, this rite is conducted at night, when the rig is aligned with the star called the Nowl (Polaris, the Pole Star).

Most roads and paths are created by human beings, but there are also those that are not made by the hands of men, but by the inhabitants of the spirit world. Through the East Anglian countryside run certain spirit paths which are especially reserved for the supernatural beings called The Good Ladies and The Princess of the Brilliant Star, whom some classify with the Fairises. However, these pathways are a dangerous terrain for mortals, for if one should be unlucky enough to encounter the spirits whilst walking upon them, then it will prove fatal. Another significant magical place is the crossroads, or Four Wentz Ways, a stopping place on the road where the wayfarer encounters various possibilities of where to go. Because of their liminal nature, crossroads are very special places magically, where it is easier to make contact with the spirit world than at

other, less active, locations. Customarily, as the sacred places of Woden, god of inspiration, crossroads are used for contacting the otherworld through divination. Often, there are pieces of uncultivated land at crossroads, sometimes with a tree. These plots, called 'No Man's Land', belong to the spirit world. Boundaries of parishes were laid out to meet at these liminal areas, which were 'no man's land', areas subject to powers higher than the human. In former times, they were also places of execution, outside the normal area of human activity, also sacred to Woden, this time in his aspect as god of the hanged.

Until 1823, the bodies of executed people, suicides and some Pagans were buried in the middle of the crossroads if possible, or at the roadside when not. Those buried at the crossroads were usually interred in a north-south orientation, rather than with the head to the west as in Christian burials. The burials were sometimes accompanied with indignities to the dead. Before the grave was filled in, it was customary to drive a stake, preferably of hawthorn, through the body with a single blow. It was believed that this would prevent the restless ghost from travelling the roads and wreaking havoc upon its tormentors. In Huntingdonshire, the Buckden Cruel Tree grew from a stake hammered through the heart of some unfortunate wretch executed and buried at the crossroads. The same story was told in Norfolk about Lush's Bush, a tree which grew at a road junction between Harleston and Redenhall. Magically, the stake served to fix the life energies of the executed person, and those not pinned down are said to be the ghosts often encountered at such places.

But not everyone buried at the crossroads was an ill-doer or a victim of rough justice, and a few of these crossroads burials are still well-kept. The best known is the Gypsy's Grave, near Kentford in Suffolk. Other named crossroads burials in East Anglia include Chunk Harvey's Grave in Thetford, where the Icknield Way crosses the old road to Euston, Alecock's Grave at Stanton in Suffolk, and Dobb's Grave, at a crossroads where the parishes of Brightwell, Kesgrave, Foxhall and Martlesham meet. A typical example of the multivalent levels of such places is now obliterated entirely by the A14 road. It was by the public house that stood at the crossroads where the road between Dry Drayton and Oakington crossed the old Roman road to Godmanchester called the Via Devana, north-west of

Cambridge. This haunted spot is a high-point and a *trifinium*, the threefold junction of the parishes of Oakington, Longstanton and Lolworth. When the new road was made in the late 1970s, a number of skeletons were discovered there.

In the old days, when people were hanged at the crossroads, it was often upon the tree which grew there on the 'No Man's Land'. A few of these mark-trees survive, though many have been destroyed over the years by neglect and road improvements. When an ash and a sycamore tree grow together at a Four Wentz Ways, they are called John and Mary. The ash is considered useful for male-oriented magic, whilst the sycamore can be used for female magic. Together, they form a magical gateway to the otherworld. Gates on roadways, either physical or magical, are another class of magical location. They are transition-points between one area and another, and many mark the boundaries of parishes and counties. Like crossroads, such gates are liminal places that are especially good for conducting magical operations. Esoterically, they are gateways to the otherworld, physical places whose magical character reflects their transitional status between areas on the physical plane.

Magical places with the 'Gate' name are often at *trifinia*, from which the local area can be affected magically. For instance, the traditional East Anglian magical cure for the *gid* (giddiness in sheep) was to cut off a sheep's head and bury it under a hawthorn bush at the meeting-place of three parishes. The disease would thus be pinned down at a magic spot, and cease to plague the rest of the flock. In Cambridgeshire, there are a number of such important places, such as Childerley Gate, on the parish boundaries of Childerley, Caldecote and Hardwick. Pelham Gate, on the county boundary between Hertfordshire and Essex, also marks the *trifinium* of the parishes of Berden, Clavering and Brent Pelham. Crossing-places, such as fords and bridges, also have the same character.

Bad luck, curses or disease can be transferred to the earth at these places. Magically harmful objects can be destroyed with a hammer at a crossroads, or on a bridge, when the road or water will carry away the malevolence rather than it falling upon the destroyer. A charm against whooping cough, recorded in 1948, is a parallel example of this. The suffering child should be taken in secrecy to a selected grassy place, and laid down. Then, using

a spade, a coffin shape is cut around the child in the turf. The child gets up, and the turf of the coffin shape is turned with the spade, roots upward. As the upturned grass yellows and withers, so the whooping cough will abate. Through the *piaculum* of a mock burial, only the illness enters the mole country, not the child.

Coffin paths are another type of magical place. Typically, they are ways across the fields where the pallbearers at a funeral would carry the coffin on their shoulders, not on a horse or in a hearse. In their character, they resemble spirit paths, and may be identical in some cases. They often give access to the churchyard by an unusual route that is not the normal pathway used by the living. The path from Abbotsley to Great Paxton in Huntingdonshire, called the Abbotsley Bier Baulk, entered the church through the Pagan north door, which appears to have been used only for funerals. Another coffin path, the Meeting Walk at Bluntisham, in Cambridgeshire, avoids houses and pre-enclosure open fields. Like all traditional features in the landscape, coffin paths are flexible, never fixed in the way that some modern people might imagine. Until World War II, it was held that new coffin paths could be created by a funeral cortège. When a gardener died in 1936 at Girton College in Cambridge, his coffin was carried across the grounds from one gate to another. Those who participated in his funeral claimed that the act of carrying a dead person along a path consecrated it, bringing it from the private into the public domain, making it into a public right of way. But even if that had been the case, there was a means of undoing the act. If pins were stuck into every gatepost on the path, then the land would remain private.

Turf mazes are another type of sacred ground. They are places where a permanent pathway has been laid in the ground that leads the visitor from the world outside into the centre, by means of a convoluted pathway. Only two ancient turf mazes still remain in the eastern counties, at Saffron Walden in Essex and at Hilton in Cambridgeshire (formerly Huntingdonshire). The maze on the common at Saffron Walden, associated once with the Guild of the Holy Trinity, which dated from around 1400, may be older than the maze on the village green at Hilton, which dates from 1660. Other turf mazes are known to have existed next to the crossroads at Comberton, near Cambridge, and at Monastery Hill in Norwich. It is possible that another existed

once at Maze Wood by Tilty Abbey in Essex. Further details of
the lore and traditions of turf mazes can be found in the author's
Mazes and Labyrinths (Robert Hale, 1990).

12 Sacred Land

Bidding for the Empowerment of the Land

East Anglian magic has the means to protect and empower plots of land and the buildings that stand there. The Nameless Art employs a bidding (consecration) technique known as a land remedy that erects a psychic barrier around the plot of land. In addition to this, it creates areas of reinforcement locally at entrances and comparable weak areas through which harmful forces may gain access to the area. This consecration technique is called The Four Holes Ceremony. It is an Old English *blout* (rite) intended to create perfect psychic conditions enabling the land to be fertile and prosperous, so that the residents can live good, harmonious, lives. It is a support for the land sprites, whose presence in the land empowers and nurtures the well-being of the earth. If they should be driven out, then the land will become *Gast*, barren both physically and spiritually.

The Four Holes Ceremony, conducted in the springtime when sowing or planting is about to take place, is essential for gardens and farmland. On the 'evening' of the ceremony, at night before sunrise on the day of consecration, we take four sods or divots of earth from the four sides of the land. Usually, they are taken from the four corners of a field, but if this is not possible, they must be from the four directions. As it is taken up, each divot is sprinkled with milk, honey, yeast, vegetable oil and appropriate parts of trees and herbs, with the spell: 'Karinder! Grow and multiply and replenish the Earth. Ka!'

After this, we take the divots to a consecrated place, where we make an observance over them. Then, before sunset, we bring them back to the holes from where they were dug. Into the holes we throw slivers of aspen wood, upon which sigils for growth and plenteousness have been carved. Then the divots are

replaced in the holes, beginning at the south side and going sunwise around the plot finishing at the east. Each time a divot is replaced, we recite the spell above nine times. After replacing the last divot, we make nine bows towards the east, the direction of the growing light of springtime, reciting the spell:

> Eastward I stand,
> To the great and mighty ones
> I call this charm
> By their power;
> To raise crops for our use,
> To fill these meadows with beauty.
> Ka!

Next, we make three sunwise turns, and take some seed, potatoes or whatever crop is to be sown. It is brought together with the tools or implements which are to be used to put them in the earth. Consecrated water, fennel seeds and soap are collected together with the seeds or potatoes. Then, we burn some barley grains to make smoke (incense) and recite the spell:

> Erce, Erce, Erce, mother of Earth,
> May the mighty one, grant thee
> Fields growing and flourishing,
> Fruitful and full of harvests,
> With broad Barley,
> And white Wheat,
> And all the fruits of the Earth.
> May this land be kept safe from all foes,
> Guarded against all ills,
> May no devil have the cunning,
> Nor any lord have the power
> To turn back these words.
> Ka!

Now we must break the surface of the earth for the sowing or planting. The rig is set up using the two dods, and as we dig or plough, we repeat the spell:

> Hail to thee, Earth, mother of all people!
> Be fruitful, filled with food for our use!
> Ka!

Then, we bring back to the earth the harvest token (corn dolly) that was made at the completion of the previous year's reaping. When we conduct the ceremoy in a grain field, then the previous year's corn dolly should be ploughed in; if a vegetable field, the previous year's vegetable token should be buried with the first potato or seed. The sowing should then proceed. When this is finished, we utter the final spell:

> Field full of food for folk,
> Blooming, be thou blessed,
> And this land in which we live.
> Ka!

Sacred Ground in the East Anglian Tradition

As practitioners of East Anglian magic, we view a consecrated sacred place as being the visible, tangible material support of the unseen, spiritual reality that underlies it. When we conduct any magical operation, each visible physical act is always paralleled by an invisible one. At the sacred place, the physical and spiritual coincide. East Anglian tradition has a number of different names for it. We often call it the Enhazelled Field, the Mystic Plot, or sometimes the Frithyard. When we use any of these names, we imply that it is a special place, which we have set aside deliberately from the everyday world for a sacred purpose. In the Four Holes Ceremony, the piece of land undergoes the land remedy which promotes the natural qualities already there. We create enclosures of sacred power, however, to accomplish more than this. We set them up to be places in which communion can take place between we humans and divine beings. East Anglian sacred enclosures are not fixed in size, shape or dimensions: they can range from the well-known round magic circle, through the triangular *Vé* to the square Mystic Plot, which is divided into nine smaller squares, the 'Grid of Nine'. The sacred ground of the Mystic Plot is a place which we have set aside magically by our willpower and skill, cut off from the everyday world. Whatever shape it takes, we must first enclose it, cleanse it of unwanted psychic and physical energies, and then infuse it with sacred power by means of ritual.

The location that we choose for sacred ground is of

paramount importance. Every place in nature has its own personal spirit or soul, the *anima loci*, which manifests in its own, unique, way. Ideally, we should choose the site for sacred ground so that the qualities and virtues of the *anima loci* present there enhance its intended use. If the inherent qualities of the *anima loci* do not enhance the function chosen for the mystic plot, then our work will be in conflict with the place, and we must create an on-lay. Also, it is a maxim of magical working that any object that has been placed with conscious care and ceremony retains the 'charge' received at that time. Because of this, the actual time of a consecration is important, as well as the form and essence of the ceremony. To get the best results, we should conduct all ceremonial cleansing and consecration at the planetary hour that corresponds best with the work that is to be done there. When we do this on land that has been psychically or physically damaged, we undertake the *Opus Restaurationis*, the work of spiritual restoration.

Once set up, we reinforce the sacred place by performing activities that are in harmony with the qualities of the *anima loci*. These are the things that recall or symbolize the spiritual qualities present there. They include beautiful and pleasing artefacts, ceremonies and actions that elicit a harmonious response in human beings. Enhancing a natural place is a form of spiritual gardening. We do not attempt to command and control, but consciously participate in supporting and nurturing the natural world. At such places of sanctity, fully-developed human beings can become outward expressions or embodiments of the divine. As time passes, the qualities of the place will be intensified by repetition of ceremonies. Thus, we can bring forth the latent spirit of the place into manifestation on the material level. Then, a truly sacred place has come into being. The invisible is made visible. There is the revelation of Paradise, a gateway to the divine.

Blouts for Purification and Consecration

Any object or place which has been consecrated properly has been brought into alignment with a certain type of spiritual essence that has been concentrated and formed by a magician's will. This spiritual essence may or may not coincide with the natural qualities of a place, expressed by its resident *anima loci*.

This means that there are two distinct types of consecrated place, though their difference may not be apparent to the casual visitor. A place where the *anima loci* has a character in harmony with our spiritual needs does not require a rite of purification that suppresses its innate magical virtues. But where a new magical virtue is created at a place by a magical operation, it is known as an on-lay. An on-lay is different in character from the magical qualities that are present naturally at any location. Unlike a place that expresses the character of the *anima loci*, a place with an on-lay has a specific character that originates in the consciousness of the magician who has laid it down there.

Most magical operators work by creating on-lays. Wherever we make them, the principle of the on-lay is to create a magical enclosure from which any non-material forces or entities that might be present are removed or suppressed by means of purification – a banishing or exorcism of the place. Then we must refill the psychic emptiness created there with another power, which we have brought into being through an invocation or blessing. East Anglian magicians have a specific technique for creating and purifying magical and sacred enclosures. Finding the place for the Mystic Plot is our first consideration. Then we must determine where the centre-point, the navel or Nowl, lies. From this, we lay out the centre-line, or Rig, then we measure and define the boundary, which we mark, consecrate and empower. We then purify the interior with salt water, and install the new psychic quality we need in the area.

How We Create the Enhazelled Field

If any place on earth is to have any chance of being in harmony with the subtle forces of earth and heavens, then it must be oriented in accordance with them. Practitioners of the Nameless Art observe the heavens to lay out the Rig, the centre-line that runs from north to south. The ritual technique we use is identical for aligning both sacred enclosures and the Rigs along which potatoes are planted. Equipped with a string and two dods we have made from thornwood – blackthorn (*Prunus spinosa*) and hawthorn (*Crataegus monogyna*) – we go out at midnight on a starry night, to the plot we have selected beforehand. Magically, we favour a red string to link the pegs of thorn. We walk around until we find the right place, and with a 'Ka!', bring down the

right heel to 'make the mark'. This is the Nowl, the place which will be the southern end of the Rig. Then, into the marked ground we thrust the hawthorn dod with string attached. We push it in consciously with one stroke of the heel of the right boot, with the call, 'Ka!' Then, looking skywards, we find the stars of the Plough and use them as a pointer to the Nowl. We direct the string towards the Nowl, pull it taut, and then thrust the blackthorn peg into the earth with the call, 'Ka!' The line, known as the centre-line, now stretches from the southern hawthorn dod at the centre, which represents the earthly Nowl or navel, to the blackthorn dod, which symbolizes the Nowl at the top of the axis of the heavens, the Pole Star.

Once we have delimited the sacred Nowl and Rig, there are several ways that we can mark the borderline that is the outer extent of the sacred ground. To empower the boundary, traditional East Anglian magicians do not use a knife or sword, as in some systems of ceremonial magic. The Nameless Art recommends that we use magically empowered knives only for ceremonially cutting wood or other materials. Often, these are folding 'shut-knives' of the type used by gardeners. Similar knives called *Drudenmesser* were used by German folk magicians. Historically, no East Anglian working man or woman owned a sword. The law only permitted the gentry to possess weapons, and in any case, they were too expensive for people who lived in chronic poverty. The common magical tool in this area is the wooden wand, stave or croomstick. The wooden stick, magically taken from the tree, empowered and enhardened by spells, can create the necessary power to make boundaries. When we require a temporary Mystic Plot for a magical operation, then, if we want to be indoors, we will draw lines on the floor in red chalk, making the Grid of Nine. Out of doors, we will enhazel the ground, marking it with hazel sticks or posts linked by red thread. We can reinforce this magic fence by enclosing it with terminal protection, turning back the lines of the grid to make a binding-knot. We may also augment the power of the boundary further by putting talismans at the four quarters, or the eight airts.

If we feel it necessary, and intuition is the guiding power here, we may sprinkle boundary strengtheners of grain or flour along the borderline. We may tie red wool or linen thread to each stick to enharden it (to give it extra power). If we leave the borderlines

of the plot 'open', that is without terminal protection, the Grid of Nine remains linked to whatever pyschic forces are present in the locality, drawing them inwards. This is the form of grid we prefer to use when 'sitting-out'. A holy enclosure that protects a tree, stone or sacred spring is called a Frithyard. Its borderlines may be delineated by a hedge or fence, within which certain strictures must be observed. The Frithyard is an area of respect, within which no harmful thoughts or mindless activities should be present. In the Frithyard, the enclosure serves to protect and enhance the sacred power of the *anima loci* that is already present there.

When we want to lay out a Grid of Nine outdoors, we use a Snor to measure it. This is a rope, a rod in length (5.0292 m, 16 ft 6 in), divided into twelve sections by thirteen knots. Also called the Druids' Cord, the Snor is an ancient means of laying out squares, rectangles and labyrinths by sacred geometry. It is believed to have been one of the secrets of the Celtic Druids, later preserved by the Freemasons, Hammermen, Locators and other esoteric orders that keep the secrets of the Perennial Philosophy. The measure of a rod comes from northern tradition land measure, and is the basis of the acre and the mile, still used in the United Kingdom. By using the Snor to measure from the centre point to the boundary, we can lay out the borderline as a perfect square, putting a stick of hazel (*Corylus avellana*) in the ground at each corner. This is one of the mysteries of sacred geometry, once known only to those called by the epithet *Quadratarius*.

Then, to empower the borderline, we ceremonially walk the perimeter of the plot sunwise carrying a wand, stave or croomstick. On each side, as we pass, we put two more hazel dods into the ground, marking the end of the dividing-lines within the Grid of Nine. As we walk, we visualize a barrier of blue light following behind us, and eventually joining up to complete the boundary. Next, at the mid-point of each side, facing the cardinal directions, we make a libation of ale, cider or apple juice to the corresponding element. We start in the north, and progress sunwise. Each of the four directions corresponds to one of the traditional elements of alchemy. We place a token of each at its appropriate place on the borderline. To the north, which corresponds with the element earth, we place a stone; to the east, which is air, we burn herbs to make smoke; to the

south, which is fire, a candle; and to the west, which corresponds with water, we place a wooden bowl of fresh water.

Having made the boundary, empowered and strengthened it, it is time to cleanse or banish the interior. We do this by a rite of purification that uses salt water which has been consecrated beforehand and brought to the place. To make holy water, we prefer to use about a pint of seawater, taken at the incoming tide. When this is not available, healing mineral water brought from the nearest local holy well is a good substitute. It is usually enough to consecrate about a pint (568 ml) at a time. We charge the water magically by means of the directed will. Placing the forefinger of the right hand into the water, we visualize Spirament flowing like a stream of vibrant, blue-white light, coming from the body into the water. Here is the sort of spell we use during this process:

> Karinder!
> In the names of the Old Ones,
> Into this water
> I direct my might,
> That it will be pure and clean,
> In their service.
> Ka!

If it is not possible to get seawater or mineral water, then we must take well water or river water instead. Water from the mains, which has the on-lay of chemical treatment, is useless magically. The initial procedure for consecration is the same as for mineral and seawater. But afterwards, we must add crystalline sea salt to the fresh water. To empower a pint of water, we take enough salt to cover an old penny (or a contemporary 2p coin). We pour this into the water. It is preferable to use sea salt from the coast of the North Sea, especially the east coast of England. Then we stir the water nine times sunwise, using the forefinger of the right hand, reciting the following spell. Of course this spell is unnecessary when we use mineral or seawater.

> Here is salt,
> Salt is life,
> To clean this place,
> Free from strife.
> Ka!

The central, enclosed part of the Enhazelled Field is the realm of spirit. We purify this by asperging it with holy water, which we sprinkle either with the fingers, or from a sprig of hyssop (*Hyssopus officinalis*) as we walk around the area. As we sprinkle the area we sing a galster which empowers the act of cleansing. When we have used the whole pint of water, the next step is to use holy smoke. We burn purifying herbal incense at the centre of the area, and, as the smoke fills the air, we make a visualization. This is of a protective roof or shield of blue light that simultaneously excludes dangerous and unwanted powers and entities, but acknowledges and encourages ones that we want there. Once the incense has burnt, then the cleansing has been performed. Next, we make an invocation which calls the power of the on-lay into the place. If we intend the place to be for worshipping the gods, then we must acknowledge the *anima loci*, and not banish her. A place created by a magical on-lay is only second best when honouring the Old Ones, and should only be used if there is genuinely no alternative.

A most basic consecration takes place in the bidding, when we call sacred names of power which in themselves have the power to alter the magical virtues of a place. Ceremonies that specifically call upon deities should be conducted facing northwards, and those concerned with the earth in a southerly direction. Fertility- and growth-promotion ceremonies are made facing east, and conversely, those to do with decline, diminution and death, to the western quarter. Death is especially associated with the north-western airt. It is a truism that nothing on earth lasts for ever, and that is the case with on-laid magical power. Like anything, if it is not used, and thereby regenerated periodically, a magically empowered place will become less and less powerful, reverting eventually to whatever condition it was in before the magical act was performed. In order to prevent this gradual disempowerment, we must perform ceremonies there periodically to perpetuate the magical virtues we need.

Magically, the whole of East Anglia is guarded against invasion by three holy crowns. But it is said that only one now remains. One was lost when the city of Dunwich was washed away by the sea. The second is thought to have been destroyed in the eighteenth century, when a silver crown was discovered by treasure-hunters at the old royal seat of Rendlesham.

Unfortunately, it was melted down. The third crown still exists somewhere, however, for it saved East Anglia from invasion by both Napoleon and Hitler. The magical enhardening of the province by the three crowns of East Anglia are acknowledged in the flags that represent the region, which, sadly, are rarely flown. There is a traditional flag that consists of three golden crowns against a red or blue background. Also, an ornate Victorian provincial flag for East Anglia was designed by George H. Langham in 1900. With the Union Flag in the canton, it bears the shields of the cities of the province. At the centre is an oval blue shield, bearing three gold crowns, and surrounded by the text, 'East Anglia'. Although Langham hoped it would serve as 'an emblem of unity amongst the people of Norfolk, Suffolk, Essex and Cambridgeshire ... a symbol of local nationality ...', it was not adoped, and remains in limbo.

13 The East Anglian Magical House

The traditional buildings of East Anglia are full of magical things. Indeed, it is impossible to distinguish 'functional' from 'magical' elements, for the very idea that there is a difference between 'functional' and 'magical' is alien to the Nameless Art. It is an artificial distinction that comes from the modern dislocation between the spiritual and the physical. When a house was built in former times, every possible factor was taken into account. These included the seemingly mundane aspects of existence, often ignored today, such as the type and quality of the soil and the direction of the slope upon which it was to stand. Also to be taken into account were surface and underground water, and which of the eight winds was the prevailing one. The obvious examples of this care required are when building on the Fenland peat, which carries the risk, if not the certainty, of damp and subsidence; and the construction of windmills, which must be located at just the right place to catch the wind properly.

In addition, there were the physical and magical attributes of the materials to be used, and the non-material aspects including the spirits of the land, and the electional astrology of the foundation. If it is to be harmonious, the entire design of the building, from its orientation to its ornamentation, must be related to the spiritual needs of its users. Traditional building in East Anglia uses a number of techniques, which either deflect harmful elements or draw in beneficial ones. The overall effect of heeding these requirements can be experienced by walking through an old East Anglian village or town which has not suffered redevelopment. Traditional cottage building continued in East Anglia much longer than in certain other parts of England. Unlike London and the cities of the Midlands and the North, East Anglia was not industrialized, and so it was spared

the industrial back-to-back housing that dispensed with the spiritual dimension in the pursuit of profit. Similarly, today, however well they are regarded as architecture, contemporary buildings are usually designed elsewhere on drawing boards in offices, and constructed of materials made in factories in other places. They have little or no spiritual connection to the land upon which they stand.

Construction Magic

Commencement of construction is viewed as the birth of the building, the planning having been its gestation. The heavenly aspects of the moment of laying the first stone of the foundation are important, for, at this moment, the horoscope of the future building is determined. This means that whichever planetary aspects prevail at the moment of foundation will affect the future existence and use of the building. The means for gaining a fortunate horoscope is through electional astrology, where the best aspects are picked in advance, and the foundation stone laid at that moment. If this is done, then the building is erected in accordance with the natural cycles of existence, and those who live and work there do so in harmony, rather than in conflict, with Nature. Today, the ceremony of foundation-stone laying is the last public survival of this practice, though it is clear that the founders of most public buildings fail to observe astrological principles. But it is still traditional for officials to deposit objects beneath the foundation-stone. Not recognizing their magical function, these deposits are often called 'time capsules', and contain coins, newspapers, etc., ostensibly for future generations to find.

But the true function of a foundation offering is to empower magically the birth of the building when it is founded. In former times, animals were sometimes used, embedding some of the Spirament (life energy) of the animal in the structure. But it was not usual to actually sacrifice a live animal: East Anglian house magicians, perhaps initiated Bonesmen, favoured skulls. Historically, the skulls of wolves, dogs, oxen and horses have been employed as foundation offerings. The choice of the animal itself was not random, being related symbolically to the geomythic quality of the place. For example, the Norman builders of Bury St Edmund's abbey placed the skulls of wolves,

the totemic animal of St Edmund, beneath the gatehouse tower. Eight hundred years later, in 1897 at Black Horse Drove, near Littleport in Cambridgeshire, builders embedded a horse skull in the foundation of a nineteenth-century chapel, and poured libations of beer over it. A witness called it 'an old heathen custom to drive evil and witchcraft away'. The chapel still exists, but it is no longer used for worship.

The Folk Museum in Cambridge possesses several horse relics recovered from old buildings. Half a horse jawbone, dating from the seventeenth century, found between two courses of brickwork in a house at Histon, shares a showcase with a horse legbone found in 1955 in the brickwork of another Histon house. Another legbone was found in the White Horse Inn in Cambridge, the building that now houses the Folk Museum. In a seventeenth-century house at Bungay in Suffolk, no fewer than forty horse skulls were discovered, laid neatly in ranks under the floor, with the incisors resting neatly on a square of oak or stone. The Cambridge Folk Museum also possesses a cat skull, found in the brickwork of a chimney of a house at Linton.

During construction, magical protection should be built into the house. Each new part is begun with a ceremony, and we draw protective sigils such as binding-knots and life-trees with tiver on woodwork before it is covered with new work. We also insert protective herbs, materials and talismans into spaces, or seal them beneath wall-plaster at important places in the building. Occasionally, in the past, animals, usually cats, were walled up in chimney-breasts, as companions of Old Clim, the chimney spirit. Animal bones, too, served the same function. Sometimes, mummified cats are found during renovation or demolition of old houses. It is often said that they were buried alive, but there is no evidence for this, as no practitioner of the Nameless Art would ever harm a cat, which is traditionally a spirit animal. Probably, these animals were buried in the building after they died. It is likely that they were the house animals or bids that belonged to the owner of the new house. Once dead, they are ever-present, and it is unlucky to remove a mummified cat from its resting-place.

The best known mummified cat story concerns the 'Sudbury Cat'. This was discovered in 1971 in an old watermill at Sudbury in Suffolk, which was being rebuilt as an hotel. The cat

was found immured in the roof, and the builder was given permission to remove it. But within three months of the cat being taken away, there was a financial crisis, and all work stopped. Menwhile, the cat had been taken to a studio, which then suffered a mysterious fire, though the cat was not burnt. Then it was taken to a farmhouse at Wickham St Paul, which also suffered a fire. The cat was then taken back to Sudbury. During this time, a beam in the mill roof, from whence the cat had come, broke, causing massive damage. When the hotel proprietors were told about the cat, they decided to reinter the cat in its original resting-place. It was put back with a ceremony, and interred with a note apologizing for moving it in the first place. After the reburial, all was well.

But despite this famous story, which has all the elements of a classic folk-tale, people still refuse to heed tradition. In 1985, a mummified cat was recovered from the roof of a house in Coggeshall in Essex. The usual 'plague of accidents' followed until a local person knowledgeable in folk tradition advised that it should be put back. According to East Anglian lore, cats buried in the roof were put there to ward off fire, as were those in the chimney-breast. Those found under the floor, or in walls, especially those accompanied by a mummified rat or mouse, were amulets against vermin. However, when a mummified whippet was discovered in 1984 beneath a fireplace in an 1898 building at Leigh-on-Sea in Essex, it was reburied in a wooden box with a red velvet lining, accompanied by some fresh offerings and a note that read: 'We apologize for disturbing you and hope you will continue to act as guardian ... A sprig of yew and the herb thyme, two plants associated with mortality and protection have been put with your carcass to help you in the role.'

Protective humanoid figures are sometimes used to empower the house spirit. Often we make a clay poppet which represents the guardian sprite of the house. It is put on top of a roof beam, or under the tiles. So long as it remains there, the house is safe from harm. A protective clay mannekin was once visible in the Anatomy School at Cambridge University, which was built in 1938. The senior laboratory men who worked there considered themselves to be its guardians, and swore that it protected the building against damage during the whole of World War II. Unfortunately, it disappeared around 1962. In 1981, during rebuilding of St Andrew's Hospital in Billericay, Essex, a group

of magical objects was discovered. There were two humanoid effigies, four inches (10 cm) long, part of a ruminant's jawbone and thighbone, a piece of coal and a notched wooden tine. They seem to date from the construction of the hospital – then a workhouse – around 1850. In former times, shoes were embedded in walls, in the chimney-breast, or in the ceiling. They served a magical function, so significant that in Suffolk, the custom continues of putting shoes in the roof.

A parallel to the skull is the bottle, in which magical materials may be deposited as house protection. The technique of making the 'witch bottle' was recorded by Joseph Glanvil in 1681 in his *Sadducismus Triumphatus – or Full and Plain Evidence Concerning Witches and Apparitions*. When William Brearly, a priest and fellow of Christ's College, Cambridge, took lodgings in a Suffolk village, he lodged at a house where the wife suffered from ill health and was haunted by an apparition, 'a thing in the shape of a bird'. The phenomenon was reported to an old cunning man, 'who travelled up and down the country'. He recommended that the woman's husband should ' ... take a bottle, and put his wife's urine into it, together with pins and needles and nails, and cork them up, and set the bottle to the fire, but be sure the cork be fast in it, and not fly out'. After a couple of tries, the remedy worked, and the unbewitching was successful, supposedly leading to the death of the wizard who had bewitched the woman.

Glanvil's story tells of the classical magical remedy but the connection between bottle-magic and geomantic protection is complex. Often, cunning men would use bottle-magic to remove other magicians' spells from people they believed to be 'overlooked'. But bottles were also used as a general prophylactic against bad luck and evil intentions. In East Anglia, there are a number of distinct types of bottle-magic. One uses the large jugs known as Greybeards or Bellarmines. These are squat, round-bellied, stoneware containers, salt-glazed with a rich brown or grey finish, first manufactured in the Rhineland around 1500. Embossed on to them are bearded faces, coats of arms and other symbols. The name Bellarmine is after a notorious Catholic inquisitor, who put the fear of god into his Protestant enemies, and who was vilified equally as a demon by his victims. The salt in their glaze obviously had a magical function in warding off harm, as did the terrifying face. Many

which have been discovered contained the remains of pins and
substances which show that the techniques of the cunning man
mentioned by Glanvil were actually used. Usually, they were
buried beneath the threshold or the hearth. Several are on
display in East Anglian museums, including those at
Cambridge, Wisbech and Bury St Edmunds. A glass
'pop-bottle' was visible once in a railway bridge on the old
Midland and Great Northern Railway near Sutton Bridge; the
railway builders, observing East Anglian tradition, had laid it in
the brickwork as a charm against evil.

Another type of magic bottle is the Cambridgeshire Witch
Bottle. These are smaller, measuring around 3 inches (8 cm)
long as compared with the Bellarmines' 5–9 inches (13–23 cm).
Made of greenish or bluish glass, they contain hair or thread,
often red, which came from sprite traps. In Cambridgeshire, the
Witch Bottle is a door-protection, being inserted in a slot over
the lintel, and then plastered in. Thread-filled bottles can also
be hung up visibly near the door or windows. They should be
hung by red thread at a place where harmful influences need to
be deflected. Like the glass charm wands mentioned below, the
tangled threads serve to dazzle and entrap malevolent entities.
Also used to protect the threshold are iron scissors, knives, or a
magnet, buried beneath the doorstep. These are permanent
protectors, but certain plants are also hung upon the door or
doorframe on festive days. Yarrow strewn across a doorstep is
said to prevent the entry of malevolent people, and honeysuckle
hung around the doorframe on May Day performs the same
warding function.

Using certain techniques, we can magically empower the
physical fabric of the building. Traditionally made bricks and
tiles have esoteric sigils engraved upon them before they are
fired, so that their magic endures so long as the building stands.
Also, East Anglian bricklayers employ a number of distinctive
magically protective patterns. They are in the form of runes, of
which the most important are those known today by their
traditional runic names of Ing, Dag, Gyfu, Gar and Odal. But,
although their meaning was recognized and understood by
practitioners of the Nameless Art, only the name Ing has
survived into modern times. Dag is known as 'the day sign',
Gyfu is called 'X', after the Roman letter, Gar is 'the knot' and
Odal, 'the own'. But whatever they are called, the protective

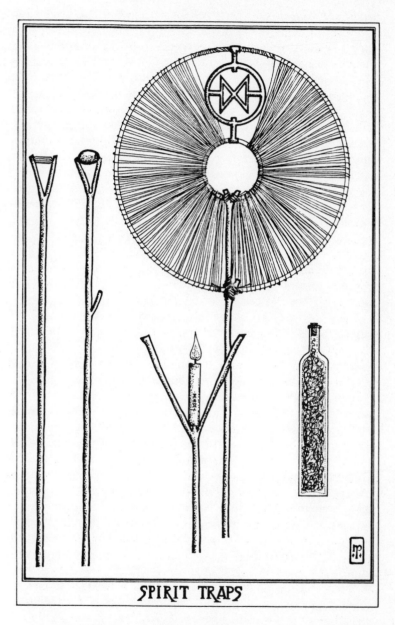

SPIRIT TRAPS

Spirit (sprite) trap, egg stave, crystal stave and Cambridgeshire
Witch Bottle.

runes are laid during construction in contrasting brickwork. Some remarkable examples dating from the nineteenth century can be seen at St Neots and St Ives (both in Cambridgeshire, formerly Huntingdonshire). They can also be carved, or painted on the outside of a building in appropriate positions. Ing, Gyfu and Odal are appropriate as wall protection, whilst Dag and Odal are appropriate for door and window-frames. The 'leaded lights' of the traditional cottage window are an Ing protection. With the re-emergence of runic knowledge and techniques since 1960, many runic protections are carried out today according to the rules of northern tradition rune magic.

We use ceremonies of erection to empower every stage of construction. When the last tile is placed, or the thatch is completed, this is the occasion for the ceremony of 'topping-out'. Here, the builders set up a green branch on the roof and enjoy a drink of ale, some of which is poured out as a libation to the new, completed, building. Once a building is finished, various further protection is needed. Windows and doors are places where harmful influences such as evil sprites may gain access. To function magically, the house must be protected both externally and internally, and also empowered internally.

In traditional houses in East Anglia, it is customary never to enter or leave the house by the front door, except for weddings or funerals. Often, one can see a cottage with a front door which has no path leading to it, the whole front garden being cultivated. External geomantic protection involves a number of strategies. Like a hedge or fence, the trees and plants growing around the house are the first line of defence. Whitethorn (*Crataegus monogyna*) and blackthorn (*Prunus spinosa*) are the primary protective plants. On the physical level, their thorns make them an impenetrable barrier, whilst on the psychic level, they are powerful in warding and binding. A related tree tradition is said to have been brought to East Anglia by Scottish prisoners of war used as slaves in the Fens in the seventeenth century. They planted hedges of hulver (holly, *ilex aquifolium*), the 'protected tree', around their huts as a magical screen to keep out demons and fairies. A holly hedge is still considered magically protective, as Thomas Chatterton noted in 1778: 'Against foul friends ... the Holly Bush and Churchyard Yew are certain antidotes.'

A rowan tree standing by the path leading to the front door and an elder (*Sambucus nigra*) tree growing by the back one are useful. Both are sacred trees in the Elder Faith which it is unwise to cut down. The rowan or rowntree, the tree of the runes, is a sovereign power against psychic attack. Short red threads tied to the tree augment its power. The elder is the residence of the Elder Mother, known also as the Old Lady or the Old Girl. It is her power that protects the rear of the house against all harm, and its twigs are used in the remedy for warts, and in horsemen's magic. Like the rowan (*Sorbus Aucuparia*), Thor's tree, the elder is never struck by lightning. As with the rowan, one should never burn the wood of the elder. On the roof, a houseleek (*Sempervivum tectorum*) is a protection against lightning and fire damage to the house. Like the rowan and elder, it must never be cut down and destroyed, or its former protective power will be reversed, and catastrophe will ensue.

A horseshoe nailed on or over the door combines the magical virtues of iron, the metal of the Great God Termagant, with the crescent symbol of the moon, and the prophylactic power of nails. As a protection, horseshoes should be nailed up with the points uppermost, so that the luck doesn't run out. In this form, the nailed-up horseshoe is known as 'the Horns of Honour'. By themselves, nails partake of the sacred power of the thunder-god Thor in his maintenance of order in the cosmos. When they are hammered ceremonially into the doorposts, roof-joists or supporting posts of a timber-framed building, nails bring good luck and protection from intruders and fire. Nail-hammering is effective in negating on-lays.

Another important aspect of iron-magic is the wall-anchor. Ostensibly a reinforcement of brick walls, it is the end part of the wall-anchor that actually serves a magical function of protection. It is customary in East Anglia to make them S-shaped, though more often than not, the 'S' is turned in the opposite direction from the letter. Symbolically, the S-shaped wall-anchor represents the pot-hake (pot-hook), the iron implement by which the cauldron is hung over the fire. The pot-hake is *par excellence* the residence of the house sprite, containing the essence of the home and acting as the spiritual guardian of the family. When people moved house, it was customary to take the pot-hake with them to their new residence, for to leave it behind was unthinkable. Magically,

pot-hakes were used in stormy weather to avert lightning, and the S-shaped wall-anchor does so too. Some are shaped to resemble a serpent, the traditional protector of the home in the Germanic and Baltic lands, and sometimes we can see two S-shapes together, making a fylfot pattern, known locally as The Hammer of Thor.

Traditional building takes care of geomantic problems by building the house properly, and with magical precautions where necessary. But where a building has been made without geomantic knowledge, or where an old building has been altered thoughtlessly, then sometimes remedial work is required. Buildings oriented wrongly cannot be dealt with without demolition. Inland, houses oriented so that the roof ridge runs from north-west to south-east are always plagued by the possibility of the loss of roof tiles each winter to strong winds. Homes constructed by traditional house-builders were oriented differently, and had brick chimneys at each end of the roof ridge, which prevented the strong north-westerlies from blowing off the roofs. Those close to the sea, too, were made with expert knowledge of the most dangerous winds, before professional architects began to design them on drawing boards in distant towns.

Inside the house, we can deal with geomantic problems more readily. Such remedial work sometimes involves alteration or reconstruction of a room, windows, doors or a whole house. A classic case of traditional English geomancy occurred in the nineteenth century at Blickling Hall in Norfolk. During alterations, the owners, Lord and Lady Lothian, ordered a partition wall to be demolished. After they pulled it down, there was considerable psychic disturbance, with a phantom black dog which appeared to run round and round in circles at certain times inside the house. The owners summoned a 'Wise Man' from London, who gave them the remedy for the apparition. Following his instructions, they erected straight partitions which 'opposed the straight lines of the partitions to the lines of the circles, and so quieted the dog'. The geomant warned that, should the partitions ever be removed, the dog would be released once more.

Mirrors are valuable weapons in the armoury of magical house protection. They reflect not only light, but also the more subtle energies that assail a house from many quarters. Of

course, it is better if a house is built in a good place where remedies are not necessary. But if remedial work must be done, then geomantic reflectors are often the easiest and most effective solutions to problems. They can be put in a window, or over the door or other parts of the house at risk. Witch balls, large glass spheres of silver, blue, green or occasionally yellow, are hung up in house windows. Silvered inside with quicksilver, which has its own magical properties against harm, they are more effective than flat mirrors because they reflect from all directions, whereas a flat mirror must be oriented precisely at right angles to the harmful influence. One once hung in the tower of Swaffham Bulbeck church, to protect it against evil spirits. Witch balls are no longer made in England, and so they are much sought after as 'collectables' or 'antiques'. Similar modern balls, for outside use, can be purchased in Germany, where they are set up in the garden in summer time 'to reflect the roses'. These witch balls are larger versions of the glass ornaments, which perform the same function on Christmas trees. Internally, mirrors are less useful, and many East Anglians believe that they attract lightning, and cover them during thunderstorms lest the house be struck.

In the Nameless Art, we recognize three classes of magic mirror. Silver mirrors are lunar in quality, reflecting away harmful entities that approach us and our property. Bottles or vases of water make good lunar mirrors. Today we can see water-filled transparent plastic or glass bottles lying on lawns outside houses 'to keep the cats away'. Because superstition is the debased remains of traditional knowledge, we can see in this recent spate of 'cat bottles' the unskilled vestiges of magical practice. Solar mirrors include mirrors made from parts of metallic spheres, and the witch balls which are hung in windows to ward off evil influences. Polished black discs are Saturnian mirrors which trap visionary images from the otherworld. Black scrying mirrors, a version of the more familiar crystal balls, are Saturnian. Glass marbles, too, have a similar effect. The function of glass spheres can be seen from the talisman carried by a Cambridgeshire man who died in 1906. It was a glass marble, wrapped in a piece of paper bearing the spell: 'I have the power to overcome evil and to prevent the corruption of the flesh.'

Sacred images, both aniconic and iconic, are relatively

uncommon nowadays. Yet they are also powerful talismans for protecting buildings. When made mindfully, they invoke directly the power that they represent. Common in former times were carvings made on exposed wooden parts, pargeted plasterwork, or figures of giants, saints, heroes and deities in paint. Whatever material is chosen, such figures summon the power of the being portrayed to defend the house and its inhabitants against all harm. There is a ceremony for installing external house protection such as images or painted sigils. When you are carving or painting the protective object, you should will into it the function that it will serve. When it is ready, you should install it in the right place at an appropriate planetary hour. The ceremony effectively empowers the magical artefact at that moment. The libation of champagne broken on the vessel at ship-launchings is a perfect example of this.

Certain woods used in the house serve a magical function, bringing their virtues into everyday life. Whitethorn twigs taken from the hedge outside are also a powerful protector when they are placed in the rafters of a house. The oak is the sacred tree of Thor, and the acorn, its fruit, invokes his protective powers. Images of acorns turned from oak wood on the lathe serve a magical function as terminals on the end of window-blind cords and as traditional stair banister finials. Rowan crosses, which are not crosses at all, but three-pronged sprigs, can be hung over the bedhead as protection against demonic interference. We make them on May Eve, or Rowan-tree day, 3 May. Small, dried sprigs of seaweed hung above the hearth, or placed in a vase on the mantelshelf in seaside houses, are called Lady's Trees. They are a powerful protection for the house and its inhabitants against fire and the activities of malevolent sprites. A bunch of all-heal (mistletoe, *Viscum album*) hung from the ceiling is charm against lightning. Mistletoe should be taken from the tree on which it grows during a waning moon in Sagittarius (23 November to 21 December). It is best to take it four, three or one day before the new moon. It must not be cut, but should be shot down from the tree, or knocked down with stones, and caught as it falls.

We keep the fossil echinoids called Frairy Loaves (fairy loaves) in the house to bring good fortune. If one is kept on a shelf, it is said that the members of the household will never lack bread. Frairy Loaves closely resemble a kind of traditional bread

roll made today in Wiesbaden and other places in Germany. It is likely that the Germanic ancestors of present-day East Anglians baked bread in this form. Holeystones, stones with natural holes through them, abound among the shingle on east coast beaches. Because of this ready availability, they are common in inland East Anglia, too. Painted white, we use them to guard the entrances to driveways. We also hang them by a string inside the door, as a protection against harm when the door is open. Hung on the same nail as the door key, the combination of iron nail, linen thread, holeystone and iron key is considered a bringer of good luck. Also, suspended by a linen string or a leather thong in the bedroom, holeystones serve to ward off nightmares. Hung from the rafters of the stable, they prevent the horses from suffering various ills and becoming 'hag-ridden'. Strings of nine or twenty-seven holed stones, hung up, are particularly powerful charms. Three horseshoes nailed to the bedhead or bedfoot are said by some to be a sure remedy against the ill effects of drinking alcohol.

Looking like a glass walking-stick, containing spirals of coloured glass threads, the charm wand was once more than just a collectable curio to be shown off to admiring visitors. When they were made, their function was more serious than the merely ornamental. The master glassmakers who created them by hand produced magically empowered artefacts with the express function of warding off airborne illness. The proper way to use a charm wand is to hang it up indoors as a protection against the entry of disease into the house. To empower the wand, each morning it should be wiped vigorously with a dry cloth, charging it up to trap contagious particles in the air. Charm wands are no longer made, and they are extremely expensive to buy. Naturally, breaking one is an extremely bad omen, and ill is sure to follow. If a malevolent or unwanted visitor should enter the house, a cushion stuffed with yarrow (*Achillea millefolium*) will suppress any magical powers that anyone sitting upon it might try to exercise. When someone leaves the house after a visit, it is unlucky if the visitor puts the chair on which he or she was sitting with its back against a wall. If this happens, the visitor will never return.

The common weed called simpson (groundsel, *Senecio vulgaris*) is an important magical plant in the Nameless Art. Because of this, it is usual for any large patch of the weed to be

thought of as an assembly-place of witches. We wear the plant as a charm against the Evil Eye and malevolent magic, but it is as a purificatory incense that it is most effective. In former times, before modern living arrangements made it difficult, it was customary to collect and dry large quantities of groundsel. Then, on the sixth full moon of the year, or Midsummer's Day, the dried herb was heaped in the middle of the ground floor of the cottage and ignited. The burning herb produces a dense white smoke, in which the inhabitants would sit until it became unbearable. Then they would leave the house, and return only when the groundsel had burnt out and the smoke had cleared away. This magical fumigation was effective for a whole year. Also to purify it, grains of wheat or barley were burnt in the house at the place where someone had died. This placated the spirit of the departed. In general, grain strewn in places of psychic disturbance 'feeds the hungry ghosts' and quietens the place. We strew grain when entering a new house, or before a performance. Sometimes, grain is deposited beneath the treads of stairs to prevent accidents, and, before 1920, when possessing it became a criminal offence, hemp (*Cannabis sativa*) seed was used in charms of protection and binding.

14 Remedies, Recipes and Spells

Herbal remedies and charms are an important part of the East
Anglian tradition, and many are genuinely useful. However, we
should not fantasize, as some do, that each and every remedy
and charm is of archaic origin in some prehistoric golden age of
wisdom; neither that every one is a sure panacea, superior in
every way to conventional medicine. Wortcunning was an
important art among the Anglians, and, even before the Norman
conquest, many texts were written containing spells and
herb-craft. To them were added techniques and knowledge
from many places and traditions. Once printing made books
cheap, a lot of knowledge of herbal remedies was collected from
oral sources and published. The information was then
transmitted orally by literate to illiterate people, who handed
them on to others orally. Also, once herbals started to circulate
widely, there was a lot of feedback between oral and published
sources. As new diseases arose, and others disappeared, new
techniques were developed and old ones abandoned. As with
everything in the world, there has been change through time,
and nothing is fixed, for that which is living is also continually
changing and adapting to new conditions. So it is with East
Anglian remedies, recipes and spells.

Certain printed books appear to have had considerable
influence upon East Anglian wortcunning. Once printing made
books generally available, the standard herbals, such as Gerard's
and Culpeper's, which contained information from the core
tradition of European herbalism, reinforced folk practices. An
important book of remedies was published in the 1650s by
Elizabeth Gray, Countess of Kent. Titled *A Choice Manual of
Rare and Select Secrets in Physick and Chirurgerie, Collected and
Practised by the Countess of Kent*, it contained techniques and

recipes that appear in the East Anglian tradition. Another important text was published in 1747 by the Methodist preacher John Wesley. In *Primitive Physic, or an Easy and Natural Method of Curing Most Diseases* Wesley published remedies that he had collected from wise women and cunning men he met on his evangelical journeys through Great Britain. His recommendations for self-prescription made the work a best seller throughout the eighteenth and early nineteenth centuries, and in many places, Wesley's published remedies overtook the local oral tradition. Thus, folk medicine in the British Isles, as it has come down to the present day, is drawn from many sources.

In former times, too, there were alternative forms of medicine, often classed as witchcraft by supporters and opponents alike. Most techniques are forgotten now, but it is likely that many were viable alternatives to the methods which became accepted. Little is recorded of these techniques, but there are some tantalizing glimpses. For example, a letter to the *East Anglian Magazine* in 1904, from a certain C.P., recalls the use of a form of English acupuncture: 'Belief in witchcraft still exists in Suffolk ... In Stowmarket, we have a woman who is said to have inherited the gift from her mother, who cuts for the spleen ... the woman cuts the back of the ear slightly with a razor ...' Other remedies are unlikely to return. The traditional cure for baldness, for example, involves applying a poultice made of chicken droppings to the hairless pate.

Because we are dealing here with areas of lost knowledge, the dangerous or cruel procedures described here should not be copied by the reader. Many herbs are difficult to identify, having numerous different local varieties and other plants that closely resemble them. These herbal procedures are described here for the record and for the interest of the reader, but under no circumstances should hey be followed blindly. Using herbs without proper supervision can be dangerous, and is not recommended. This is because herbs work. Not all traditional remedies are the stuff of quack doctors. Many have proved themselves to be very effective, even if scientific medicine has produced more convenient and sometimes better alternatives. Many herbs and roots contain active substances that have a real effect on the human body. So, like all medicines, they should be used under the supervision of someone who has a proper knowledge of them. Readers who wish to use herbs responsibly

would do best to undertake a course of study with a reputable herbalist.

Prevention and Cure

The traditional landscape, much of which has been destroyed in eastern England, contains places of power at which healing or transformation can take place. Holy wells are resorted to as places of healing. The guardian spirit of the well is invoked, the water is drunk, and an offering, such as a coin or bent pin, left behind. Among others, the holy wells at Longstanton near Cambridge, Holywell near St Ives, Lady's Well at Blythburgh, and the wells of St Wulstan at Bawburgh, St Withburga at East Dereham, St Wendreda's Well at Exning, St Chad's at Ilford, and the holy wells at Walsingham are still reputed to effect cures.

Sacred trees, too, can bring spiritual and physical changes. In former times, the holy thorns that blossomed in early January, like the famous Glastonbury Thorn, were resorted to at that time. A century ago, the holy thorn at Woodham Ferrers in Essex was famed throughout the east of England, though others existed in the county at Billericay, Coggeshall and Stock. Slivers, sprigs and branches from these trees were held in great regard as bringers of healing. A hulver (holly) tree in the middle of a field is a 'protected tree' that can also be resorted to for healing.

Talismans and amulets play an important part in folk medicine. Until the mechanization of agriculture, labourers using the scythe would carry a bloodstone, which they used for the treatment of cuts. It was also carried as an amulet against nosebleeds. Natural bloodstones are said to fall from the sky during nights when the Perry Dancers (Northern Lights) can be seen. They are held to be the petrified congealed blood of the supernatural warriors whose combat appears as lights in the sky. The more usual bloodstone is a holed bead of glass or crystal worn as an amulet around the neck on a red silk thread, with knots tied in it at intervals of three inches (76 mm). When one is cut, the bloodstone should be rubbed against it to stop the bleeding. The bloodstone is an ancient Germanic tradition which goes back at least 1,700 years. Bloodstones can be seen attached to the scabbards of Anglo-Saxon, Alamannic and other Germanic

swords preserved in museums, and a similar tradition may account for the magic scabbard of King Arthur, who could not die of wounds so long as he wore it. Glass bloodstones were manufactured in King's Lynn until the later part of the nineteenth century, latterly by a French glass-master. When someone obtained a bloodstone in Cambridgeshire, it was customary to consecrate it with blood. It was deemed necessary for a woman's blood to fall on to a man's bloodstone, and a man's on to a woman's.

Another remedy for a cut finger involves pepper sprinkled on the bandage. For a deep cut, it was customary to apply a slice of horseradish (*Amoracia rusticana*) to it to arrest the bleeding, put pepper on the wound, and then draw the edges of the cut back together to effect healing. The mythical stones called Raven Stones were ascribed powers of regeneration of the wounded and resurrection of the dead. According to tradition, to obtain a Raven Stone, the magician must climb a tree in which ravens are nesting, and take out a nestling, kill it and put it back in the nest. Then the tree will become invisible. The mother raven will return, and, finding the chick dead, will go away to find a certain type of stone, with which it will return to the nest. It will place it on the neck of the dead nestling, which will revive. Then the magician must climb the invisible tree and take the stone.

East Anglian charms for a burn recall the northern tradition cosmological union in which ice from the north comes together with fire from the south to create or restore wholeness. As in all oral traditions, there are a number of recorded variants of this spell, of which the following is the most comprehensive:

> An angel came from the north,
> And he brought cold and frost.
> An angel came from the south,
> And he brought heat and fire.
> The angel came from the north,
> And he put out the fire.
> Come out fire,
> Go in frost.
> Ka!

Another interesting charm is the remedy for viper bite, which uses the power of hazel wood and the magic of the number nine (by the power of three times three). To perform this spell, make

a cross from hazel (*Corylus avellana*) twigs, and lay it on the
snakebite. Then breathe the following spell on to the wound:

> Underneath this Hazelen mote
> Is a maggoty worm with a speckled throat.
> Nine double is he,
> Now from nine double to eight double
> And from eight double to seven double
> And from seven double to six double
> And from six double to five double
> And from five double to four double
> And from four double to three double
> And from three double to two double
> And from two double to one double
> And from one double to no double
> No double hath he.

Beans are sometimes carried as lucky charms. They are the
traditional food served at the feast after a funeral, so the real
meaning of a 'beanfeast' is a wake rather than something good.
'God save your soul, beans and all' was a spell recited as the
coffin was lowered into the 'mole country'. The reason for
eating beans after a burial may be linked with the East Anglian
belief that the flowers of broad bean plants contain a certain
element of departed human beings. As a plant of the spirit
world, the scent of broad bean flowers is said to induce
terrifying visions, demonic hallucinations, nightmares and
insanity. If anyone is foolhardy enough to try it, to sleep
overnight in a beanfield will induce horrific dreams, and
possibly permanent psychological damage. But because they are
receptacles of human souls, and perform a psychic function,
beans are magically protective, and perform a useful function as
sprite-traps in growing gardens, where they banish evil spirits.
As well as banishing evil, they also possess curative properties.
The following bean-spell or tongue-twister is said to ward off
evil sprites, but only if called very rapidly, three times in one
breath: 'Three blue beans in a blue bladder, Rattle, Bladder,
Rattle.' A cure for warts from the Nameless Art involves taking a
bean pod and cutting it open. The warts are rubbed with the
white inner lining of the pod, which is then buried in a secret
place. As the pod rots, so the warts will also wither away. Other

herbal treatments for warts include the juice of radishes and the flowers of the pot marigold (*Calendula officinalis*).

Wart-charmng is an art whose value has never been doubted. In the Cambridgeshire Fens in the nineteenth century, Old Nanny Howlett, 'The Witch of Wicken' was the acknowledged mistress of the art. Different practitioners recommended a number of alternative methods. One uses a piece of meat which is touched against each wart in turn. This must be done at a crossroads. Then the meat is impaled upon a blackthorn. As the meat rots, so will the warts dwindle and disappear. Another technique is to use the human *spirament* to blow the warts away magically. The wart-charmer blows across the warty hand, which then must be pointed towards the new crescent moon. By the time of the next dark of the moon, the warts should have disappeared. Yet another technique transfers the warts to a magic stave. The sufferer first tells the wart-charmer how many warts they have, and the charmer will then buy them for a penny. Then, the warts are transferred to a twig, into which a number of notches ('scotches') corresponding with the number of warts have been cut ceremonially. A remedy for ague fits also uses scotches cut into a stick. Notch a stick with the number of fits, tie the stick to a stone, throw them into a pond, and walk away without looking back. This method of keeping magical score of warts or fits of ague, thereby 'scotching' them, eliminating them one by one, is related to the magical control of the land through the Wardstaff.

At one time, viperskins were considered to be an effective remedy for headache. One was worn around the forehead as a headband, or, more permanently, on the hat as a hatband. Snake-sellers were formerly a sight in East Anglian markets. In the middle of the nineteenth century, one of Cambridge's notable characters was an old man, who sat on the steps of King's College Chapel, selling live snakes from a basket to passers-by. The oil from vipers was also sold at fairs by the legendary travelling snake-oil salesmen. To collect the oil, a dead viper was hung in front of a fire, and the oil which oozed and dripped from the carcass was collected in a cup, then bottled. A remedy for cramp uses a holeystone, or a special magical cramp ring, which were formerly sold for the purpose. Another way of avoiding cramp is to sleep with corks beneath one's pillow. Bonesmen have their own means for avoiding

cramp, carrying as they do the 'cramp bone'.

Secrets of the Wild Herb Men

Traditionally, East Anglian cunning men and wise women used certain herbs as 'gear-stuff', for medicinal and magical purposes. Readers should note that it is dangerous to use any herbs without full knowledge of what you are doing. Some herbs are notoriously difficult to identify, even for experts, and extremely dangerous plants may superficially resemble harmless ones. This description is for information only, and is not a recommendation that you should experiment with potentially harmful things.

From the time of Queen Elizabeth I, and perhaps earlier, in the winter half of the year (November to April) the Wild Herb Men would tramp the highways and byways. Under the liberties granted by Elizabeth's *Wild Herb Act*, they asserted their right to gather herbs and roots on wild, uncultivated land, in hedgerows, roadsides and lanes. Carters would carry these medicinally valuable roots and herbs at a cheaper rate than 'normal goods', and, when the railways were built, railway companies, similarly recognizing their social value, carried herbs and roots at a special cheap price they called 'The Green Herb Rate'. Cecil Grimes was the last master of the Wild Herb Men. His band of twenty men operated out of Wisbech, and tramped the lanes and roadsides of Norfolk, Suffolk, Essex and Cambridgeshire, occasionally making forays into Northamptonshire and Lincolnshire. In later days, their main objective was to dig the roots of comfrey, dandelion, burdock, horseradish and mandrake (respectively, *Syphytum officinale, Taraxacum officinale, Arctium lappa, Armoracia rusticana*, and *Mandragora officinarum*). The last year that the Wild Herb Men dug for roots was 1962.

In former times in the Cambridgeshire Fens, opium eating and smoking was a way of life. Addiction was widespread throughout the damp Fenland areas, where the drug was believed to combat the diseases of the wetlands – collectively known as The Ague. Most gardens had a patch of the white or blue opium poppy (*Papaver somniferum*), and fields of them were cultivated by farmers who sold the crop in London. Although the dried sap of the poppy can be smoked, this was rarely done.

People preferred to make 'Poppy Tea' of the seeds, opium pills to eat, and tinctures and cordials to drink. Until 1868, opium could be bought in every place from any shop. In more rural areas, pedlars sold it from door to door. Opium pills, laudanum, 'penny sticks' and a tincture known as Godfrey's Cordial were consumed in great quantities by almost everyone. In the nineteenth century, beer with a 'chaser' in the form of 'opic', an opium pill, was a favourite drink of the Fenman. Even babies were given an opium concoction called Mrs Winslow's Syrup to keep them quiet. When a woman was about to give birth on May Day, the day considered to be the unluckiest birthday, she was dosed with large quantities of laudanum. This would render her comatose, and stop the contractions. Hopefully, the baby would be alive when it was born on 2 May. Also, it was not uncommon for lethal doses of opium to be given to deformed or illegitimate babies, or to one of a pair of twins. Only with the beginning of the Great War was opium growing suppressed, and opium supplies were curtailed under the Dangerous Drugs Act of 1920. The cultivation of 'Neckweed' – hemp (*Cannabis sativa*) – which in addition to being used for ropes, was smoked in the Fens, was also prohibited at this time.

Cambridgeshire cunning men and wise women would not take opium, as they knew its detrimental effects on the body, memory and psyche. This gave them the advantage over others that they often showed in their powers of insight and magical abilities. Not being drugged gives one the edge over those who are. However, East Anglian cunning men and wise women did burn henbane (*Hyoscyamus niger*) on their fires to evoke spirits and assist clairvoyance. In the nineteenth century, the 'Planet Reader' of Shipham, a Mr Rix, also smoked a special 'tobacco of memory' that empowered him in his astrological operations. What this was, we can only guess. Under no circumstances should you try this, however, as all parts of the plant are extremely toxic. Folk wisdom teaches that any child who falls asleep near a henbane plant will die from its exhalations. To eat any part of the plant, especially the root, is extremely dangerous. In former times, root-doctors used it in small amounts as a painkiller in cases of toothache, but in larger doses it induces trance, sterility and madness.

To go into trance, wise women and cunning men would usually inhale the smoke of burning bay leaves, wormwood or

mugwort (*Laurus nobilis, Artemisia absinthium,* or *Artemisia vulgaris*). Mugwort has a curious root structure which contains black nodules which have protective and medicinal properties. It is used as a remedy against exhaustion, and it makes a useful incense, too. To gain trance, practitioners might also drink infusions containing rosemary and wild thyme leaves (*Rosmarinus officinalis* and *Thymus serpyllum*), or rowan berries (*Sorbus aucuparia*). 'Tea' made from yarrow (*Achillea millefolium*) was an infusion especially recommended for clairvoyance, or accurate readings in divination. In the Fens of Cambridgeshire, Rue Tea is known as Witch Broth. It seems that they were used together for 'flying', as recalled in the old wiccan couplet. 'By Yarrow and Rue, and my red cap too!' Yarrow plants strewn across the threshold prevent the entry of unwanted magic. Also, a cushion stuffed with yarrow can nullify the magic powers of a person who gains entry to one's dwelling with evil intent. Yarrow is also employed as a love herb. If it is cut on St Swithin's Day (15 July), and put into a pillow, it will bring great happiness to the lovers who sleep on it. Both yarrow and rue (*Ruta graveolens*) have been ascribed the power to regulate the menstrual cycle, but as with all medicinal herbs, they should never be taken without qualified supervision. To bring a good night's rest, rather than a good night's loving, it is customary to make a sleep-pillow stuffed with hops (*Humulus lupulus* or lady's bedstraw (*Galium verum*). Other useful herbs for love potions or charm-bags are rose, basil and meadowsweet (*Rosa spp., Ocimum basilicum,* and *Filipendula ulmaria,* respectively).

Sage (*Salvia officinalis*) is reputed to be a health-bringer, and a promoter of longevity, especially when eaten in the merry month of May. As John Hill tells us in his curious book *On the Virtues of Sage, in Lengthening Human Life,* 'I can remember a woman of the little town of Stanground, near Peterborough ... she was called a witch. About five square yards of ground, enclosed with a mud-wall before the door of her little habitation, was planted with Sage ... the people in general remember their fathers calling her the Old Woman.' Despite this glowing tribute to the longevity attributable to eating a sage diet, modern herbalism warns that it should not be consumed in large doses, or for long continuous periods, because it contains large quantities of *Thujone*. Today, under the influence of Native American tradition, brought to East Anglia by American servicemen, sage is often used as a smoke to purify rooms and sacred places.

Practitioners of the Nameless Art use the strong-smelling parts of the cypress tree (*Cupressus spp.*) and garlic (*Allium sativum*) for psychic protection. Garlic, especially, has been used as a preservative against evil spirits, malevolent magic and demonic entities. For purification, we favour Scots pine, cedar, lavender and hyssop (*Pinus sylvestris, Cedrus spp., Lavandula angustifolia,* and *Hyssopus officinalis*). Smoke from the burning resins of some conifers can be very purifying, but others are extremely hazardous. Resin of the yew tree (*Taxus baccata*) is highly toxic, and under no circumstance should be used as an incense. Similarly, it was once customary to burn all-heal (mistletoe, *Viscum album*) on the midsummer fire. But this is not recommended because of the toxicity of the smoke. Simpson, otherwise known as groundsel (*Senecio vulgaris*) is also used in the Fens as a plant of purification. On the sixth full moon of the year, it should be burnt in the house, to purify it physically and spiritually. Old Job Harley, a resident of Littleport in Cambridgeshire, was known as one of the most tenacious observers of this ceremony. The wearing of groundsel flowers was once the sign of a witch, who could only die when the plant is in flower. For luck, pouches containing leaves of ling, holly and oak are recommended (respectively *Calluna vulgaris, Ilex aquifolium* and *Quercus spp.*)

For general healing, the old herbalists recommended rosemary, thyme and peppermint. The latter name may be misleading, as there are well over a dozen different sorts of mint traditionally cultivated in eastern England, and the craft of the mint-grower is a rare skill. Mints are notoriously difficult to describe precisely, but the most common variety is *Mentha* x *piperata*, which is the most useful peppermint. Comfrey (*Symphytum officinale*), otherwise known as 'Bone-Set', was always considered useful for broken bones, though modern medicine is always the preferred option. But although no one would use comfrey any more for setting broken bones, it has remarkable properties with cuts and grazes, bringing about rapid healing. But comfrey should never be used to treat soreness of sensitive areas like the genitals, as the results are disastrous.

For kidney problems, East Anglian herbalists recommend agrimony (*Agrimonia agriminoides*) and borage (*Borago officinalis*). Arthritis is said to respond favourably to the eating of celery, and

primrose (*Primula vulgaris*) leaves in salads. Against headaches, valerian (*Valeriana officinalis*), ground ivy (*Glechoma hederacea*) and tea made from camomile (*Chamaemelum nobile*) are considered very effective remedies. Nervous headache, hysteria, spasms, cramps and even fits were treated with an infusion of lady's slipper (*Cypripedium calceolus*). In the nineteenth century, it was recommended as a safer alternative to opium.

Remedies against the 'ague', now classified as a catch-all term for malaria and other diseases and disorders of the wetlands, are many. To prevent the ague, Fenland people would scratch their legs with branches of holly (*Ilex aquifolium*), wear a herb-bag containing grated horseradish (*Armoracia rusticana*) on a cord around the neck, or strap a dock root (*Arctium lappa*) to the thigh. For relief from the ague, people would drink a decoction of the bark of the Sally Tree (willow, *Salix alba*). Mothers would make their children waistcoats into which the bark of the tree was sewn. Chips of wood from a gallows or gibbet also provided magical relief from the ailment. Another personal remedy uses sage (*Salvia officinalis*) and a spell.

A charm to banish ague from the house must be made after sunset on 19 January St Agnes' Eve. The oldest female of the household must go to the fireplace, and say the following spell up the chimney:

> Tremble and go!
> First day, shiver and burn,
> Tremble and quake!
> Second day, shiver and burn,
> Tremble and die!
> Third day, never to return,
> Ka!

In the days before termination of pregnancy was criminalized by the Abortion Act of 1803, and reinforced by the Offences Against the Person Act of 1861, decoctions of pennyroyal (*Mentha pulegium*), rue (*Ruta graveolens* and fennel (*Foeniculum vulgare*) were used by Handywomen to procure abortions. The herb was always used before 'quickening' of the foetus at 16–18 weeks. Alternatively, to prevent miscarriage, belladonna (*Atropa belladonna*) was used. As this is one of the most toxic plants, there is enormous risk to mother and baby in using this plant.

For what the herbalists called 'female disorders', they recommended drinking an infusion of motherwort (*Leonurus cardiaca*), or lad's love (Southernwood, (*Artemisia abrotanum*)).

Knowledge of abortifacients and trance-inducing agents was essential for Handywomen who were midwives and surgeons. There are numerous plants that contain highly toxic substances. They are known as 'The Weird Plants', and many have folklore that recalls their connection with older ways of understanding. They are the plants popularly associated with people who walk on the dangerous side. They include deadly nightshade (Belladonna, *Atropa bella-donna*), enchanter's nightshade (*Circaea lutetiana*), foxglove (*Digitalis purpurea*) and monkshood, (*Aconitum anglicum*). Reflecting the law of the unity of opposites, all of the toxic substances in these plants, used in small, precise, quantities, can alleviate serious disorders. The dividing line between curing and killing is very fine indeed, and the penalties for those that make mistakes are unforgiving.

Fungi do not figure large in the herb-bag. However, fly agaric (*Amanita muscaria*), associated in the popular mind with witchcraft, was used as an antidote to poisons. According to East Anglian herb-lore, the red and white toadstool has 'complete antagonism to the action of atropine (Belladonna), the active poison in deadly nightshade. This is due to the effect of 'the uncrystallizable alkaloid', *Muscarin*, that the fungus contains. The cunning men and wise women also used it as an antidote to the effects of poisonous fungi. When one uses dangerous substances, it is necessary to know how to undo their effects.

Recipes

Recipes for Ceremonial Food

East Anglia cuisine has a number of tried-and-tested recipes for food that can be used for special occasions, or at ceremonial events at certain times of the year. The recipes given here are traditional, but modern measures are given as well as the avoirdupois measure traditionally used in eastern England. The obsolete Fahrenheit temperatures are also given. When preparing the ceremonial food, one must retain the same state of mind that we use when making magical artefacts or conducting ceremonies. That way, the food is empowered with the correct

spirit, and will bring spiritual as well as nutritional benefits.

EAST ANGLIAN SOULCAKES (for Hollantide)

>
30 oz (750 g) flour
4 oz (100 g) butter
5 oz (125 g) sugar
1 tsp dried yeast
mixed spice
milk, sufficient to make a paste

Mix together the ingredients except the sugar and spice, then leave the mixture in a warm place for an hour, allowing it to rise. Then add the sugar and spice, make into flat cakes and bake in the oven at 375°F, 190°C for 15 to 20 minutes.

FAIR BUTTONS (once sold at the Easter fairs at Norwich and Great Yarmouth)

>
8 oz (200 g) plain flour
½ oz (12 g) ground ginger
2 oz (50 g) butter
4 oz (100 g) soft brown sugar
4 oz (100 g) golden syrup
a pinch of salt
a pinch of bicarbonate of soda
grated rind of a lemon

Sift the flour, bicarbonate of soda and ginger into a bowl. Cut up the butter, and rub it into the flour. Then add salt, golden syrup, sugar and lemon rind. Roll out thinly on a floured surface, cut into rounds and place on a greased baking tray. Cook in a hot oven (355°F, 180°C) for 10 to 12 minutes.

NORFOLK or SUFFOLK SCONES (for ceremonies at any time)

>
1 lb self-raising flour
1 level tsp salt
4 oz (100 g) butter
2 eggs
¼ pint (150 ml) milk

Sift the flour and salt, and mix them together. Then rub in the butter, until the texture is 'crumby'. Next, beat the eggs and add them to the mixture. Add milk, and knead the mixture to a soft dough. Turn the dough on to a floured surface, and knead lightly. Then divide the dough into two equal portions, and roll out.

NORFOLK RUSKS (for ceremonies at any time)

 8 oz (200 g) self-raising flour
 3 oz (75 g) butter
 milk
 salt

Sift the flour into a basin and add a pinch of salt. Cut up the butter into small pieces and rub them into the flour, then stir in enough milk to make an elastic dough. Roll out thickly, and cut into 16 rounds 1½ inches (4 cm) in diameter, place on a greased baking sheet and bake for 10 minutes in a hot oven (425°F, 220°C). Them remove the round, split them in half, and bake them in a cooler oven (325°F, 160°C).

YARMOUTH BISCUITS (for ceremonies at any time)

 12 oz (300 g) flour
 6 oz (150 g) currants
 8 oz (200 g) butter
 8 oz (200 g) sugar
 3 eggs

First, grease two baking sheets and soften the butter. Next, toss the currants in flour, add sugar, and mix the ingredients into a thick paste with the butter. Roll out thinly on to a floured surface, and cut into rounds like the Norfolk Rusks. Place on the greased baking sheets, and bake in the oven at 375°F, 190°C for 15 to 20 minutes.

GOD'S KITCHELS

God's Kitchels are the Suffolk speciality for the twelve days of Yule.

1 lb (400 g) puff pastry
½ lb (200 g) currants
2 oz (50 g) butter
3 oz (75 g) candied peel
2 oz (50 g) ground almonds
½ tsp cinnamon
½ tsp ground nutmeg

Divide the puff pastry into two portions and roll it out into squares. Then spread the filling inside one square, and moisten the edges of the other one with water. Bring together the two pieces, enclosing the mixture. Then mark out the top into squares measuring two inches along each side. This empowers the whole kitchel with the sacred grid. Then bake the kitchels in a hot oven for around half an hour. Finally, take them from the oven, sprinkle with caster sugar and cut up along the marking-out lines into squares. For New Year's Eve (after sunset on 31 December), triangular kitchel cakes are made to the same recipe.

NORFOLK PEA SOUP

Another food customary for the festival of Yule is pea soup, of which the following recipe is customary in Norfolk. It includes the sacred pig-meat of Yule celebrations in the northern tradition:

12 oz (300 g) split peas
1 smoked hock of bacon
1 diced onion, medium
3 carrots, sliced
2 sticks of celery, chopped
1 tsp marjoram
¼ tsp ginger
¼ tsp thyme
½ tsp pepper

2 tsp salt
bay leaf
2 pints (1.2 l) water

First soak the split peas, then bring all of the ingredients together in a large pot. Put them on the hob to bring them to the boil. Then cover the pot and let the soup simmer for half a tide (1½ hours), stirring the contents now and then until the peas disintegrate. Then the soup is ready to serve at the Yule festivities.

Conclusion

The ceremonies and methods of The Way of the Eight Winds described here are a means of coming into alignment with the natural cycles of existence. They are not a panacea, but provide us with a way of living with a greater awareness of ourselves and those around us, on the visible and invisible levels. In times of rapid change, such as these, people sometimes express a wish to return to the lifestyles of earlier times. Because people in the past lived nearer to nature than we do today, apologists for simplicity seem to believe that they were in some ways happier, or more noble, than we are. It is convenient for them to ignore the historic reality of 'the hard times of Old England', to present instead a fantastic vision of former times as more desirable than our own. Far from presenting a golden age, much of English history is a cavalcade of merciless wars and vicious invasions, ethnic and religious killings, feudal oppression, slavery, famines, plagues, mass deportations, witch-hunting, terrible punishments and appalling institutionalized cruelty to human beings and animals alike.

Attempts to restore what is essentially legendary, such as the 'Merrie England' myth of a happy land filled with pure peasants living in harmony with nature and each other, are doomed to fail. In addition to ignoring what history teaches us about human nature, this myth of the good old days, and how they must be recreated if we are to have health and happiness, has a dangerous side that is often manifested as religious fundamentalism and political extremism. The Nameless Art is not a means of regaining this imaginary past. Nor is it a form of escapism, which is a retreat from creative living in the present. It is a means to living more consciously now, for at its core is a positive attitude to life, which recognizes that nature is alive and

hallowed by the immanent presence of that which we call the divine. In the past, the spiritual tradition of East Anglia has continued by accommodating itself to many changes, and so long as its inner essence remains, it will continue to be of great value to those who practise it.

Appendix: The Correspondences and Meanings of Time and Tide in the Nameless Art

1 The Eight Tides of the Day and the Winds

Traditionally, the day is divided into eight three-hour periods known as Tides. Each has a name, coresponds with one of the eight winds of classical location, and has a spiritual attribute.

	Tide Name	*Wind*	*Sele Quality*
4.30–7.30	Morntide	Solanus	Arousal, awakening, life
7.30–10.30	Daytide	Eurus	Gentleness, earning, gain, money
10.30–13.30	Midday	Auster	Sustaining, perseverance, continuance
13.30–16.30	Undorne	Africus	Receptiveness, parents
16.30–19.30	Eventide	Favonius	Joyousness, family, children
19.30–22.30	Night-tide	Caurus	Creativity
22.30–1.30	Midnight	Septentrio	Bedtime, lovemaking
1.30–4.30	Uht	Aquilo	Stillness, sleep, death

2 The Seles and Meals

Some specific Times, or Seles, in the day have their own names, associated with traditional mealtimes.

4.30	Risingsele
7.30	Daymark
11.00	Beevers
12.00	Noonsele
16.30	Fourses
19.30	Evening Meal

3 The Week

Each day of the week is ruled by and dedicated to one of the deities, which is also related to one of the heavenly bodies:

175

Day of Week	Planet	Element	Herb
Sunday	Sun	Fire	Polygonum
Monday	Moon	Water	Chickweed
Tuesday	Mars	Fire	Plantain
Wednesday	Mercury	Air	Cinquefoil
Thursday	Jupiter	Fire	Henbane
Friday	Venus	Earth	Vervain
Saturday	Saturn	Earth	Daffodil

Day of the week	Tree	Prohibition	Deity
Sunday	Birch	Scissors	Phoebe
Monday	Willow		Lady Moon
Tuesday	Holly		Termagant
Wednesday	Ash		Woden
Thursday	Oak		Thor
Friday	Apple	Nail/haircut	Frea
Saturday	Alder		Saturnus

4 Lapidiary Correspondences

Precious stones are rare crystals whose inner nature reflects the magical properties of the planets and zodiacal constellations:

Stone	Day	Planet	Zodiac sign	Deity
Diamond	Tuesday	Mars	Aries	Termagant
Sapphire	Friday	Venus	Taurus	Frea
Emerald	Wednesday	Mercury	Gemini	Woden
Agate	Monday	Moon	Cancer	Lady Moon
Ruby	Sunday	Sun	Leo	Phoebe
Sardonyx	Wednesday	Mercury	Virgo	Woden
Chrysolite	Friday	Venus	Libra	Frea
Opal	Tuesday	Mars	Scorpio	Termagant
Topaz	Thursday	Jupiter	Capricorn	Thor
Amethyst	Saturday	Saturn	Aquarius	Saturnus
Bloodstone	Thursday	Jupiter	Pisces	Thor

Glossary of Terms

The Nameless Art uses the following specialist terms, most of which originate in the East Anglian dialect.

Airt	one of the eight directions.
Balderick	a horse-hair girdle.
Bellarmine	a brown, salt-glazed Witch Bottle with a bearded face.
Belweather	a good spirit.
Ben	the corn effigy put in front of the last load of the harvest.
Besom	a witch's broomstick.
Bid	a house animal, a familiar.
Bidding	praying, offering to a deity.
Blind Days	the three days (St David, St Chad and St Winnal; 1–3 March), when seed should not be sown.
Blout	a ceremony.
Bonesman	a member of the secret society known as The Ancient Order of Bonesmen.
Bought	a circular magical enclosure, a magic circle.
Bull's Noon	midnight.
Clim	the spirit of the chimney.
Corposant	an electrostatic emanation in unsettled weather; St Elmo's Fire.
Cramp-bone	the patella of a sheep or lamb, carried as a prophylactic against cramp.
Croomstick	magical stave with hooked end.
Dapter	a skilled person.
Deadman's Day	20 November, St Edmund's day.
Dod	a peg or stick upon which a rig (see below) is lined up.
Eager	tidal wave in a river.
Eagershelm	a magically protective Germanic sigil, obtained from

	the dragon Fafner by Sigurd, identical with Aegishjalmur of Iceland.
Enhardening, spell of	a protective spell that enables a person, animal or thing to withstand an attack which otherwise would destroy him, her or it.
Enhazelled Field, The	a piece of ground consecrated by hazel staves and red strings.
Fairises	the fairies.
Farseer	a person with second sight, or powers of divination.
Ferridge	a thick gingerbread biscuit with imprinted sigils.
Fetch	a spirit-entity which every person has accompanying him or her from birth to death.
Four Wentz Ways	crossroads.
Freethorn	whitethorn or hawthorn, *Crataegus monogyna*.
Frithyard	sacred ground.
Gaffel	a guild of craftspeople; a magical society.
Galster	a magical call, chant or song.
Gansey	a fisherman's sweater, knitted with magically protective patterns.
Gast	barren land, from which the earth-sprites have been driven.
Gear-stuff	herbal medicine.
Geomancy	the mystical art of placement, also a classical technique of divination.
Horseman	a member of the secret Society of the Horseman's Word.
Hulver	holly, *Ilex aquifolium*
Hytersprite	benevolent earth spirit.
Jiece	a small quantity of anything.
Ka!	'And so mote it be.'
Karinder!	'Attention!'
Lie by the wall (to)	to be dead.
Locator	a person who finds the right place for anything, be it a plant or a house, by means of geomancy.
Mell	ceremonial hammer.
Mole Country (gone to)	died.
Morcan	a ceremonial effigy.
Midsummer	mandrake, *Mandragora officinarum*.
Nayword	password, watchword.
Neckweed	hemp, *Cannabis sativa*.
No Man's Land	a piece of uncultivated ground at a road junction.

No Nation Place	an out-of-the-way place ignored by the authorities.
Nowl	navel, as in the Pole Star, or the centre of a piece of land.
Odling	something without equal.
Old Sows	woodlice. When they live in the roots of herbs, they accumulate active ingredients, and were swallowed as the original pills to treat illnesses and disorders. Also called 'Pill-Bugs'.
Otherworld	the area of consciousness beyond the everyday world; the spirit-world.
Overlooked	bewitched.
Padduck	a toad.
Pargeting	East Anglian external plasterwork on buildings, patterned with magical symbols.
Perry Dancers	the Aurora Borealis, the Northern Lights.
Pungled Potato	a dried, mummified potato, carried in the pocket as an amulet against rheumatism or arthritis.
Ramper	a metalled public road.
Rig	a straight line on the ground, in which potatoes, barley etc. are sown.
Rockstaff	a distaff, an 'Old Wives' Tale'.
Sele	hour, time of day or time of year.
Shoat	the line or field along which stones or slivers are cast in divination.
Shotsele	evening time.
Simpson	the plant groundsel, *Senecio vulgaris*
'Sit Ye Merry'	'behold, the end'.
Sliver	flat slice of wood fashioned to bear runes or sigils as a talisman or for divination.
Snor	ceremonial measuring cord (The Druids' Cord), with twelve knots and thirteen sections.
Snotches	knots on the Snor.
Spirament	subtle energy or 'cosmic breath'.
Spirit	lightning.
Sprite Flail	a magical whip, made from branches of bramble (blackberry, *Rubus fruticosus*).
Spur-way	a bridleway.
Stale	the staff or handle of the besom.
Summer's Day	14 April, the beginning of the summer half of the year.
Sway	a wand.
Thunder-pipe	a meteorite or any stone fallen from the heavens.
Tide	one of the eight divisions of the day.
Tiugunde Day	13 January, the mid-point of the winter half of the year.

Toadsman (or Toadswoman)	a person who has gained the toad's bone, and with it certain magical powers.
Totalled	killed.
Troshel	the threshold of a house.
Ward, The	the protection of a settlement at night by its spirit-guardians.
Wardstaff	staff of office.
Wassail	literally 'be whole', the ceremonial charming of apple and other fruit trees after midwinter.
Weer	pale and ghastly in appearance.
Whiffle	to beat the air with a stick, driving off unwanted people and spirits.
Whiffler	a ceremonial official who walks in front of a parade to clear the way physically and magically.
Will	Will O' The Wisp, Jinny Burntarse, the Hobby Lanthorn – marsh lights.
Winter's Day	14 October, the beginning of the winter half of the year.
Witch Ball	a silvered spherical reflector, hung in a window or door.
Witch Bottle	a bottle, prepared magically, with the function of warding off evil spirits and magical attack.
Yard	a cottage garden.
Yarthkin	a malevolent earth spirit.
Yerbes	herbs.
Yerth	the earth.
Yule	the festival of midwinter.

Bibliography

Individual articles, letters, notes and queries are too numerous to list.
The following journals, magazines and serials have been consulted.

Albion
Ancient Mysteries
Archaeological Journal
British Journal of Sociology
Bygones
Caerdroia
Cambridgeshire Ancient Mysteries
Cambridgeshire, Huntingdonshire and Peterborough Life
Cambridgeshire Public Library Record
Cauldron
Durobrivae
East Anglian Magazine
East Anglian Miscellany
East Anglian Notes and Queries
Eastern Counties Magazine
English Historical Review
Essex Landscape Mysteries
Essex Naturalist
Exploring the Supernatural
Fenland Notes and Queries
Folklore
Folk-Lore
History Teachers' Miscellany
Institute of Geomantic Research Occasional Papers
Journal of the Folk-Song Society
Journal of Geomancy
Journal of the History of Ideas
Lantern
Lincolnshire Past and Present
Medieval Archaeology

Norfolk and Norwich Notes and Queries
Norfolk Antiquarian Miscellany
Norfolk Archaeology
Norfolk Fair
Odinic Rite Briefing
Popular Archaeology
Practical Geomancy
Proceedings of the Cambridge Antiquarian Society
Proceedings of the Suffolk Institute of Archaeology
Publications of the Camden Society

Quarterly Review
Raven Banner
Spellthorn
Suffolk Archaeology
Suffolk Fair
Suffolk Notes and Queries
Suffolk Review
Supernaturalist
Symbol
Transactions of the Cambridgeshire and Huntingdonshire Archaeological Society
Transactions of the Essex Archaeological Society
Transactions of the Suffolk Natural History Society
Waveney Clarion
Wiccan

Books, Papers and Pamphlets:
Anonymous manuscript versions of *The Secret Granary*
Anon., *Handbook of the Eastern Counties* (John Murray, London, 1892)
Anon., *More Secret Remedies* (British Medical Association, London, 1912)
Anon., *Secret Remedies* (British Medical Association, London, 1909)
Anon., *Wisbech Hundred* (Wisbech, 1850)
Amos, G.S., *The Scratch Dials of Norfolk* (G.S. Amos, South Walsham, n.d. (*c.* 1980)
Andrews, William, *Ecclesiastical Curiosities* (William Andrews, London, 1899)
Barrett, W.H., *Tales from the Fens* (Routledge and Kegan Paul, London, 1963)
Barrett, W.H., and Garrod, R.P., *East Anglian Folklore and Other Tales*, (Routledge and Kegan Paul, London, 1976)
Bevis, Trevor, *Wide Horizons: Hard graft for old-time Fenmen* (T. Bevis, March, 1994)

Black, William George, *Folk Medicine* (Elliot Stock, London, 1893)

Blomefield, Francis, *History of Norfolk* (Miller, London, 1808)

Browne, Sir Thomas, *Religio Medici* (1635) (Macmillan, London, 1946)

Bunn, Ivan, and Burgess, Michael, W., *Haunted Lowestoft* (BSIG, Lowestoft, 1975)

Bunn, Ivan and Burgess, Michael W., *Local Curiosities: A miscellany of ghosts, legends and unusual facts from the Lowestoft area* (East Suffolk and Norfolk Antiquarians, Lowestoft, 1976)

Burgess, Michael, W., *The Standing Stones of Norfolk and Suffolk* (East Suffolk and Norfolk Antiquarians, Lowestoft, 1978)

Burgess, Michael, W., *Holy Wells and Ancient Crosses* (East Suffolk and Norfolk Antiquarians, Lowestoft, 1978)

Clarke, William George, *In Breckland Wilds* (Robert Scott, London, 1925)

Cockayne, Oswald, *Leechdoms, Wort Cunning and Star Craft of Early England* (Longmans, London, 1864)

Chamberlain, Mary, *Old Wives' Tales* (Virago, London, 1981)

Cross, Arthur, *Time-dials in the Deanery of Depwade* (Norwich and Norfolk Archaeological Society, Norwich, 1914)

Culpeper, Nicholas, *Herbal* (many editions)

Dack, Charles D., *Weather and Folklore of Peterborough and District* (Peterborough Natural History, Scientific and Archaeological Society, Peterborough, 1911)

Dawson, W.R., *A Leech Book of Medical Recipes of the 15th Century* (Macmillan, London, 1934)

Drake, Mavis R., *A Pot-Pourri of East Anglian Witchcraft* (Sylvana Publications, Royston, 1989)

Dutt, W.A., *Highways and Byways of East Anglia* (Macmillan, London, 1902)

Dutt, W.A., *Norfolk* (Methuen, London, 1902)

Dutt, W.A., *The Norfolk and Suffolk Coast* (T. Fisher Unwin, London, 1909)

Dutt, W.A., *Standing Stones of East Anglia* (Flood and Sons, Lowestoft, 1921)

Dutt, W.A., *The Ancient Mark-Stones of East Anglia* (Flood and Sons, Lowestoft, 1926)

Ehrenreich, Barbara, and English, Deidre, *Witches, Midwives and Nurses* (The Feminist Press, New York, 1973)

Evans, George Ewart, *The Pattern Under the Plough* (Faber and Faber, London, 1966)

Evans, George Ewart, *Ask the Fellows Who Cut the Hay* (Faber and Faber, London, 1973)

Forrest, A.J., *Under Three Crowns* (Boydell Press, Ipswich, 1961)

Gerish, W.B., *Norfolk Folklore* (London, 1892)

Gerish, W.B., *Norfolk Folklore Collections* (1916–18)

Gillingwater, E., *History of Lowestoft* (J. Rackham, London, 1794)

Gillingwater, E., *Historical and Descriptive Account of St Edmunds Bury* (J. Rackham, London, 1804)

Glyde, John, *The Norfolk Garland* (Jarrold, Norwich, 1872)

Gurdon, Lady, *County Folklore: Suffolk* (David Nutt, London, 1893)

Grattan, J. and Singer, C., *Anglo-Saxon Magic and Medicine* (Oxford University Press, Oxford, 1952)

Green, H.J.M., *Godmanchester* (Oleander Press, Cambridge, 1977)

Haining, Peter, *The Supernatural Coast: Unexplained Mysteries of East Anglia* (Robert Hale, London, 1992)

Harvey, Michael, and Compton, Rae, *Fisherman Knitting* (Shire, Princes Risborough, 1978)

Houghton, Bryan, *St Edmund: King and Martyr* (T. Dalton, London, 1970)

Howard, Michael, *Traditional Folk Remedies* (Century, London, 1987)

Howat, Polly, *Tales of Old Cambridgeshire* (Countryside, Newbury, 1990)

Johnson, Walter, *Byways in British Archaeology* (Cambridge University Press, Cambridge, 1912)

Jones, Prudence, *Eight and Nine: Sacred Numbers of Sun and Moon in the Pagan North* (Fenris-Wolf, Bar Hill, 1982)

Jones, Prudence, *Sundial and Compass Rose: Eight-Fold Time Division in Northern Europe* (Fenris-Wolf, Bar Hill, 1982)

Jones, Prudence, *Northern Myths of the Constellations* (Fenris-Wolf, Cambridge, 1991)

Jones, Prudence and Pennick, Nigel, *A History of Pagan Europe* (Routledge, London, 1995)

Keynes, F.A., *Byways of Cambridge History* (Cambridge University Press, Cambridge, 1947)

Laing, J.M., *Notes on Superstition and Folk-Lore* (John Menzies, London, 1885)

'Lugh', *'Old George' Pickingill and the Roots of Modern Witchcraft* (Wiccan Publications, London, 1982)

'Lugh', *Medieval Witchcraft and the Freemasons* (Wiccan Publications, London, 1982)

MacLaren, Angus, *Birth Control in Nineteenth Century England* (Croom Helm, London, 1978)

Mann, Ethel, *Old Bungay* (Heath Cranton, London, 1934)

Maple, Eric, *Medicine and Quackery* (Robert Hale, London, 1968)

Marlowe, Christopher, *Legends of the Fenland People* (Cecil Palmer, London, 1926)

Marshall, Sybil, *Fenland Chronicle* (Cambridge University Press,

Cambridge, 1967)

McFadzean, Patrick, *Astrological Geomancy* (Northern Earth Mysteries, York, 1985)

Norbury, James, *Traditional Knitting Patterns* (Batsford, London, 1962)

Norris, Herbert E., *History of St Ives, Hunts* (*County Guardian*, St Ives, 1889)

Page, Robin, *Cures and Remedies the Country Way* (Davis-Poynter, London, 1978)

Papworth, Cyril, *Polka Round: The Cambridgeshire Feast Dances* (Cyril Papworth, Comberton, 1984)

Parker, Rowland, *The Cottage on the Green* (Rowland Parker, Foxton, 1973)

Parsons, Catherine, *Notes on Cambridgeshire Witchcraft* (Cambridge Folk Museum, 1985)

Peck, A., *The Morris Dances of England* (Morris Ring, London, 1970)

Pennick, Nigel, *The Mysteries of King's College Chapel* (The Land of Cokaygne, Cambridge, 1974)

Pennick, Nigel, *Daddy Witch and Old Mother Redcap* (Cornerstone Press, Bar Hill, 1985)

Pennick, Nigel, *Skulls, Cats and Witch Bottles* (Nigel Pennick Editions, Bar Hill, 1986)

Pennick, Nigel, *Mazes and Labyrinths* (Robert Hale, London, 1990)

Pennick, Nigel, *Rune Magic* (Aquarian, London, 1992)

Pennick, Nigel, *The Pagan Book of Days* (Destiny Books, Rochester, Vermont, 1992)

Pennick, Nigel, *Practical Magic in the Northern Tradition* (Thoth, Loughborough, 1994)

Pennick, Nigel, *The Oracle of Geomancy* (Capall Bann, Chieveley, 1995)

Pennick, Nigel and Devereux, Paul, *Lines on the Landscape* (Robert Hale, London, 1989)

Porter, Enid, *Cambridgeshire Customs and Folklore* (Routledge, London, 1969)

Porter, Enid, *The Folklore of East Anglia* (Batsford, London, 1974)

Pritchard, V., *English Medieval Graffiti* (Cambridge University Press, Cambridge, 1967)

Randell, A., *Sixty Years a Fenman* (Routledge and Kegan Paul, London, 1966)

Reuter, Otto Sigfrid, *Skylore of the North* (Runestaff, Bar Hill, 1985)

Rye, Walter, *Norfolk Songs, Stories and Sayings* (Goose and Sons, London, 1897)

Rye, Walter, *Norfolk Essays* (Jarrolds, Norwich, 1926–28)

Saunders, W.H.B., *Legends and Traditions of Huntingdonshire* (Simpkin Marshall, London, 1888)

Savory, Alan, *Norfolk Fowler* (Boydell Press, Ipswich, 1953)

Smart, C. and Smart, C. (eds.), *Women, Sexuality and Social Control* (Routledge and Kegan Paul, London, 1979)

Stevens, Beatrice, *Stretham: A Feast of Memories* (Providence Press, Haddenham, 1989)

Swinger, Charles, *Early English Medicine and Magic* (Oxford University Press, Oxford, 1920)

Taylor, Alison, *Anglo-Saxon Cambridgeshire* (Oleander Press, Cambridge, 1978)

Tebbutt, C.F., *Huntingdonshire Folklore* (Friends of the Norris Museum, St Ives, 1984)

Thistleton-Dyer, T.F., *The Folk-lore of Women* (Elliot Stock, London, 1905)

Toulson, Shirley, *East Anglia: Walking the Ley Lines and Ancient Tracks*, (Wildwood House, London, 1979)

Turner, William, *The New Herball* (London, 1551)

Tymms, Samuel, *A Handbook of Bury St Edmunds* (F. Lankester, London, 1859)

Watkins, Alfred, *Archaic Tracks Round Cambridge* (Simpkin Marshall, London, 1932)

Wentworth-Day, James, *Essex Ghosts* (Spurbooks, Bourne End, 1973)

Williamson, Tom, *The Origins of Norfolk* (Manchester University Press, Manchester, 1993)

Yates, Richard, *The History and Antiquities of the Abbey of St Edmunds Bury* (Nichols and Son, London, 1843)

Index